American Artists
on Art

from 1940 to 1980

American Artists on Art

from 1940 to 1980

Edited by
ELLEN H. JOHNSON

ICON EDITIONS

HARPER & ROW, PUBLISHERS, New York

Cambridge, Philadelphia, San Francisco
London, Mexico City, São Paulo, Sydney

Grateful acknowledgment is made for permission to reprint:

page 5: Statement from *Jackson Pollock* by Francis V. O'Connor. Copyright © 1967 The Museum of Modern Art, New York. All rights reserved. Reprinted by permission.

page 10: Letter by Adolph Gottlieb, Mark Rothko and Barnett Newman in Edward Alden Jewell, "'Globalism' Pops into View," *The New York Times*, June 13, 1943. © 1943 by The New York Times Company. Reprinted by permission.

FIRST EDITION

Library of Congress Cataloging in Publication Data
Main entry under title:

American artists on art from 1940 to 1980.
 Includes index.
 1. Art, American. 2. Art, Modern—20th century
—United States. 3. Happening (Art)—United States.
4. Artists as authors—United States. I. Johnson,
Ellen H.

N6512.A586	1982 700'.973	80–8702
		AACR2
ISBN 0–06–433426–0		82 83 84 85 86 10 9 8 7 6 5 4 3 2 1
ISBN 0–06–430112–5 (pbk.)		82 83 84 85 86 10 9 8 7 6 5 4 3 2 1

CONTENTS

1

Abstract Expressionism

2

Other Art of the Forties and Fifties

3

Color Field Painting

4

Happenings and Other Pre-Pop Art

5

Pop Art

6

Minimal Art

7

Systemic and Conceptual Art

8

Photo-Realist Painting and Super-Realist Sculpture

9

Earth and Process Art

10

Site and Architectural Sculpture

11

Performance Art, Film, and Video

12

Decorative, Narrative, and Popular Image Painting and Installations

ACKNOWLEDGMENTS

I should like to offer my personal thanks to organizations and individuals for permission to reprint articles and interviews and to reproduce works of art. I am especially grateful to those artists who have allowed me to use previously unpublished material and to those who have supplied photographs. Particular thanks are due my editor, Cass Canfield, Jr., and his assistant, Pamela Jelley, for their unfailing courtesy and attention. I am much indebted to Richard E. Spear for his suggestions regarding my text and to Athena Tacha for her invaluable help and advice from start to finish.

E.H.J.

PREFACE

The fact that so much of modern art has devoted itself to the exploration and assertion of its own identity is reflected in, but does not explain, the increasing amount of writing and talking on the part of contemporary artists. Rather, the whole history of the changing role of art and artists in a democratic, industrial, and technological society stands behind the spate of artists' words and the public's hunger for them—even some of the general public out there beyond art's little circle. Statements by artists appeal somewhat the way drawings do: they bring us, or at least they hold the promise of bringing us, closer to the artist's thoughts and feelings and to an understanding of his or her *modus operandi;* they hold the keys to a mysterious realm. And sometimes they offer us the sheer pleasure of good reading. Such is the primary *raison d'être* of this book.

Its other motivation is educational, and stems from the frustrating lack, in teaching contemporary art, of any single compilation of statements by American artists from 1940 to the present. For courses in earlier modern art, from the eighteenth to the twentieth centuries, there are several useful anthologies, such as the *Sources and Documents* series, which include writings by artists together with those of their critics and associates. As a teacher who cherishes the belief that, regardless of what explications and interpretations we historians and critics might assign to an artist's work, the person who created it should have first say, I have especially prized Robert Goldwater and Marco Treves, *Artists on Art.* This is acknowledged in the title of my anthology, which can be seen as a latterday extension of theirs, although theirs embraces more centuries than mine does decades.

This anthology differs in several respects from those others that do include documents of American art since 1940 (such as Barbara Rose, ed., *Readings in American Art 1900–1975,* and Herschel B. Chipp, *Theories of Modern Art*) and from those that present specific groups (e.g., Cindy Nemser, *Art Talk: Conversations with Twelve Women Artists*) or individual movements (e.g., Gregory Battcock's several "critical anthologies" on minimal art, super-realism, video, etc.—the early ones apparently the least hastily compiled). The selection I have made is devoted exclusively to statements of artists; it is limited to the last four decades; it presents in a single volume a representative and fairly comprehensive coverage of major developments in American art beginning with Abstract Expressionism; and, whenever possible, it cites the first, or among the very earliest, documents signalizing a shift in the definition, intent, or direction of art.

The categories are arranged chronologically to the extent that the over-lapping or simultaneous emergence of multiple currents and the varied activity of individual artists permit. Which, for example, should be cited first—performance or site sculpture? (I chose site to keep it next to earth art.) While some photo-realist painting and super-realist sculpture preced-ed systemic and conceptual art, the latter is so directly related to minimal-ism that absolute chronology had to give way to ideological and visual continuity. In fact, the work of such artists as Sol LeWitt suggests that a single rubric might embrace minimalism, systemic and conceptual art. Other artists, especially Claes Oldenburg and Robert Morris, have made important contributions in such widely different areas that it was impossi-ble to limit selections of their writings to a single category. Such problems in classifying demonstrate the inadequacy of labels—they also bear wit-ness to the flexibility and range of the creative mind and to the steady flow of continuity that courses through all the innovations of modern art. The names of the sections into which the book has been ordered are those most frequently accepted for the given movement or group by the art public, which clamors for classification as ardently as the artist resists it. However, these categories must be conceived of as elastic—if not alto-gether dispensable. Certainly none of them is terminal; even now, when there is a revival of Abstract Expressionism, such important original mem-bers of that group as de Kooning and Motherwell continue to expand the borders of its territory. I hold no special brief for the type of classification I have chosen. These writings could just as well have been presented ac-cording to issues, themes, styles, or genres, any of which might have been more provocative but less straightforward and helpful to the general read-er, as well as the student.

At first it was planned to publish all selected writings in their total length, but I soon found that some excerpting was not only essential be-cause of space limitations but sometimes even desirable for the sake of clarity and focus, particularly in the case of interviews. If it were only that not all artists write and that not all writings by artists are significant or available, the selection would have been relatively easy; the task was made more painful by the abundance of valuable material to choose from, especially in the seventies. My choices from that richly varied dec-ade, with its wealth of artists' writings and interviews, may turn out to be more arbitrary and less significant than those from earlier decades, which have had more time to simmer down to essentials. But any anthology, like any course syllabus, will include some personal preferences along with as many indisputably decisive documents as possible.

Oberlin
September 1980

American Artists
on Art

from 1940 to 1980

1

Abstract Expressionism

With the emergence, during World War II, of Abstract Expressionist painting (also known as Action Painting and the New York School), the dates began to play a major role in world art. The presence of several important European artists, especially Mondrian and the Surrealists— actually living right there, in the same place, during those years—was a profoundly liberating force to our artists, as Pollock acknowledges.

JACKSON POLLOCK (1912-1956)

Jackson Pollock, Response to questionnaire, *Arts and Architecture* (February 1944)

This early statement by the artist who is universally identified with the American breakthrough in the 1940s was effectively titled simply by Pollock's signature, with no interviewer named. Francis O'Connor as certained from the artist's widow, Lee Krasner, that the questionnaire was "formulated by Pollock with the assistance of Howard Putzel." °
Putzel was associated with the Art of This Century Gallery, where, during the war years, the expatriate Peggy Guggenheim showed the work of the European Surrealists whom she had brought here, as well as that of several of the Americans who later became known as Abstract Expressionists.

★ ★ ★

Where were you born?

J.P.: Cody, Wyoming, in January, 1912. My ancestors were Scotch and Irish.

Have you traveled any?

J.P.: I've knocked around some in California, some in Arizona. Never been to Europe.

Would you like to go abroad?

° Francis V. O'Connor, *Jackson Pollock*. New York: Museum of Modern Art, 1967, p. 31.

1

J.P.: No. I don't see why the problems of modern painting can't be solved as well here as elsewhere.

Where did you study?

J.P.: At the Art Student's League, here in New York. I began when I was seventeen. Studied with Benton, at the League, for two years.

How did your study with Thomas Benton affect your work, which differs so radically from his?

J.P.: My work with Benton was important as something against which to react very strongly, later on; in this, it was better to have worked with him than with a less resistant personality who would have provided a much less strong opposition. At the same time, Benton introduced me to Renaissance art.

Why do you prefer living here in New York to your native West?

J.P.: Living is keener, more demanding, more intense and expansive in New York than in the West; the stimulating influences are more numerous and rewarding. At the same time, I have a definite feeling for the West: the vast horizontality of the land, for instance; here only the Atlantic Ocean gives you that.

Has being a Westerner affected your work?

J.P.: I have always been very impressed with the plastic qualities of American Indian art. The Indians have the true painter's approach in their capacity to get hold of appropriate images, and in their understanding of what constitutes painterly subject matter. Their color is essentially Western, their vision has the basic universality of all real art. Some people find references to American Indian art and calligraphy in parts of my pictures. That wasn't intentional; probably was the result of early memories and enthusiasms.

Do you consider technique to be important in art?

J.P.: Yes and no. Craftsmanship is essential to the artist. He needs it just as he needs brushes, pigments, and a surface to paint on.

Do you find it important that many famous modern European artists are living in this country?

J.P.: Yes. I accept the fact that the important painting of the last hundred years was done in France. American painters have generally missed the point of modern painting from beginning to end. (The only American master who interests me is Ryder.) Thus the fact that good European moderns are now here is very important, for they bring with them an

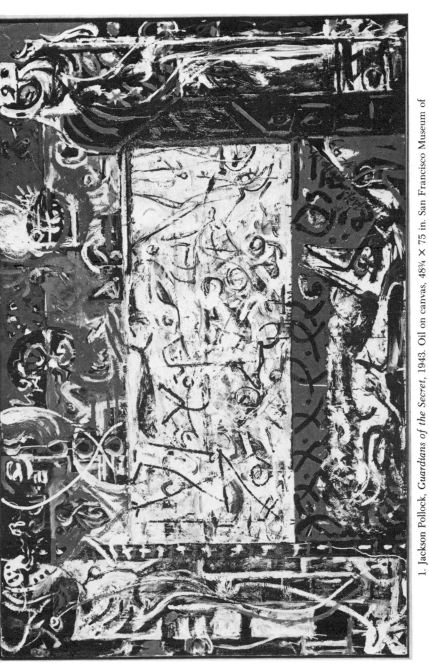

1. Jackson Pollock, *Guardians of the Secret*, 1943. Oil on canvas, 48¾ × 75 in. San Francisco Museum of Modern Art, Albert M. Bender Bequest Fund Purchase.

understanding of the problems of modern painting. I am particularly impressed with their concept of the source of art being the unconscious. This idea interests me more than these specific painters do, for the two artists I admire most, Picasso and Miró, are still abroad.

Do you think there can be a purely American art?

J.P.: The idea of an isolated American painting, so popular in this country during the thirties, seems absurd to me, just as the idea of creating a purely American mathematics or physics would seem absurd.... And in another sense, the problem doesn't exist at all; or, if it did, would solve itself: An American is an American and his painting would naturally be qualified by that fact, whether he wills it or not. But the basic problems of contemporary painting are independent of any one country.

Jackson Pollock, "My Painting," *Possibilities I* (Winter 1947–48)

This brief document, which included six illustrations of Pollock's paintings, appeared in the first and only issue of *Possibilities,* published by Wittenborn, Schultz, Inc., and edited by Robert Motherwell, art; Harold Rosenberg, writing; Pierre Chareau, architecture; and John Cage, music. Pollock's recorded statements are even more scant than Picasso's—and nearly as influential. "On the floor I am more at ease. I feel nearer, more a part of the painting, since this way I can walk around, work from the four sides and literally be *in* the painting" is as familiar to the student of contemporary art now as Picasso's "When a form is realized it is there to live its own life" was thirty or forty years ago.

★　★　★

My painting does not come from the easel. I hardly ever stretch my canvas before painting. I prefer to tack the unstretched canvas to the hard wall or the floor. I need the resistance of a hard surface. On the floor I am more at ease. I feel nearer, more a part of the painting, since this way I can walk around it, work from the four sides and literally be *in* the painting. This is akin to the method of the Indian sand painters of the West.

I continue to get further away from the usual painter's tools such as easel, palette, brushes, etc. I prefer sticks, trowels, knives and dripping fluid paint or a heavy impasto with sand, broken glass and other foreign matter added.

When I am *in* my painting, I'm not aware of what I'm doing. It is only after a sort of "get acquainted" period that I see what I have been about. I have no fears about making changes, destroying the image, etc., because the painting has a life of its own. I try to let it come through. It is only when I lose contact with the painting that the result is a mess. Otherwise

there is pure harmony, an easy give and take, and the painting comes out well.

Excerpted from William Wright, "An Interview with Jackson Pollock," 1950, quoted in Francis V. O'Connor, *Jackson Pollock*, New York, Museum of Modern Art, 1967.

Taped for the Sag Harbor radio station but not broadcast, this interview dates from the same year as Hans Namuth's extraordinarily illuminating film of Pollock at work, in which the artist voices some of the ideas expressed in these three documents.

★ ★ ★

w.w.: Mr. Pollock, in your opinion, what is the meaning of modern art?

j.p.: Modern art to me is nothing more than the expression of contemporary aims of the age that we're living in.

w.w.: Did the classical artists have any means of expressing their age?

j.p.: Yes, they did it very well. All cultures have had means and techniques of expressing their immediate aims—the Chinese, the Renaissance, all cultures. The thing that interests me is that today painters do not have to go to a subject matter outside of themselves. Most modern painters work from a different source. They work from within.

w.w.: Would you say that the modern artist has had more or less isolated the quality which made the classical works of art valuable, that he's isolated it and uses it in a purer form?

j.p.: Ah—the good ones have, yes.

w.w.: Mr. Pollock, there's been a good deal of controversy and a great many comments have been made regarding your method of painting. Is there something you'd like to tell us about that?

j.p.: My opinion is that new needs need new techniques. And the modern artists have found new ways and new means of making their statements. It seems to me that the modern painter cannot express this age, the airplane, the atom bomb, the radio, in the old forms of the Renaissance or of any other past culture. Each age finds its own technique.

w.w.: Which would also mean that the layman and the critic would have to develop their ability to interpret the new techniques.

j.p.: Yes—that always somehow follows. I mean, the strangeness will wear off and I think we will discover the deeper meanings in modern art.

w.w.: I suppose every time you are approached by a layman they ask you

how they should look at a Pollock painting, or any other modern paint-ing—what they look for—how do they learn to appreciate modern art?

J.P.: I think they should not look for, but look passively—and try to re-ceive what the painting has to offer and not bring a subject matter or preconceived idea of what they are to be looking for.

W.W.: Would it be true to say that the artist is painting from the uncon-scious, and the—canvas must act as the unconscious of the person who views it?

J.P.: The unconscious is a very important side of modern art and I think the unconscious drives do mean a lot in looking at paintings.

W.W.: Then deliberately looking for any known meaning or object in an abstract painting would distract you immediately from ever appreciating it as you should?

J.P.: I think it should be enjoyed just as music is enjoyed—after a while you may like it or you may not. But—it doesn't seem to be too serious. I like some flowers and other flowers I don't like. I think at least . . . give it a chance.

W.W.: . . . A person would have to subject himself to it [modern painting] over a period of time in order to be able to appreciate it.

J.P.: I think that might help, certainly.

W.W.: Mr. Pollock, the classical artists had a world to express and they did so by representing the objects in that world. Why doesn't the modern artist do the same thing?

J.P.: H'm—the modern artist is living in a mechanical age and we have a mechanical means of representing objects in nature such as the camera and photograph. The modern artist, it seems to me, is working and ex-pressing an inner world—in other words—expressing the energy, the mo-tion, and other inner forces.

W.W.: Would it be possible to say that the classical artist expressed his world by representing the objects, whereas the modern artist expresses his world by representing the *effects* the objects have upon him?

J.P.: Yes, the modern artist is working with space and time, and expressing his feelings rather than illustrating.

W.W.: . . . Can you tell us how modern art came into being?

J.P.: It didn't drop out of the blue; it's a part of a long tradition dating back with Cézanne, up through the Cubists, the Post-Cubists, to the paint-ing being done today.

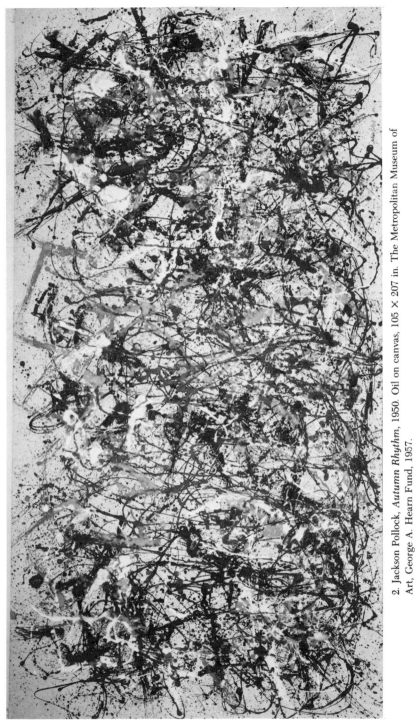

2. Jackson Pollock, *Autumn Rhythm*, 1950. Oil on canvas, 105 × 207 in. The Metropolitan Museum of Art, George A. Hearn Fund, 1957.

w.w.: Then, it's definitely a product of evolution?

j.p.: Yes.

w.w.: . . . Can you tell us how you developed your method of painting, and why you paint as you do?

j.p.: Well, method is, it seems to me, a natural growth out of a need, and from a need the modern artist has found new ways of expressing the world about him. I happen to find ways that are different from the usual techniques of painting, which seems a little strange at the moment, but I don't think there's anything very different about it. I paint on the floor and this isn't unusual—the Orientals did that.

w.w.: How do you go about getting the paint on the canvas? . . .

j.p.: Most of the paint I use is a liquid, flowing kind of paint. The brushes I use are used more as sticks rather than brushes—the brush doesn't touch the surface of the canvas, it's just above.

w.w.: Would it be possible for you to explain the advantage of using a stick with liquid paint rather than a brush on canvas?

j.p.: Well, I'm able to be more free and to have a greater freedom and move about the canvas, with greater ease.

w.w.: . . . Isn't it more difficult to control than a brush? . . .

j.p.: No, I don't think so . . . with experience—it seems to be possible to control the flow of the paint, to a great extent, and . . . I don't use the accident—'cause I deny the accident.

w.w.: I believe it was Freud who said there's no such thing as an accident. Is that what you mean?

j.p.: I suppose that's generally what I mean.

w.w.: Then, you don't actually have a preconceived image of a canvas in your mind?

j.p.: Well, not exactly—no—because it hasn't been created, you see. Something new—it's quite different from working, say, from a still life where you set up objects and work directly from them. I do have a general notion of what I'm about and what the results will be.

w.w.: That does away, entirely, with all preliminary sketches?

j.p.: Yes, I approach painting in the same sense as one approaches drawing; that is, it's direct. I don't work from drawings, I don't make sketches and drawings and color sketches into a final painting. Painting, I think,

today—the more immediate, the more direct—the greater the possibilities of making a direct—of making a statement.

w.w.: Actually every one of your paintings, your finished canvases, is an absolute original.

j.p.: Well—yes—they're all direct painting. There is only one.

w.w.: Would you care to comment on modern painting as a whole? What is your feeling about your contemporaries?

j.p.: Well, painting today certainly seems very vibrant, very alive, very exciting. Five or six of my contemporaries around New York are doing very vital work, and the direction that painting seems to be taking here—is—away from the easel—into . . . some kind of wall painting.

w.w.: I believe some of your canvases are of very unusual dimensions, isn't that true?

j.p.: Well, yes, they're an impractical size—9 x 18 feet. But I enjoy working big and—whenever I have a chance, I do it whether it's practical or not.

w.w.: Can you explain why you enjoy working on a large canvas more than on a small one?

j.p.: Well, not really. I'm just more at ease in a big area than I am on something 2 x 2; I feel more at home in a big area.

w.w.: You say "in a big area." Are you actually on the canvas while you're painting?

j.p.: Very little. I do step into the canvas occasionally—that is, working from the four sides I don't have to get into the canvas too much.

w.w.: I notice over in the corner you have something done on plate glass. Can you tell us something about that?

j.p.: That's something new for me. That's the first thing I've done on glass and I find it very exciting. I think the possibilities of using painting on glass in modern architecture—in modern construction—terrific.

w.w.: Well, does the one on glass differ in any other way from your usual technique?

j.p.: It's pretty generally the same. In this particular piece I've used colored glass sheets and plaster slabs and beach stones and odds and ends of that sort. Generally it's pretty much the same as all of my paintings.

w.w.: Well, in the event that you do more of these for modern buildings, would you continue to use various objects?

J.P.: I think so, yes. The possibilities, it seems to me are endless, what one can do with glass. It seems to me a medium that's very much related to contemporary painting.

W.W.: Mr. Pollock, isn't it true that . . . your technique is important and interesting only because of what you accomplish by it?

J.P.: I hope so. Naturally, the result is the thing—and—it doesn't make much difference how the paint is put on as long as something has been said. Technique is just a means of arriving at a statement.

ADOLPH GOTTLIEB (1903-1974) / MARK ROTHKO (1903-1970)

Adolph Gottlieb, Mark Rothko (and Barnett Newman),* Letter to *The New York Times,* quoted in Edward Alden Jewell, "'Globalism' Pops into View," *The New York Times,* Sunday, June 13, 1943

Two of the paintings that caused Jewell such "befuddlement" in the third annual exhibition of the Federation of Modern Painters and Sculptors, held at the Wildenstein Gallery in New York, were Mark Rothko's *Syrian Bull* and Adolph Gottlieb's *The Rape of Persephone.* These titles, and those that Pollock, Newman, Hofmann, Baziotes, and so on also assigned to their vaguely figurative abstract paintings of the mid-forties, characterize their common inspiration and sense of kinship with the mysterious power of primitive and archaic art and myth. At that time they even considered themselves, in Rothko's phrase, the "Myth Makers."

This letter constitutes the visual and spiritual creed of the Abstract Expressionists, formulated long before we historians and critics recognized the new movement sufficiently to try to put a name to it. The artists' manifesto also establishes the trend of much Abstract Expressionist criticism, with its emphasis on the "tragic and timeless" content carried in this abstract painting. Another quality, the "sublime," often referred to by these artists and critics and the subject of an essay by Barnett Newman ("The Sublime Is Now," *Tiger's Eye* [December 1948]), is nowhere more pronounced than in Clyfford Still's vast can-

* Not being a member of the Federation, Newman did not exhibit with them, but his friend, Gottlieb, asked Newman to help formulate a response to Jewell's invitation for Gottlieb and Rothko to explain their pictures. The original document, liberally inscribed with Newman's handwriting, is in the possession of his widow Annalee Newman, as are Rothko's *Syrian Bull* and Gottlieb's *The Rape of Persephone,* both pictures given to Newman by the artists in thanks.

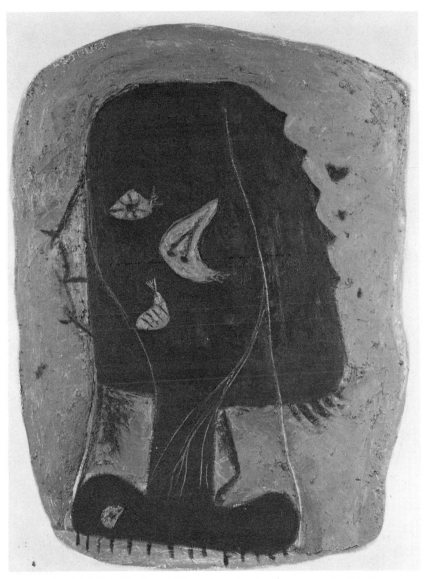

3. Adolph Gottlieb, *Rape of Persephone*, 1942. Oil on canvas, 34 × 26 in. Collection Annalee Newman.

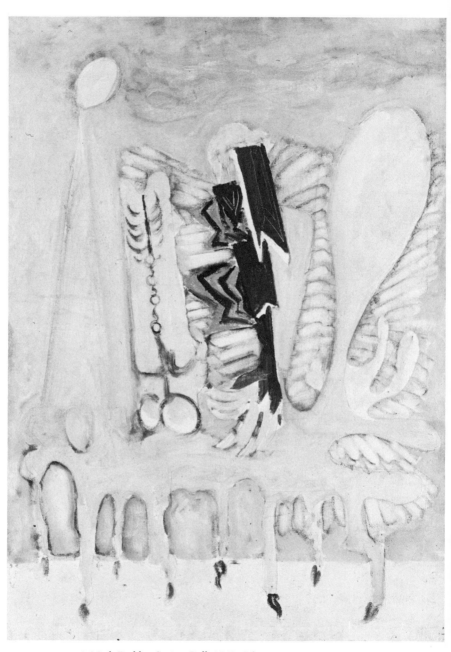

4. Mark Rothko, *Syrian Bull*, 1942. Oil on canvas, 39½ × 27½ in.
Collection Annalee Newman.

vases, whose jagged abstract shapes evoke awesome forms of nature: mountainous peaks, crevasses, torrential cataracts, and flaming holocausts. Still's writings, in which he courts a comparable grandeur ("let no man under-value the implications of this work or its power for life;—or for death, if it is misused"), do not do justice, I feel, to his work, nor add appreciably to our understanding of it or of the Abstract Expressionist movement in general.

<div align="center">★ ★ ★</div>

To the artist the workings of the critical mind is [sic] one of life's mysteries. That is why, we suppose, the artist's complaint that he is misunderstood, especially by the critic, has become a noisy commonplace. It is therefore an event when the worm turns and the critic quietly, yet publicly, confesses his "befuddlement," that he is "nonplused" before our pictures at the federation show. We salute this honest, we might say cordial, reaction toward our "obscure" paintings, for in other critical quarters we seem to have created a bedlam of hysteria. And we appreciate the gracious opportunity that is being offered us to present our views.

We do not intend to defend our pictures. They make their own defense. We consider them clear statements. Your failure to dismiss or disparage them is *prima facie* evidence that they carry some communicative power.

We refuse to defend them not because we cannot. It is an easy matter to explain to the befuddled that *The Rape of Persephone* is a poetic expression of the essence of the myth; the presentation of the concept of seed and its earth with all its brutal implications; the impact of elemental truth. Would you have us present this abstract concept, with all its complicated feelings, by means of a boy and girl lightly tripping?

It is just as easy to explain *The Syrian Bull* as a new interpretation of an archaic image, involving unprecedented distortions. Since art is timeless, the significant rendition of a symbol, no matter how archaic, has as full validity today as the archaic symbol had then. Or is the one 3,000 years old truer?

. . . These easy program notes can help only the simple-minded. No possible set of notes can explain our paintings. Their explanation must come out of a consummated experience between picture and onlooker. The point at issue, it seems to us, is not an "explanation" of the paintings, but whether the intrinsic ideas carried within the frames of these pictures have significance. We feel that our pictures demonstrate our aesthetic beliefs, some of which we, therefore, list:

1. To us art is an adventure into an unknown world, which can be explored only by those willing to take the risks.
2. This world of the imagination is fancy-free and violently opposed to common sense.

3. It is our function as artists to make the spectator see the world our way—not his way.

4. We favor the simple expression of the complex thought. We are for the large shape because it has the impact of the unequivocal. We wish to reassert the picture plane. We are for flat forms because they destroy illusion and reveal truth.

5. It is a widely accepted notion among painters that it does not matter what one paints as long as it is well painted. This is the essence of academism. There is no such thing as good painting about nothing. We assert that the subject is crucial and only that subject matter is valid which is tragic and timeless. That is why we profess spiritual kinship with primitive and archaic art.

Consequently, if our work embodies these beliefs it must insult anyone who is spiritually attuned to interior decoration; pictures for the home; pictures for over the mantel; pictures of the American scene; social pictures; purity in art; prize-winning potboilers; the National Academy, the Whitney Academy, the Corn Belt Academy; buckeyes; trite tripe, and so forth.

BARNETT NEWMAN (1905-1970)

Barnett Newman, "The Ideographic Picture," Betty Parsons Gallery, New York, January 20-February 8, 1947

Newman's short introduction is a memorable declaration of the Abstract Expressionist conviction, shared with the Kwakiutl artist, that "a shape was a living thing, a vehicle for an abstract thought-complex, a carrier of the awesome feelings he felt before the terror of the unknowable." Among the eight artists in the exhibition besides Newman were Rothko, Still, Stamos, Hofmann, and Ad Reinhardt (the last an extremely interesting inclusion, in view of his subsequent repudiation of such out-and-out metaphysical symbolism; he even entitled one of his two entries *Dark Symbol*). Poles apart in some respects, Reinhardt and Newman were kindred spirits in their love of polemics. Newman's writings° include numerous "letters to the editor," among them his dazzling rebuttal of Panofsky's charge of philological inaccuracy in Newman's title *Vir Heroicus Sublimis.*†

Newman was also a student of natural science and philosophy. Probably his most quoted pronouncement is "Esthetics is for artists like ornithology is for the birds." Rather more like Delacroix, who was

° See the bibliography in Thomas B. Hess, *Barnett Newman*. New York: Museum of Modern Art, 1971.

† See Newman's two letters: *Art News* (May 1961), p. 6, and (September 1961), p. 6.

right there on the barricades during the July 1830 Revolution, than Ingres who, on that occasion, stood guard, sword in hand, in the Italian painting gallery at the Louvre, Barney Newman ran for mayor of the City of New York in 1933 on a "Writers-Artists Ticket" that he organized.

★ ★ ★

The Kwakiutl artist painting on a hide did not concern himself with the inconsequentials that made up the opulent social rivalries of the Northwest Coast Indian scene, nor did he, in the name of a higher purity, renounce the living world for the meaningless materialism of design. The abstract shape he used, his entire plastic language, was directed by a ritualistic will towards metaphysical understanding. The everyday realities he left to the toymakers; the pleasant play of non-objective pattern to the women basket weavers. To him a shape was a living thing, a vehicle for an abstract thought-complex, a carrier of the awesome feelings he felt before the terror of the unknowable. The abstract shape was, therefore, real rather than a formal "abstraction" of a visual fact, with its overtone of an already-known nature. Nor was it a purist illusion with its overload of pseudo-scientific truths.

The basis of an aesthetic act is the pure idea. But the pure idea is, of necessity, an aesthetic act. Here then is the epistemological paradox that is the artist's problem. Not space cutting nor space building, not construction nor Fauvist destruction; not the pure line, straight and narrow, nor the tortured line, distorted and humiliating; not the accurate eye, all fingers, nor the wild eye of dream, winking; but the idea-complex that makes contact with mystery—of life, of men, of nature, of the hard, black chaos that is death, or the grayer, softer chaos that is tragedy. For it is only the pure idea that has meaning. Everything else has everything else.

Spontaneous, and emerging from several points, there has arisen during the war years a new force in American painting that is the modern counterpart of the primitive art impulse. As early as 1942, Mr. Edward Alden Jewell was the first publicly to report it. Since then, various critics and dealers have tried to label it, to describe it. It is now time for the artist himself, by showing the dictionary, to make clear the community of intention that motivates him and his colleagues. For here is a group of artists who are not abstract painters, although working in what is known as the abstract style.

Mrs. Betty Parsons has organized a representative showing of this work around the artists in her gallery who are its exponents. That all of them are associated with her gallery is not without significance.

Barnett Newman, Reply to Clement Greenberg's review in *The Nation*, December 6, 1947, quoted in Thomas B. Hess, *Barnett Newman*, New York, 1969 (Newman's letter was not published in *The Nation*)

Newman's attempt to explain the meaning of Abstract Expressionist art is as illuminating and convincing as any subsequent critical explication that I am familiar with. Its date, 1947, is just prior to his first "zip" paintings (*Onement I* is 1948); had his essay been written thereafter, he would have had to get around the corner of his statement that "A ninety-degree angle is a known natural image." Newman's vertical lines shoot out of the top and bottom of the canvas, not stopping to create rectangles; in his own phrase, he "declares space" rather than representing it.

★ ★ ★

I agree with Mr. Greenberg when he points out, by linking "among others" Adolph Gottlieb, Mark Rothko, Clyfford Still and myself, the existence of a "new, indigenous school." I think it is important, however, to emphasize that the evidence for such a school is contained in the work of the artists, as a phenomenon in art history, and not as the word "school" may imply, in any organizational technique. This distinction is important, for when Mr. Greenberg further on in his article discusses the "metaphysical content" of this work, I think he produces the impression, when he calls it "revivalist in a familiar American way," that the artists are working from a set of *a priori* mystical precepts and are using their art for metaphysical exercises. I am certain that this is an unintentional distortion based on a misunderstanding; i.e., that an ideological dogma exists here rather than that the work of these men has given them ideological or historical position. It is precisely to make this latter point that I have on occasion entered the critic's realm.

Without premeditation, spontaneously, this art has arisen in all parts of the country. It is truly a free movement built on work, not on any contrived "literature." The "among others" in Mr. Greenberg's phrase is significant because it implies some widespread prevalence, that it is not a freak accident. When a number of American painters are found using the abstract idiom in a fashion that is unique, that is unfamiliar any place else, I am convinced that it indicates a singular fact in American painting of historic importance. The only reason for a literature is that this work cannot be described within the present framework of established notions of plasticity. Any formulation that I have attempted I have done to help meet this need. I have never tried to speak *à la* Breton as a program-maker.

The question arises, what does this uniqueness consist of? A complete discussion of this question would involve the exposition of the kind of reality these artists create, the nature of its abstract idiom, a description of its subject matter, and the exploration of their plastic imagery. In the limited space I have, I shall try to clarify what I think is the uniqueness of

the work by confining myself to an attempt to present the world these artists create (the reality they evoke), and the nature of their imagery (the means used to build this new reality).

The world the European artists have created has always been tied to sensation in spite of the fact that in recent years their constant struggle has been to free themselves from the natural world. Brilliant as their successes have been they have always had their base in the material world of sensuality. They may have transcended it but they have never been able to do without it. Can anyone name a single European painter who is able to dispense completely with nature? The links of the Cubists, Fauvists and Surrealists with nature are obvious. The Purists tried to deny nature and became involved with its diagrammatic equivalents—with the realism of geometric shapes. A ninety-degree angle, a triangle and a circle are as much a part of nature as a tree and have all its elements of recognizability. In truth the Purists, from Mondrian to Kandinsky, never denied nature but asserted they were depicting the truest nature, the nature of mathematical law.

The American artists under discussion create a truly abstract world which can be discussed only in metaphysical terms. These artists are at home in the world of pure idea, in the *meanings* of abstract concepts, just as the European painter is at home in the world of cognitive objects and materials. And just as the European painter can transcend his objects to build a spiritual world, so the American transcends his abstract world to make that world real, rendering the epistemological implications of abstract concepts with sufficient conviction and understanding to give them body and expression.

The images of even the most original of the abstract European painters, Miró and Mondrian, have always had their base in sensual nature, so that Miró, when he produces his fantasies, transcendental as they may be, always takes off from the factual image to stretch it into the chaos of mystery. We are brought into his world of imagination always through the seen shape or image. Likewise Mondrian, no matter how formally pure his abstraction, creates a diagrammatic world which is the geometric equivalent for the seen landscape, the vertical trees on a horizon, and we are brought into the world of material purity through a representational depiction of its mathematical equivalents. A ninety-degree angle is a known natural image.

The American painters under discussion create an entirely different reality to arrive at new unsuspected images. They start with the chaos of pure fantasy and feeling, with nothing that has any known physical, visual or mathematical counterpart and they bring out of this chaos of emotion images which give these intangibles reality. There is no struggle to go to the fantastic through the real, or to the abstract through the real. In-

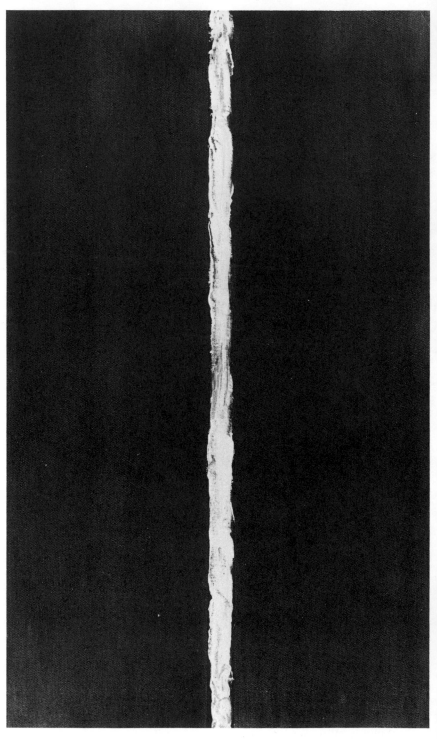

5. Barnett Newman, *Onement I*, 1948. Oil on canvas, 27 × 16 in.
Collection Annalee Newman.

stead the struggle is to bring out from the non-real, from the chaos of ecstasy, something that evokes a memory of the emotion of an experienced moment of total reality. This of course may be a metaphysical notion but it is no more metaphysical than the idea that the realization by Cézanne of his complete and pure sensation of his apples adds up to more than the apples, or that the two-faced heads by Picasso are more than the two heads, or that the strict geometry of Mondrian is more than the sum of its angles. That to me is an equal kind of mysticism.

If I may make an analogy, it is as if we were to compare an Einsteinian formula to a non-Euclidean geometry. In one the formulas are symbols that evoke in stenographic fashion the imagined idea-complex that is Einstein's vision of a cosmos. In the other we have a pure world of esoteric mathematical truth, a fantasy in symbolic logic. It is of course more difficult to understand Einstein, for we must evoke his world, recreating his reality from his non-material stenography. (His formula is not just pure formula.) The non-Euclidean mathematical genius, building his fanciful world on materialistic abstractions, is simpler, for all one needs is the ability to follow his language step by step into his world of fantasies.

And so with the painters. The Americans evoke their world of emotion and fantasy by a kind of personal writing without the props of any known shape. This is a metaphysical act. With the European abstract painters we are led into their spiritual world through already known images. This is a transcendental act. To put it philosophically, the European is concerned with the transcendence of objects while the American is concerned with the reality of the transcendental experience.

WILLEM DE KOONING (1904-)

During the fifties and early sixties, de Kooning was by far the most imitated of the Abstract Expressionists. In studios and classrooms all across the country, painters were attacking canvases with slashing strokes of thick juicy paint. They got the superficial look of de Kooning's rejection of the French *belle peinture* ("They [French paintings] have a particular something that makes them look like a 'finished' painting. They have a touch which I am glad not to have"). But his imitators missed the bite and discipline that inform not only the visible drawing—the gesture—in de Kooning's paintings but their entire structure. That character is still present, although less explicit, in his late figure-landscape-sea pictures, which are as luscious coloristically as the ripe nudes from Renoir's old age. De Kooning's retention of an

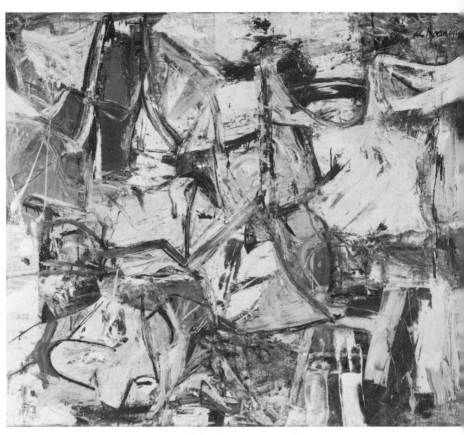

6. Willem de Kooning, *Gotham News*, 1955. Oil on canvas, 69 × 79 in. Albright-Knox Art Gallery, Buffalo, N.Y., Gift of Seymour H. Knox.

underlying structure may be best understood in the context of his statement: "Of all movements, I like Cubism most. It had that wonderful unsure atmosphere of reflection—a poetic frame where something could be possible, where an artist could practice his intuition. It didn't want to get rid of what went before. Instead it added something to it. The parts that I can appreciate in other movements came out of Cubism." °

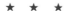

Excerpted from Willem de Kooning, "Content is a glimpse . . . ," *Location* (Spring 1963), from an interview with David Sylvester for the BBC

. . . It is a certain burden, this American-ness. If you come from a small nation, you don't have that. When I went to the Academy and I was drawing from the nude, *I* was making the drawing, not Holland. I feel sometimes an American artist must feel, like a baseball player or something—a member of a team writing American history . . . I think it is kind of nice that at least part of the public is proud that they have their own sports and things like that—and why not their own art? I think it's wonderful that you know where you came from—I mean you know, if you are American, you are an American.

Certain artists and critics attacked me for painting the *Women*, but I felt that this was their problem, not mine. I don't really feel like a non-objective painter at all. Today, some artists feel they have to go back to the figure, and that word "figure" becomes such a ridiculous omen—if you pick up some paint with your brush and make somebody's nose with it, this is rather ridiculous when you think of it, theoretically or philosophically. It's really absurd to make an image, like a human image, with paint, today, when you think about it, since we have this problem of doing or not doing it. But then all of a sudden it was even more absurd not to do it. So I fear that I have to follow my desires.

The *Women* had to do with the female painted through all the ages, all those idols, and maybe I was stuck to a certain extent; I couldn't go on. It did one thing for me: it eliminated composition, arrangement, relationships, light—all this silly talk about line, color and form—because that was the thing I wanted to get hold of. I put it in the center of the canvas because there was no reason to put it a bit on the side. . . .

Forms ought to have the emotion of a concrete experience. For instance, I am very happy to see that grass is green. At one time, it was very daring to make a figure red or blue—I think now that it is just as daring to make it flesh-colored.

° De Kooning, "What Abstract Art Means to Me," for a symposium, *Museum of Modern Art Bulletin*, vol. 18, no. 3 (Spring 1951), pp. 4–8.

Content is a glimpse of something, an encounter like a flash. It's very tiny—very tiny, content. When I was painting those figures, I was thinking about Gertrude Stein, as if they were ladies of Gertrude Stein—as if one of them would say, "How do you like me?" Then I could sustain this thing all the time because it could change all the time; she could almost get upside down, or not be there, or come back again, she could be any size. Because this content could take care of almost anything that could happen.

I still have it now from fleeting things—like when one passes something, and it makes an impression, a simple stuff.

I wasn't concerned to get a particular kind of feeling. I look at them now and they seem vociferous and ferocious. I think it had to do with the idea of the idol, the oracle, and above all the hilariousness of it. I do think that if I don't look upon life that way, I won't know how to keep on being around. . . .

For many years I was not interested in making a good painting—as one might say, "Now this is really a good painting" or a "perfect work." I didn't want to pin it down at all. I was interested in that before, but I found out it was not my nature. I didn't work on it with the idea of perfection, but to see how far one could go—but not with the idea of really doing it. With anxiousness and dedication to fright maybe, or ecstasy, like the *Divine Comedy*, to be like a performer: to see how long you can stay on the stage with that imaginary audience.

The pictures done since the *Women*, they're emotions, most of them. Most of them are landscapes and highways and sensations of that, outside the city—with the feeling of going to the city or coming from it. I'm not a pastoral character. I'm not a—how do you say that?—"country dumpling." I am here, and I like New York City. But I love to go out in a car. I'm crazy about weekend drives, even if I drive in the middle of the week. I'm just crazy about going over the roads and highways. . . . They are really not very pretty, the big embankments and the shoulders of the roads and the curves are flawless—the lawning of it, the grass. This I don't particularly like or dislike, but I wholly approve of it. Like the signs. Some people want to take the signs away, but it would break my heart. All those different big billboards. There are places in New England where they are not allowed to put those signs, and that's nice too, but I love those grotesque signs. I mean, I am not undertaking any social . . . I'm no lover of the new—it's a personal thing.

When I was working on this *Merritt Parkway* picture, this thing came to me: it's just like the Merritt Parkway. . . .

I get freer. I feel I am getting more to myself in the sense of, I have all

my forces. I hope so, anyhow. I have this sort of feeling that I am all there now. It's not even thinking in terms of one's limitations because they have to come naturally. I think whatever you have, you can do wonders with it, if you accept it. . . .

FRANZ KLINE (1910-1962)

To Franz Kline, more obviously than to Pollock, Newman, or de Kooning, "painting is a form of drawing." His work has often been compared with Chinese calligraphy, but that is only a superficial resemblance. Kline's black lines are not flat figures resting on a light background, but black areas interacting with white ones; both constitute forces that shoot in and out and across space in a sometimes dramatic and sometimes majestic tempo. Franz Kline said something to his friend the poet Frank O'Hara which every student and lover of art would do well to remember: "Like with Jackson: you don't paint the way someone, by observing your life, thinks you *have* to paint, you paint the way you have to in order to *give*, that's life itself, and someone will look and say it is the product of knowing, but it has nothing to do with knowing, it has to do with giving." ° Besides the powerful drawing, an inherent scale distinguishes Kline's paintings; even the little 8-by-10-inch ones are monumental.

★ ★ ★

Excerpted from Franz Kline, "An Interview with David Sylvester," *Living Arts I* (1963)

SYLVESTER: During the time that you were producing black-and-white paintings only—this long series of black-and-white paintings—were you ever using colour and then painting over it with black?

KLINE: No, they started off that way. I didn't have a particularly strong desire to use colour, say, in the lights or darks of a black-and-white painting, although what happened is that accidentally they look that way. Sometimes a black, because of the quantity of it or the mass or the volume, looks as though it may be a blue-black, as if there were blue mixed in with the black, or as though it were a brown-black or a red-black. No, I didn't have any idea of mixing up different kinds of blacks; as a matter of fact, I just used any black that I could get hold of.

. . . The whites the same way; the whites, of course, turned yellow, and many people call your attention to that, you know; they want white to

° Frank O'Hara, "Franz Kline Talking," *Evergreen Review*, vol. 2, no. 6 (Autumn 1958), pp. 58–64.

stay white for ever. It doesn't bother me whether it does or not. It's still white compared to the black.

. . . Paint never seems to behave the same. Even the same paint doesn't, you know. In other words, if you use the same white or black or red, through the use of it, it never seems to be the same. It doesn't dry the same. It doesn't stay there and look at you the same way. Other things seem to affect it. There seems to be something that you can do so much with paint and after that you start murdering it. There are moments or periods when it would be wonderful to plan something and do it and have the thing only do what you planned to do, and then, there are other times when the destruction of those planned things becomes interesting to you. So then, it becomes a question of destroying—of destroying the planned form; it's like an escape, it's something to do; something to begin the situation. You yourself, you don't decide, but if you want to paint you have to find out some way to start this thing off, whether it's painting it out or putting it in, and so on. . . .

SYLVESTER: How do you want your pictures to be read? Are they to be read as referring to something outside themselves? Do you mind whether they are? Do you mind whether they're not?

KLINE: No, I don't mind whether they are or whether they're not. No, if someone says, "That looks like a bridge," it doesn't bother me really. A lot of them do.

SYLVESTER: And at what point in doing them are you aware that they might look like a bridge?

KLINE: Well, I like bridges.

SYLVESTER: So you might be aware quite early on?

KLINE: Yes, but then I—just because things look like bridges, I mean . . . Naturally, if you title them something associated with that, then when someone looks at it in the literary sense, he says, "He's a bridge painter," you know.

SYLVESTER: If somebody were to say to you that they felt that one of the excitements of your painting was this kind of sense of city life that it has . . .

KLINE: Oh, I like that (You like that?) because I like the city better than I do the country.

SYLVESTER: But would that seem to you to be an irrelevant or a relevant response to your paintings?

KLINE: No, that's all right. After all I've lived here—I've lived in New

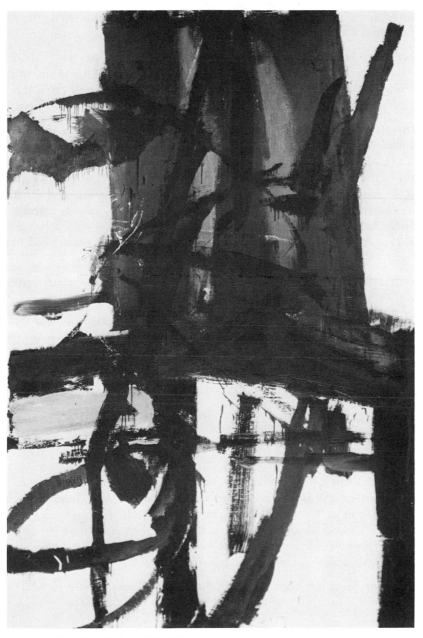

7. Franz Kline, *The Bridge*, 1955. Oil on canvas, 80 × 52¾ in. Munson-Williams-Proctor Institute, Utica, N.Y.

York for twenty years. Years ago, when I went out with a paintbox, I painted from rooftops and I painted from studio windows; so, the last recollection I have of objective painting has been in the city, you see. . . .

SYLVESTER: Are you conscious of particular paintings having particular feeling tones? Particular emotional content? That some of them might be, say, angry; that one of them might be cheerful; that some of them might be sad? (Yes.) You do feel them that way? (Yes.) Is this important for you?

KLINE: Yes. As a matter of fact it is nice to paint a happy picture after a sad one. I think that there is a kind of loneliness in a lot of them which I don't think about as the fact that I'm lonely and therefore I paint lonely pictures, but I like kind of lonely things anyhow; so if the forms express that to me, there is a certain excitement that I have about that. Any composition—you know, the overall reality of that does have something to do with it; the impending forms of something, do maybe have a brooding quality, whereas in other forms, they would be called or considered happier.

SYLVESTER: Are you aware of these qualities when you are actually painting or only after you have finished the painting?

KLINE: No, I'm aware of them as I paint. I don't mean that I retain those. What I try to do is to create the painting so that the overall thing has that particular emotion; not particularly just the forms in it.

SYLVESTER: But you do try to retain a certain emotion in the overall thing? (Yes.) An emotion you might be able to name while you are painting it?

KLINE: Yes, at times, yes.

SYLVESTER: That you might do something in a painting because you wanted to preserve a particular brooding quality?

KLINE: Yes. I think it has to do with the movement, even though it can be static. In other words, there's a particular static or heavy form that can have a look to it, an experience translated through the form; so then it does have a mood. And when that is there, well then it becomes—it becomes a painting, whereas all the other pictures that have far more interesting shapes and so on, don't become that to me. . . .

SYLVESTER: A lot has been made of this thing of spontaneity in Abstract Expressionism but you make a lot of use of preliminary drawing in your painting.

KLINE: I rather feel that painting is a form of drawing and the painting that I like has a form of drawing to it. I don't see how it could be disassociated from the nature of drawing. As to whether you rush up to the

canvas and knock yourself out right away or you use something . . . I find that in many cases a drawing has been the subject of the painting—that would be a preliminary stage to that particular painting. . . .

The painting can develop into something that is not at all related to the drawing. . . .

SYLVESTER: Do you ever find you can work with a painting over a long period and it comes off? Or do you find that if it doesn't come off fairly quickly, it doesn't come off at all?

KLINE: Some of the pictures I work on a long time and they look as if I've knocked them out, you know, and there are other pictures that come off right away. The immediacy can be accomplished in a picture that's been worked on for a long time just as well as if it's been done rapidly, you see. But I don't find that any of these things prove anything really.

ROBERT MOTHERWELL (1915-)

The youngest of the original Abstract Expressionists, Robert Motherwell was associated with the group from its very beginnings in Peggy Guggenheim's gallery and throughout the years of "The Club"—the weekly gatherings for discussion and debate (many of which are recorded in Motherwell and Reinhardt, eds., *Modern Artists in America*, New York, 1952). Highly trained in philosophy and art history, Motherwell has written a good deal, and from 1947 to 1955 served as a director and editor of the influential *Documents of Modern Art* series, published by Wittenborn, Schultz, Inc. However, as he recalls: "Barnett Newman for years has said that when he reads my writings, he learns what I have been reading, but when he wants to know what I am really concerned with at a given moment, he looks at my pictures. He's right." °

The grace, elegance, and *mesure* of Motherwell's painting have earned him the designation "most French" of the group. However, his work has a sweeping space that is more "American" than French, and it ranges in expressiveness from lyrical to somber.

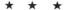

Robert Motherwell's statement in *The New Decade,* Whitney Museum of American Art, New York, 1955

° "Letter from Robert Motherwell to Frank O'Hara," dated August 18, 1965, in Frank O'Hara, *Robert Motherwell, with Selections from the Artist's Writings.* New York: Museum of Modern Art, 1965, p. 70.

8. Robert Motherwell, *Elegy to the Spanish Republic, XXXIV*, 1953–54. Oil on canvas, 80 × 100 in. Albright-Knox Art Gallery, Buffalo, N.Y., Gift of Seymour H. Knox.

I never think of my pictures as "abstract," nor do those who live with them day by day—my wife and children, for example, or the profound and indomitable old French lady whose exile in New York has been enhanced by a miniature collection of them. I happen to think primarily in paint—this is the nature of a painter—just as musicians think in music. And nothing can be more concrete to a man than his own felt thought, his own thought feeling. I feel most real to myself in the studio, and resent any description of what transpires there as "abstract"—which nowadays no longer signifies "to select," but, instead, something remote from reality. From whose reality? And on what level?

If a painting does not make a human contact, it is nothing. But the audience is also responsible. I adore the old French lady because among my works she chooses those that specifically move *her*. Through pictures, our passions touch. Pictures are vehicles of passion, of all kinds and orders, not pretty luxuries like sports cars. In our society, the capacity to give and to receive passion is limited. For this reason, the act of painting is a deep human necessity, not the production of a hand-made commodity. I respect a collector who returned one of my "abstract" pictures to the gallery, saying it was too tragic in feeling for her to be able to look at it every day. But somewhere there is a man with a tragic sense of life who loves that same picture, and I think he will find one day a way to have it. These are real human contacts, and I love painting that it can be a vehicle for human intercourse. In this solitary and apathetic society, the rituals are so often obsolete and corrupt, out of accord with what we really know and feel. . . . True painting is a lot more than "picture-making." A man is neither a decoration nor an anecdote.

2

Other Art of the Forties and Fifties

AD REINHARDT (1913-1967)

A belligerent negativism, presented with wit in irresistible prose and cartoons, was the tool Ad Reinhardt used to champion art against the philistines and malpractitioners. Among the worst of the lot to him were the Action Painters, for their romantic expressionism and their mixing of art and life. Given the Eastern tenor of his negativism, it is not surprising to learn that he taught Oriental art at Brooklyn and Hunter colleges (he had studied art history at Columbia and the Institute of Fine Arts, New York University). By casting off everything that to him was not art, he also cast off everything that was not spirit; hence, his profoundly reductive paintings—especially the late all-"black" ones—are as mystic, *malgré lui,* as anything of Rothko or Newman. A minimalist *avant la lettre,* he was one of the sources of inspiration to that group and to the conceptual artists. Reinhardt's provocative essays have been compiled by Barbara Rose, ed., *Art as Art, The Selected Writings of Ad Reinhardt,* New York, 1975.

★　★　★

Ad Reinhardt, "Art-as-Art," *Art International* (December 1962)

The one thing to say about art is that it is one thing. Art is art-as-art and everything else is everything else. Art-as-art is nothing but art. Art is not what is not art.

The one object of fifty years of abstract art is to present art-as-art and as nothing else, to make it into the one thing it is only, separating and defining it more and more, making it purer and emptier, more absolute and more exclusive—non-objective, non-representational, non-figurative, non-imagist, non-expressionist, non-subjective. The only and one way to say what abstract art or art-as-art is, is to say what it is not.

The one subject of a hundred years of modern art is that awareness of art of itself, of art preoccupied with its own process and means, with its own identity and distinction, art concerned with its own unique statement, art conscious of its own evolution and history and destiny, toward its own freedom, its own dignity, its own essence, its own reason, its own morality and its own conscience. Art needs no justification in our day with "realism" or "naturalism," "regionalism" or "nationalism," "individual-

ism" or "socialism" or "mysticism," or with any other ideas.

The one content of three centuries of European or Asiatic art, and the one matter of three millennia of Eastern or Western art, is the same "one significance" that runs through all the timeless art of the world. Without an art-as-art continuity and art-for-art's-sake conviction and unchanging art-spirit and abstract point of view, art would be inaccessible and the "one thing" completely secret.

The one idea of art as "fine," "high," "noble," "liberal," "ideal" of the seventeenth century is to separate fine and intellectual art from manual art and craft. The one intention of the word "esthetics" of the eighteenth century is to isolate the art-experience from other things. The one declaration of all the main movements in art of the nineteenth century is of the "independence" of art. The one question, the one principle, the one crisis in art of the twentieth century centers in the uncompromising "purity" of art, and in the consciousness that art comes from art only, not from anything else.

The one meaning in art-as-art, past or present, is art-meaning. When an art-object is separated from its original time and place and use and is moved into the art-museum, it gets emptied and purified of all its meanings except one. A religious object that becomes a work of art in an art-museum loses all its religious meanings. No one in his right mind goes to an art-museum to worship anything but art, or to learn about anything else.

The one place for art-as-art is the museum of fine art. The one reason for the museum of fine art is the preservation of ancient and modern art that cannot be made again and that does not have to be done again. A museum of fine art should exclude everything but fine art, and be separate from museums of ethnology, geology, archaeology, history, decorative-arts, industrial-arts, military-arts, and museums of other things. A museum is a treasure-house and tomb, not a counting-house or amusement-center. A museum that becomes an art-curator's personal-monument or an art-collector-sanctifying-establishment or an art-history-manufacturing-plant or an artists'-market-block, is a disgrace. Any disturbance of a true museum's soundlessness, timelessness, airlessness and lifelessness is a disrespect.

The one purpose of the art-academy-university is the education and "correction of the artist"-as-artist, not the "enlightenment of the public" or the popularization of art. The art college should be a cloister-ivyhall-ivory-tower-community of artists, an artists' union and congress and club, not a success-school or service-station or rest-home or house of artists' ill-fame. The notion that art or an art-museum or art-university "enriches life" or "fosters a love of life" or "promotes understanding and love

among men" is as mindless as anything in art can be. Anyone who speaks of using art to further any local, municipal, national or international relations is out of his mind.

The one thing to say about art and life is that art is art and life is life. A "slice-of-life" art is no better or worse than a "slice-of-art" life. Fine art is not a "means of making a living" or a "way of living a life," and an artist who dedicates his life to his art or his art to his life, burdens his art with his life and his life with his art. Art that is a matter of life and death is neither fine nor free.

The one assault on fine art is the ceaseless attempt to subserve it as a means to some other end or value. The one fight in art is not between art and non-art, but between true and false art, between pure art and action-assemblage-art, between abstract art and surrealist-expressionist-anti-art, between free art and servile art. Abstract art has its own integrity, not someone else's "integration" with something else. Any combining, mixing, adding, diluting, exploiting, vulgarizing or popularizing abstract art deprives art of its essence and depraves the artist's artistic consciousness. Art is free, but it is not a free-for-all.

The one struggle in art is the struggle of artists against artists. Of artist-as-man, -animal, or -vegetable. Artists who claim their art-work comes from nature, life, reality, earth or heaven, as "mirrors of the soul" or "reflections of conditions" or "instruments of the universe," who cook up "new images of man"—figures and "nature-in-abstraction"—pictures, are subjectively and objectively, rascals or rustics. The art of "figuring" or "picturing" is not a fine art. An artist who is lobbying as a "creature of circumstances" or log-rolling as a "victim of fate" is not a fine master-artist. No one ever forces an artist to be pure.

The one art that is abstract and pure enough to have the one problem and possibility in our time and timelessness, of the "one single grand original problem," is pure abstract painting. Abstract painting is not just another school or movement or style but the first truly unmannered and untrammelled and unentangled, styleless universal painting. No other art or painting is detached or empty or immaterial enough.

The one history of painting progresses from the painting of a variety of ideas with a variety of subjects and objects, to one idea with a variety of subjects and objects, to one subject with a variety of objects, to one object with a variety of subjects, then to one object with one subject, to one object with no subject, and to one subject with no object, then to the idea of no object and no subject and no variety at all. There is nothing less significant in art, nothing more exhausting and immediately exhausted, than "endless variety."

The one evolution of art-forms unfolds in one straight logical line of

9. Ad Reinhardt, *Red Painting*, 1952. Oil on canvas, 6 ft. 6 in. × 12 ft. The Metropolitan Museum of Art, Arthur Hoppock Hearn Fund, 1968.

negative actions and reactions, in one predestined, eternally recurrent stylistic cycle, in the same all-over pattern, in all times and places, taking different times in different places, always beginning with an "early" archaic schematization, achieving a climax with a "classic" formulation, and decaying with a "late" endless variety of illusionisms and expressionisms. When late stages wash away all lines of demarcation, framework and fabric, with "anything can be art," "anybody can be an artist," "that's life," "why fight it," "anything goes," and "it makes no difference whether art is abstract or representational," the artists' world is a mannerist and primitivist art-trade and suicide-vaudeville, venal, genial, contemptible, trifling.

The one way in art comes from art-working and the more an artist works the more there is to do. Just as artists come from artists and art-forms from art-forms, painting comes from painting. The one direction in fine or abstract art today is in the painting of the same one form over and over again. The one intensity and the one perfection comes only from long and lonely routine preparation and attention and repetition. The one originality exists only where all artists work in the same tradition and master the same convention. The one freedom is realized only through the strictest art-discipline and through the most similar studio-ritual. Only a standardized, prescribed and proscribed form can be imageless, only a stereotyped image can be formless, only a formulaized art can be formulaless. A painter who does not know what or how or where to paint is not a fine artist.

The one work for a fine artist now, the one thing in painting to do, is to repeat the one-size-canvas—the single-scheme, one colour-monochrome, one linear-division in each direction, one symmetry, one texture, one formal device, one free-hand-brushing, one rhythm, one working everything into one dissolution and one indivisibility, painting everything into one overall uniformity and non-irregularity. No lines or imaginings, no shapes or composings or representings, no visions or sensations or impulses, no symbols or signs or impastos, no decoratings or colourings or picturings, no pleasures or pains, no accidents or ready-mades, no things, no ideas, no relations, no attributes, no qualities—nothing that is not of the essence. Everything into irreducibility, unreproducibility, imperceptibility. Nothing "useable," "manipulatable," "saleable," "dealable," "collectable," "graspable." No art as a commodity or a jobbery. Art is not the spiritual side of business.

The one standard in art is oneness and fineness, rightness and purity, abstractness and evanescence. The one thing to say about the best art is the breathlessness, lifelessness, deathlessness, contentlessness, formlessness, spacelessness and timelessness. This is always the end of art.

DAVID SMITH (1906-1965)

The writings comprising *David Smith by David Smith* are taken primarily from Smith's papers in the Archives of American Art, interlarded with a few from other sources. Exact references are cited for all entries and a full bibliography is included.

David Smith occupies a position in American sculpture somewhat similar to that of Pollock and de Kooning in American painting, but his major disciple is the Englishman Anthony Caro. In the early sixties, when young American sculptors like Morris, Andre, and Judd were evolving their idiom, they tended to shy away from Smith's Cubist interrelationship of planes and volumes, and from the anthropomorphism that still clung to his forms. They probably would also not care for the Whitmanesque flavor to his writing ("I feel no tradition. I feel great spaces . . .").

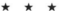

Excerpted from Cleve Gray, ed., *David Smith by David Smith,* New York, 1968

I make 300 to 400 large drawings a year, usually with egg yolk and Chinese ink and brushes. These drawings are studies for sculpture, sometimes what sculpture is, sometimes what sculpture can never be. Sometimes they are atmospheres from which sculptural form is unconsciously selected during the labor process of producing form. Then again they may be amorphous floating direct statements in which I am the subject, and the drawing is the act. They are all statements of my identity and come from the constant work stream. . . .

I belong with painters, in a sense; and all my early friends were painters because we all studied together. And I never conceived of myself as anything other than a painter because my work came right through the raised surface and color and objects applied to the surface. Some of the greatest contributions to sculpture of the twentieth century are by painters. Had it not been for painters, sculpture would be in a very sorry position. . . . Some of the greatest departures in the concept of sculpture have been made by Picasso and Matisse. There was a series of heads that Matisse made called . . . *Jeanette;* in there are some of the very brilliant departures in the concept of sculpture. Painting and sculpture aren't very far apart.

I painted for some years. I've never given it up; I always, even if I'm having trouble with a sculpture, I always paint my troubles out.

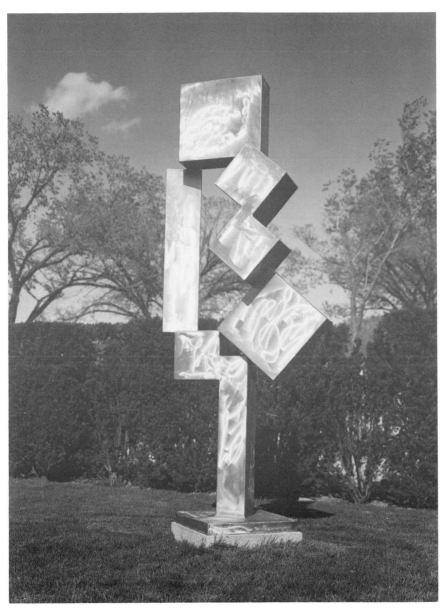

10. David Smith, *Cubi XII*, 1963. Stainless Steel, 109⅝ × 49¼ × 32¼ in. Hirshhorn Museum and Sculpture Garden, Smithsonian Institution, Washington, D.C.

I color them. They are steel, so they have to be protected, so if you have to protect them with a paint coat, make it color. Sometimes you deny the structure of steel. And sometimes you make it appear with all its force in whatever shape it is. No rules . . .

The paint here is not artist's paint. It is auto enamel, and I mix it and it is much better than artist's paint for outdoors. First the iron is ground down so that it is raw, and it is painted with about fifteen coats of epoxy primer and then a few coats of zinc—and then a few coats of white—and then the color is put on. So it runs about twenty-five or thirty coats and that's about three times the paint coat on a Mercedes or about thirty times the paint coat on a Ford or Chevrolet. And if it doesn't get scratched or hammered I think the paint coat will last longer than I do. There is nothing better for outside painting than auto enamel as far as I know.

I like outdoor sculpture and the most practical thing for outdoor sculpture is stainless steel, and I make them and I polish them in such a way that on a dull day, they take on the dull blue, or the color of the sky in the late afternoon sun, the glow, golden like the rays, the colors of nature. And in a particular sense, I have used atmosphere in a reflective way on the surfaces. They are colored by the sky and the surroundings, the green or blue of water. Some are down by the water and some are by the mountains. They reflect the colors. They are designed for outdoors.

I believe that my time is the most important in the world. That the art of my time is the most important art. That the art before my time has no immediate contribution to my aesthetics since that art is history explaining past behaviour, but not necessarily offering solutions to my problems. Art is not divorced from life. It is dialectic. It is ever changing and in revolt to the past. It has existed from the minds of free men for less than a century. Prior to this the direction of art was dictated by minds other than the artist for exploitation and commercial use. That the freedom of man's mind to celebrate his own feeling by a work of art parallels his social revolt from bondage. I believe that art is yet to be born and that freedom and equality are yet to be born.

If you ask me why I make sculpture, I must answer that it is my way of life, my balance, and my justification for being.

If you ask me for whom do I make art, I will say that it is for all who approach it without prejudice. My world, the objects I see are the same for all men of good will. The race for survival I share with all men who work for existence.

Art is a paradox that has no laws to bind it. Laws set can always be violated. That confuses the pragmatic mind. There may exist conventionalized terminologies and common designations for periods, but no rules bind, either to the material substances from which it is made or the men-

tal process of its concept. It is created by man's imagination in relation to his time. When art exists, it becomes tradition. When it is created, it represents a unity that did not exist before.

> I feel no tradition. I feel great spaces.
> I feel my own time. I am disconnected.
> I belong to no mores—no party—no religion—
> no school of thought—no institution.
> I feel raw freedom and my own identity.

The artist must work towards that which he does not know. Whether this is called invention or finding or searching, it must be a projection beyond the given state of art.

In the actual sense we should not stretch to invent but we should feel what has gone before us, and know what has been found; and what has been found is heritage, and what are problems are the things we are to find, the seeing of things from our vantage point, which is a place no artist has stood before, and not that of invention in the narrow sense but passionately found visions, because they are inspired answers to the problems of who we are in the time we are placed to speak.

There is nothing in art that there wasn't some of before.

We have all let anthropologists, philosophers, historians, connoisseurs and mercenaries, and everybody else tell us what art is or what it should be. But I think we ought to very simply let it be what the artist says it is. And what the artist says it is, you can see by his work. I would like to leave it just like that.

The trouble is, every time I make one sculpture, it breeds ten more, and the time is too short to make them all.

LOUISE NEVELSON (1900–)

Outside any movement, as independent in her work as in her life, Louise Nevelson shares the honors with David Smith and Alexander Calder as America's major sculptors. Such a glowing person emerges from *Dawns and Dusks* that it was especially difficult to limit the selections from this buoyant text.

★ ★ ★

Excerpted from Louise Nevelson, *Dawns and Dusks* (taped conversations with Diana MacKown), New York, 1976

11. Louise Nevelson, *Sky Cathedral*, 1958. Wood construction painted black, 11 ft. 3½ in. × 10 ft. ¼ in. × 18 in. Museum of Modern Art, New York, Gift of Mr. and Mrs. Ben Mildwoff.

Candidly, I've always thought that two dimensions, the flat surface like in painting, is far superior to sculpture. . . . I feel that there's more myth and more mystery in painting—because you have to give three dimensions to a two-dimensional plane. You look at a flat surface and you've got your depth—that's an illusion. (When we are giving up, today, the illusion of space in a picture, that doesn't suit me.) Sculpture's more physical. Sculpture, we have the four sides, reality. . . . But a great painter or a great sculptor transcends it. So we're only talking about the laws. Since we know that greatness breaks laws.

Of course, I have never *left* two dimensions, because I've always been doing etchings and lithographs and drawing. I'm drawing all the time. If you really go through just one piece of mine, you can see drawing. Take two fingers together and you will see a line between them. Well, that's what gives these two fingers their definition—just that line . . . and that's just what makes my work. It's really the line between two objects. You see how delicate that can be? . . .

I just automatically went to wood. I wanted a medium that was immediate. Wood was the thing that I could communicate with almost spontaneously and get what I was looking for . . . when I'm working with wood, it's very alive. The fact that it's wood means it has another life. . . .

Another thing that fascinated me and really clicked it for me. . . . I saw a canoe paddle. It must have been African or Indian—carved. . . . It couldn't have been more than a quarter of an inch in depth and probably six inches in width, and it went right up and with the handle and all it was at least six feet long. And the slenderness of it and the glory of it and the love that whoever had handled it gave it, just oozed out of it. I thought that it was unique in its proportion, which encompassed grandeur. And I thought, well, that's a work of art. You see, it was wood, and . . . somehow it touched me. . . .

You'll notice how consistent it is that I identify with what went through another human mind more than with nature. Nature is a great organized thing, an intelligence in itself. But when that's filtered through the human mind, it becomes another thing. I identify with one, but I work a little bit more through the other. Of course, we have lived with wood through the ages: the furniture in the house, the floors of the houses. There was a time before cement when the sidewalks were made of wood. Maybe my eye has a great memory of many centuries. And maybe there's something about wood that is closer to the feminine, too. . . .

Different people have different memories, too. Some have memories for words, some for action—mine happens to be for form. Basically, my memory is for wood, which gives a certain kind of form—it isn't too hard and it isn't too soft. Just to show you my relationship with wood, I was having a guest exhibition—this was in the 1950s—and the dealer called

me with great excitement and anger. He had a photograph and he said, "You know, Nevelson, there is one piece of this sculpture that is missing." The problem was that a museum wanted to buy the piece—a City-Scape—and I had made it years before I had exhibited it. In time my sense of space had changed—in other words, the so-called negative space certainly became as important as the forms—and there was one piece of wood that I had taken off. Time had given me two versions of this piece. When this museum director wanted the first version, I felt it was justified, since it was dated at the time it was made. So I said to the dealer, "All right, I'll be up in a taxi with the piece within an hour." . . . I bet I had easily fifty thousand pieces of wood, piled on the kitchen floor. And I didn't count how many pieces I had in the studio, but the studio was loaded. And to my amazement, that piece appeared almost immediately. In two minutes I went and found it, took a taxi, took it up, and put it back on, and the piece went to the museum.

So each individual has awareness for the things they truly identify with. . . . I feel in my being that I'm right for what I do. . . .

I think all great innovations are built on rejections. In our time, in the work we break formal form. It has been attempted for many years now; form has broken. But then another form has come out of that broken form. It is not formless. And even formless has a form. . . .

Of course the Abstract Expressionists started in New York. . . . Seeing those high risers, bigger and bigger and bigger . . . you couldn't think of little paintings or little pieces. And I also never wanted to make a piece that they put on a table for decoration. . . . No parlor pieces. I didn't want that. *This* is what I have lived in. When you think that my whole adult life almost, summer and winter, I was here . . . thinking of these great buildings and the scale of everything and my own energy, it was just a natural. Now if you take a car and you go up on the East River and come down the West Side Highway toward evening or toward morning, when the buildings are silhouetted and they are not disturbed by that much activity, you will see that many of my works are real reflections of the city. . . .

. . . I'm a work horse. I like to work. I always did. . . . I've never had a day when I didn't want to work. . . . And even if I didn't want to compose, so I painted or stacked the pieces or something. In my studio I'm as happy as a cow in her stall. That's the only place where everything is all right. . . .

Sometimes it's the material that takes over; sometimes it's me that takes over. I permit them to play, like a seesaw. I use action and counteraction, like in music, all the time. . . .

You add or subtract until you feel . . . the form, the principle, that something that makes the house stand; that makes you stand.

You see, I think that we have measurements in our bodies. Measurements in our eyes. Look, dear, we walk on two feet. So we're vertical. That doesn't mean the work has to be vertical, but it means that there is a weight within ourselves, or this flight. All these things are within the being: weight and measure and color. And if the work is good work, it is built on these laws and principles that we have within ourselves. . . .

I don't say I'm born with a perfect eye, but I'm born with the rightness of my being. I have a mind for what I need. That's why I can do so much. I just don't have any trouble. I feel maybe someone will say, "How sure she is of herself." So I restrain myself from saying it. But I am sure. Let's face it. . . .

Well, I knew I had it, and I also knew I had the energy of many people. I've always had it. So I'm prolific, to begin with; but I'm also prolific because I know how to use time. I prepare my materials for the next day. I get up, six in the morning. And I wear cotton clothes so that I can sleep in them or I can work in them—I don't want to waste time. I go to the studio, and usually I put in pretty much of a big day. And very often, almost all the time (I think I have a strong body), it wears me out. The physical body is worn out before the creative. When I finish, I come in and go to sleep if I'm tired, have something to eat. Time as such doesn't involve me. . . . I think humans have measured things to the majority, but the person that is being on another level can't take the clock with him.

Sometimes I could work two, three days and not sleep and I didn't pay any attention to food, because . . . a can of sardines and a cup of tea and a piece of stale bread seemed awfully good to me. You know, I don't care about food and my diet has very little variety. . . .

I jump around and people say, oh, why does she have to go there so much to her openings? . . . When I went with these shows, I learned a great deal about how these things are placed. And how they hold their own. . . . I really got quite an insight into various spaces, the architectural, the ornamental, just everything about architecture and the work that's in it.

I have seen sculpture placed and misplaced. When I was on a panel not too long ago in Newport, Rhode Island, there were several large pieces of sculpture that were placed around. But they weren't placed with any kind of awareness in the environment, so the effect of much of it was a hodgepodge. And the works of art did not necessarily hold up well. In fact in some cases, they destroyed each other. So that now, particularly, that we have and can produce these monumental pieces, I think that room must be made for people who really have to study and make a blueprint for the placement of sculpture in space. Maybe we could call them sculpture-architects.

Remember I was in my early seventies when I came to the monumen-

tal, outdoor sculpture. Now something in the living conscious being has a beat, and you move on. Something happens and you become private, something happens and you become public. Sometimes you want to be alone, sometimes you want to communicate. And that is expressed in the work. Now from the time that I did work in the so-called round—in the forties, the war years, and early fifties—I had begun wanting to enclose it. My whole work in wood was enclosure, an enclosed or interior environment. . . .

So then I naturally wanted the next step, and I moved into what I called the out-of-doors sculpture. I had been through the enclosures of wood, I had been through the shadow. I had been through the enclosure of light and reflection. And now I was ready to take away the enclosures and come out into the open and let the out-of-doors be the reflection. . . .

I think often people don't realize the meaning of space. Space, they think, is something empty. Actually, in the mind and the projection into this three-dimensional world, space plays the most vital part in our lives. Your concept of what you put into a space will create another space. I have seen a person walk in a room and dominate the space. Space has an atmosphere, and what you put into that space will color your thinking and your awareness. The whole body is in space. We are space. . . .

. . . There hasn't been a space that I've lived in that I didn't transform into an environment for myself. Either by placement of objects, or colors, or tearing out an area to open a space. I love an empty house. I love the luxury of space. . . .

Objects that one collects have vibrations, and they can usurp you. So I didn't always like to have things around me. But I love the activity of accumulating them. I am still giving things away and I am still collecting because that is an activity I understand and it's a natural. Artists are born collectors. . . .

The world as such—technology, science, chemistry—has opened avenues, and we, if we are centered, can move with it. We take all of these things and we add something of our own awareness. The point is, you take that material and you stamp on it your own consciousness.

In our times, the new materials like Plexiglas or Cor-ten are just a blessing for me. Because I was ready for them and the material was ready for me. . . .

It's not only that I take something. Look at the minds through the ages to project this material into the world. The greatest minds had to produce it, the greatest scientists, the greatest chemists gave us this material. And they have introduced another dimension, where we can enter into another place. And so, when I'm working with my materials, I recognize that they are accumulation of thought. Cor-ten, Plexiglas, all materials are accumulation of thought.

So by the time you are ready for a thing, don't underestimate that there are other minds that are ready for you. For instance, I have been going now, for several seasons, to Lippincott's, the foundry up in New Haven. And when I go to the foundry to work, the whole place is at my disposal. It is geared for the artist to work. . . .

I feel, in a way, that my work has encompassed every movement. I started with Cubism and I've gone through every period. It was not my desire to consciously do that. But it was like a tree that grew. It unfolded. So I feel that in the end, I have used a hunk of time.

I have taken everything out of this world, everything that I could, to become more aware of what it is. Let me explain something that happened in San Francisco not too long ago. . . . Someone at the luncheon party said to me, "Mrs. Nevelson, we hear or we read that when you eat raisins, you make a selection of each raisin. . . ." When you are eating raisins—I haven't eaten them for twenty years but never mind—why shouldn't I select every little form that I put in my mouth? Now I would say that that's one of the basic things I'm pleased about in retrospect . . . that twenty or thirty years ago when I probably didn't have anything else but raisins, or a package of raisins, I made a selection of each one. I gave each little form its due. I didn't fill my mouth with a *bunch* of raisins. *That* would offend me. Now I think that is more important to state and give people to think about than a lot of subjects that I couldn't talk about in history books, even art and architecture. I love art and architecture, and I know there are critics and authorities that can certainly surpass me, because it means a life study to really be authoritative. But when I put a raisin in my mouth I know what I'm doing. . . .

. . . When I clean house or sweep the street in front of the house, I am not really cleaning house. I am building architecture. Every time, because the way I place a thing back, the way I touch a thing, the way I move a thing . . . so for me it is exercise in space of building a beautiful architecture. And if I can, why not live in it?

. . . I'm seventy-six. I will get on my knees and wipe up a floor or the stairs . . . for me, it is just not cleaning. When I have a cleaning woman or man, they do it to make the house clean. I do it for a higher order.

There is something strange about nature that everything has to crumble. There's no material on earth, may it be steel or rock, that will stay that way forever. They all powder down in time. In the end everything on earth has to crumble. In the beginning there's a promise. The teeth get stronger, and the body gets stronger and then as it gets ready to function and it functions, it's destroyed and destroyed and destroyed. The human spirit—creation works in the opposite direction. In that place, you are

creating, you are tapping life. But our physical life is mortal, so far as I'm concerned. Half the time we're growing up and there are labor pains right along the line, and half we're dying and that is the other pain.

But I'll tell you something, dear, that I've never feared death. To hell with it. I've met it daily and I want to feel that I was aware of it as possible. I think of Shankar, the great Indian dancer whom I sketched years ago . . . and of his father who was a great poet and used the symbol of the rose in his writings. He said that the world can be seen in one rose. And one rose can probably see the world. To have come to that essence of rose is a very high order of consciousness. . . . And maybe you have to confront not being on earth to come to that place.

3

Color Field Painting

While the term "color field" could be, and sometimes has been, validly applied to the expansive paintings of several artists, including Barnett Newman, the designation is more often reserved for a group of Washington, D.C., painters, and above all for Morris Louis and his younger associate, Kenneth Noland. It also extends, by virtue of her role in its genesis, to the New York artist Helen Frankenthaler, and to a few others, especially Jules Olitski. In 1953, on Clement Greenberg's suggestion, Louis and Noland visited Helen Frankenthaler's studio, where they were deeply affected by her work, in particular *Mountains and Sea*, (p. 53), painted the year before when she was twenty-three years old. In it Frankenthaler used paint as a stain into the canvas to become one with it, not as a layer on top of it. Thereafter, Morris Louis painted his pictures by pouring thin washes of acrylic colors over unstretched canvas, which he tilted to control the flow and stain of the paint. Louis called Frankenthaler "a bridge between Pollock and what was possible." Of course, she did not "invent" stain painting: several artists before her had used it here and there in their work (among them Pollock and Arshile Gorky), but not so fully nor consistently as Frankenthaler.

Louis, Noland, and Olitski made few, if any, statements about their work; but they didn't need to with Michael Fried, Clement Greenberg's disciple, to explicate it for them in numerous publications.

Noland's brief remarks of 1968 would make more sense to the uninitiated reader if they could have appeared further on in this anthology, that is, after the systemic and minimal art to which he refers. But since color field painting emerged in the fifties, his piece could hardly be placed in the late sixties.

KENNETH NOLAND (1924-)

Kenneth Noland, Statement quoted by Philip Leider, "The Thing in Painting Is Color," *The New York Times,* August 25, 1968 (review of a Noland exhibition)

... The thing is color, the thing in painting is to find a way to get color down, to float it without bogging the painting down in Surrealism, Cubism or systems of structure.

12. Morris Louis, *Pendulum No. 46*, 1954. Acrylic resin on canvas, 79 × 105 in. Collection Mr. and Mrs. Harry W. Anderson, Atherton, Calif.

13. Kenneth Noland, *Ember*, 1960. Acrylic on canvas, 70½ × 70 in. Private collection. Courtesy André Emmerich Gallery.

Structure is an element profoundly to be respected, but too open an engagement with it leaves one in the back waters of what are basically Cubist concerns. In the best color painting, structure is nowhere evident, or nowhere self-declaring.

No graphs; no systems; no modules. No shaped canvases. Above all, no *thingness,* no *objectness.* The thing is to get that color down on the thinnest conceivable surface, a surface sliced into the air as if by a razor. It's all color and surface. That's all.

JULES OLITSKI (1922–)

Jules Olitski, "Painting in Color," *Artforum* (January 1967)—a slightly revised and expanded version of his statement in the American catalogue, Venice Biennale, 1966

Painting is made from inside out. I think of painting as possessed by a structure—i.e., shape and size, support and edge—but a structure born of the flow of color feeling. Color *in* color is felt at any and every place of the pictorial organization; in its immediacy—its particularity. Color must be felt throughout.

What is of importance in painting is paint. Paint can be color. Paint becomes painting when color establishes surface. The aim of paint surface (as with everything in visual art) is appearance—color that appears integral to material surface. Color is of inherent significance in painting. (This cannot be claimed, however, for any particular type of paint, or application of paint.)

I began with color. The development of a color structure ultimately determines its expansion or compression—its outer edge. Outer edge is inescapable. I recognize the line it declares, as drawing. This line delineates and separates the painting from the space around and appears to be on the wall (strictly speaking, it remains in front of the wall). Outer edge cannot be visualized as being in some way within—it is the outermost extension of the color structure. The decision as to *where* the outer edge is, is final, not initial.

Wherever edge exists—both within a painting and at its limits—it must be felt as a necessary outcome of the color structure. Paint can be color and drawing when the edge of the painting is established as the final realization of the color structure.

The focus in recent painting has been on the lateral—a flat and frontal view of the surface. This has tended toward the use of flat color areas

14. Installation photograph by André Emmerich of Frankenthaler, Louis, Noland, Olitski Exhibition, C.A.P.A., Bordeaux, January 1981. Left: Jules Olitski, *First Pull*, 1963. 89⅜ × 102 in. Collection of the artist. Right: Jules Olitski, *Cleopatra Flesh*, 1963. Acrylic on canvas, 81⅞ × 68⅞ in. Museum of Modern Art, New York. Courtesy André Emmerich.

bounded by and tied inevitably to a structure composed of edges. Edge is drawing and drawing is *on* the surface. (Hard-edge or precision-made line is no less drawing than any other kind.) Because the paint fills in the spaces between the edges, the color areas take on the appearance of over-lay. Painting becomes subservient to drawing. When the conception of internal form is governed by edge, color (even when stained into raw canvas) appears to remain on or above the surface. I think, on the contrary, of color as being seen *in* and throughout, not solely *on*, the surface.

HELEN FRANKENTHALER (1928–)

Excerpted from Cindy Nemser, "Interview with Helen Frankenthaler," *Arts magazine* (November 1971)

CINDY NEMSER: I know other people have asked you if you feel your work relates to nature or not.

HELEN FRANKENTHALER: That depends on what you mean by nature. What do you mean by nature?

C.N. I mean references to the outside world.

H.F. Well, I'm not doing landscapes.

C.N. But there does seem to be a landscape in your work.

H.F. I think there is, but it's not through a conscious effort. I'm not in-volved in nature per se. I am involved in making pictures. I think what you call nature is an aspect of some of them. But often "nature" associ-ations are used as a handle . . . held onto by people who want a clue as to how to read the surface of an abstract picture. That's *their* problem, whether nature is in it or not.

C.N. Do you consider the paintings totally abstract?

H.F. I call them abstract paintings. But perhaps they are less abstract or differently abstract from harder-edged pictures—that is, the geometry and sharp edges—of circles, squares, stripes are apt to be less associative and more reference-free than other kinds of shape and gesture. . . .

C.N. In your interview with Henry Geldzahler in *Artforum*, you said that you were often touched by the Surrealist associative qualities you found in Jackson Pollock's paintings. Do you think you were responding to the sub-conscious elements which enrich his images?

15. Helen Frankenthaler, *Mountains and Sea*, 1952. Oil on canvas, 86⅜ × 117¼ in. Collection of the artist, on loan to the National Gallery of Art, Washington, D.C.

H.F. I think that whenever one sees a shape or color or juxtaposition of related forms that isn't recognizable as a specific subject matter (unless, perhaps, when it is simple geometry) that there is some conscious and subconscious association. But that, while it is an element in the work, that association isn't what makes it aesthetically meaningful, successful or unsuccessful.

C.N. It seems to me that many of your paintings . . . have an innate sense of rightness and balance. . . . Your pictures seem to have grown naturally, as if you just *do* them, and they weren't planned.

H.F. Very often something that doesn't look planned—what you call "rightness"—has had long moments or decades of planning going into it. And very often a certain kind of "wrongness" (awkwardness, surprise) is right, and one must seize it. . . .

C.N. Do you still pour the paint from buckets?

H.F. I've used many different methods: pour, sponge, use the brush. I generally work with the canvas on the floor, and from pails of paint. . . . I usually don't like to work over pictures, because very often, not always, what I want to accomplish in the picture can't be experienced by worrying the canvas, reworking, salvaging. I try never to let the event and the result become a beautiful trap.

C.N. So there's always the element of chance in your work, your risk, which other people have talked about.

H.F. Yes, but I think, relatively, there probably is chance and risk in all the history of painting. No matter how fine or meticulous or tortured a picture may be in execution, the risk or chance of its working or not is always there, no matter what the method. One hopes every picture will be a new birth, a fresh experience within a growing framework. My attitude, my pictures, were recently compared, to my surprise (since I'm neither Zen nor Oriental-oriented!) to a Japanese wrestling-match confrontation. But I understood the analogy. One prepares, bringing all one's weight and gracefulness and knowledge to bear: spiritually, emotionally, intellectually, physically. And often there's a moment when all frequencies are right and it hits. But in making a picture, very often from the "hitting point" on, you can pursue that moment and follow it with a whole future aesthetic vocabulary. One produces the moment and hopes to have the ability to let that moment guide from there. You guide it and it guides you. Every picture—somewhat of an experiment. . . . No rules. All approaches and responses should be open possibilities. In a healthy way, one earns freedom from having self-imposed limitations. . . . I think just as in relations with people, as in art, if you always stick to style,

manners, and what will work, and you're never caught off guard, then some beautiful experiences never happen . . . when I look at a picture I've made it strikes me as working or not working in relation to my range of expectancies: my experience, hopes, surprises, or what I ask for in my pictures. I respond, like or dislike work, or look for certain things. Usually, I know them, if my sense of what art or my pictures are about is there, on the canvas, and working or not.

C.N. Is keeping the surface of the canvas flat one of the things you would expect?

H.F. Well, I have never said I want to keep the surface flat. What I have said, occasionally, is that pictures *are* flat and part of the nuance and often the beauty or the drama that makes a work, or gives it life—whatever—is that it presents such an ambiguous situation of an undeniably flat surface, but on it and within it an intense play and drama of space, movements, light, illusion, different perspectives, elements in space.

C.N. And you visualized this situation in a new way?

H.F. For me it certainly came out of Cubism—playing with planes on a flat surface.

C.N. True. But in Cubism there's still an illusion of depth evolving out of the method of constantly overlapping planes. Whereas in your paintings there is an attempt to get rid of even that kind of shallow illusionism.

H.F. That might be true, but I feel that in the pictures that work part of it is the fact that different areas, colors, portions, lines, corners, sides, can move in a space miles back and forth, while clearly, at the same time, they are resting smack flat next to each other. . . .

C.N. What would you define as a successful painting for yourself?

H.F. I don't think one can describe that. I think you have to stand in front of it and feel it—but part of that feeling involves certain elements of space and light, scale, "the moment caught."

4

Happenings and Other Pre-Pop Art

ALLAN KAPROW (1927-)

Excerpted from Allan Kaprow, "The Legacy of Jackson Pollock," *Art News* (October 1958)

The conclusion of Kaprow's essay, which is all that is given here, is extraordinarily prophetic of the astonishing changes and crashing of boundaries that art underwent in the sixties and seventies. In his environments and happenings of the late fifties and early sixties, Allan Kaprow himself became one of the prime forces instituting those changes.

★ ★ ★

What we have then, is a type of art which tends to lose itself out of bounds, tends to fill our world with itself, an art which, in meaning, looks, impulse, seems to break fairly sharply with the traditions of painters back to at least the Greeks. Pollock's near destruction of this tradition may well be a return to the point where art was more actively involved in ritual, magic and life than we have known it in our recent past. If so, it is an exceedingly important step, and in its superior way, offers a solution to the complaints of those who would have us put a bit of life into art. But what do we do now?

There are two alternatives. One is to continue in this vein. Probably many good "near-paintings" can be done varying this aesthetic of Pollock's without departing from it or going further. The other is to give up the making of paintings entirely, I mean the single, flat rectangle or oval as we know it. It has been seen how Pollock came pretty close to doing so himself. In the process, he came upon some newer values which are exceedingly difficult to discuss, yet they bear upon our present alternative. To say that he discovered things like marks, gestures, paint, colors, hardness, softness, flowing, stopping, space, the world, life, death—is to sound either naive or stupid. Every artist worth his salt has "discovered" these things. But Pollock's discovery seems to have a peculiarly fascinating simplicity and directness about it. He was, for me, amazingly childlike, capable of becoming involved in the stuff of his art as a group of *concrete facts* seen for the first time. There is, as I said earlier, a certain blindness, a mute belief in everything he does, even up to the end. I urge that this

be not seen as a simple issue. Few individuals can be lucky enough to possess the intensity of this kind of knowing, and I hope that in the near future a careful study of this (perhaps) Zen quality of Pollock's personality will be undertaken. At any rate, for now, we may consider that, except for rare instances, Western art tends to need many more indirections in achieving itself, placing more or less equal emphasis upon "things" and the *relations* between them. The crudeness of Jackson Pollock is not, therefore, uncouth or designed as such; it is manifestly frank and uncultivated, unsullied by training, trade secrets, finesse—a directness which the European artists he liked hoped for and partially succeeded in, but which he never had to strive after because he had it by nature. This by itself would be enough to teach us something.

It does. Pollock, as I see him, left us at the point where we must become preoccupied with and even dazzled by the space and objects of our everyday life, either our bodies, clothes, rooms, or, if need be, the vastness of Forty-Second Street. Not satisfied with the *suggestion* through paint of our other senses, we shall utilize the specific substances of sight, sound, movements, people, odors, touch. Objects of every sort are materials for the new art: paint, chairs, food, electric and neon lights, smoke, water, old socks, a dog, movies, a thousand other things which will be discovered by the present generation of artists. Not only will these bold creators show us, as if for the first time, the world we have always had about us, but ignored, but they will disclose entirely unheard of happenings and events, found in garbage cans, police files, hotel lobbies, seen in store windows and on the streets, and sensed in dreams and horrible accidents. An odor of crushed strawberries, a letter from a friend or a billboard selling Draino; three taps on the front door, a scratch, a sigh or a voice lecturing endlessly, a blinding staccato flash, a bowler hat—all will become materials for this new concrete art.

The young artist of today need no longer say, "I am a painter" or "a poet" or "a dancer." He is simply an "artist." All of life will be open to him. He will discover out of ordinary things the meaning of ordinariness. He will not try to make them extraordinary. Only their real meaning will be stated. But out of nothing he will devise the extraordinary and then maybe nothingness as well. People will be delighted or horrified, critics will be confused or amused, but these, I am sure, will be the alchemies of the 1960s.

Excerpted from Allan Kaprow, " 'Happenings' in the New York Art Scene," *Art News* (May 1961)

Kaprow's 1961 essay on happenings in *Art News*—then the most influential organ for contemporary art—was the first full-scale, richly illustrated presentation of the new movement. Within a few years, "hap-

penings" were being performed in school auditoriums, cafés, and drawing rooms throughout the country. A handful of the original group working in that medium have continued to pursue it (Kaprow consistently, Whitman occasionally), but most of them (e.g., Dine, Oldenburg, Grooms) soon began to concentrate their creativity elsewhere. Among the antecedents and sources of happenings were the Futurist and Dada demonstrations (Schwitters's Merz theater proposal might have served as the script for several pieces by Oldenburg), and, more immediately, John Cage's performances and his ideas, especially those on chance. From 1956 to 1958, Kaprow studied with Cage at the New School. By the early sixties, Cage's influence had become as pervasive as that of his precursor, Marcel Duchamp, whose concepts he helped make applicable to a whole generation of artists. As a matter of fact, in 1952 at Black Mountain College where he was then teaching, Cage gave what can be called the first American happening (in which Robert Rauschenberg and Merce Cunningham participated).

On the origin of the term "happenings," Kaprow writes: "I doubt that this is a term acceptable to all artists. It was part of the title of a score included in the body of an article written in early 1959 for the Rutgers University *Anthologist* (vol. 30, no. 4). This was apparently circulated in New York City. In October of the same year, I presented *18 Happenings in Six Parts* at the Reuben Gallery, a loft on New York's lower Fourth Avenue.... A number of artists picked up the word informally and the press then popularized it. I had no intention of naming an art form and for a while tried, unsuccessfully, to prevent its use." °

Further in his book, Kaprow makes clear the difference between his conception and execution of happenings and those of Dine, Oldenburg, and Whitman, all of which are either too emotional, violent, or poetic for Kaprow.

<p style="text-align:center">★ ★ ★</p>

If you haven't been to the Happenings, let me give you a kaleidoscope sampling of some of their great moments.

Everybody is crowded into a downtown loft, milling about, like at an opening. It's hot. There are lots of big cartons sitting all over the place. One by one they start to move, sliding and careening drunkenly in every direction, lunging into people and one another, accompanied by loud breathing sounds over four loudspeakers. Now it's winter and cold and it's dark, and all around little blue lights go on and off at their own speed, while three large, brown gunny-sack constructions drag an enormous pile of ice and stones over bumps, losing most of it, and blankets keep falling over everything from the ceiling. A hundred iron barrels and gallon wine

°Kaprow, *Assemblage, Environments and Happenings.* New York: Abrams, 1966, p. 184n).

jugs hanging on ropes swing back and forth, crashing like church bells, spewing glass all over. Suddenly, mushy shapes pop up from the floor and painters slash at curtains dripping with action. A wall of trees tied with colored rags advances on the crowd, scattering everybody, forcing them to leave. There are muslin telephone booths for all with a record player or microphone that tunes you in to everybody else. Coughing, you breathe in noxious fumes, or the smell of hospitals and lemon juice. A nude girl runs after the racing pool of searchlight, throwing spinach greens into it. Slides and movies, projected over walls and people, depict hamburgers: big ones, huge ones, red ones, skinny ones, flat ones, etc. You come in as a spectator and maybe you discover you're caught in it after all, as you push things around like so much furniture. Words rumble past, whispering, dee-daaa, baroom, love me, love me; shadows joggle on screens, power saws and lawnmowers screech just like the I.R.T. at Union Square. Tin cans rattle and you stand up to see or change your seat or answer questions shouted at you by shoeshine boys and old ladies. Long silences, when nothing happens, and you're sore because you paid $1.50 contribution, when bang! there you are facing yourself in a mirror jammed at you. Listen. A cough from the alley. You giggle because you're afraid, suffer claustrophobia, talk to some one nonchalantly, but all the time you're *there*, getting into the act. . . . Electric fans start, gently wafting breezes of "New-Car" smell past your nose as leaves bury piles of a whining, burping, foul, pinky mess.

So much for the flavor. Now I would like to describe the nature of Happenings in a different manner, more analytically—their purpose and place in art.

Although widespread opinion has been expressed about these events, usually by those who have never seen them, they are actually little known beyond a small group of interested persons. This small following is aware of several different kinds of Happening. There are the sophisticated, witty works put on by the theater people; the very sparsely abstract, almost Zen-like rituals given by another group (mostly writers and musicians); and there are those in which I am most involved, crude, lyrical and very spontaneous. The last grew out of the advanced American painting of the last decade and I and the others were all painters (or still are). However, there is some beneficial exchange between these three areas.

In addition, outside New York, there is the Gutai group in Osaka, reported activity in San Francisco, Chicago, Cologne, Paris and Milan, as well as a history that goes back through Surrealism, Dada, Mime, the circus, carnivals, the traveling saltimbanques, all the way to medieval mystery plays and processions. Of most of this we know very little; only the spirit has been sensed. Of what *I* know, I find that I have decided philosophical reservations about much of it. Therefore, the points I shall

make are not intended to represent the views of all of those who create works that might be generically related, nor even of all of those whose work I admire, but are the issues which I feel to be the most adventuresome, fruitfully open to applications, and the most challenging of anything that is in the air at present.

Happenings are events which, put simply, happen. Though the best of them have a decided impact—that is, one feels, "here is something important"—they appear to go nowhere and do not make any particular literary point. In contrast to the arts of the past, they have no structured beginning, middle or end. Their form is open-ended and fluid; nothing obvious is sought and therefore nothing is won, except the certainty of a number of occurrences in which one is more than normally attentive. They exist for a single performance, or only a few more, and are gone forever, while new ones take their place.

These events are essentially theater pieces, however unconventional. That they are still largely rejected by most devotees of the theater may be due to their uncommon power and primitive energy, and to the fact that the best of them have come directly out of the rites of American Action Painting. But by widening the concept "theater" to include them (like widening the concept "painting" to include collage) it is possible to see them against this basic background, and to understand them better.

To my way of thinking, Happenings possess some crucial qualities which distinguish them from the usual theatrical works, even the experimental ones of today. First, there is the *context*, the place of conception and enactment. The most intense and essential happenings have been spawned in old lofts, basements, vacant stores, in natural surroundings and in the street, where very small audiences, or groups of visitors, are commingled in some way with the event, flowing in and among its parts. There is thus no separation of audience and play (as there is even in round or pit theaters), the elevated picture-window view of most playhouses, is gone, as are the expectations of curtain-openings and *tableaux-vivants* and curtain-closing. . . . The sheer rawness of the out-of-doors or the closeness of dingy city quarters, in which the radical Happenings flourish, are more appropriate, I believe, in temperament and unartiness, to the materials and directness of these works. The place where anything grows up (a certain kind of art in this case), that is its "habitat," gives to it not only a space, a set of relationships to various things around it, a range of values, but an overall atmosphere, as well, which penetrates it and whoever experiences it. This has always been true, but it is especially important now, when our advanced art approaches a fragile but marvelous life, one that maintains itself by a mere thread, melting into an elusive, changeable configuration, the surroundings, the artist, his work and everyone who comes to it.

16. Allan Kaprow, *Household*, 1964. Happening, Cornell University, Ithaca, N.Y., May 1964.
(*Photo: Courtesy Harry N. Abrams, Inc.*)

If I may digress a moment to bring into focus this point, it may reveal why the "better" galleries and homes (whose décor is still a by-now-anti-septic Neo-Classicism of the twenties) desiccate and prettify modern paintings and sculpture which had looked so natural in their studio birth-place. It may also explain why artists' studios do not look like galleries and why, when an artist's studio does, everyone is suspicious. I think that, today, this organic connection between art and its environment is so meaningful and necessary that removing one from the other results in abortion. Yet, this life-line is denied continuously by its most original seers, the artists who have made us aware of it; for the flattery of being "on show" blinds them to every insensitivity heaped upon their suddenly weakened offerings. There seems no end to the white walls, the tasteful aluminum frames, the lovely lighting, fawn-grey rugs, cocktails, polite conversation. The attitude, I mean the world view, conveyed by such a fluorescent reception is in itself not "bad." It is unaware. And being un-aware, it can hardly be responsive to the art it promotes and professes to admire.

Happenings invite one to cast aside for a moment these proper manners and partake wholly in the real nature of the art and (one hopes) life. Thus a Happening is rough and sudden and it often feels "dirty." Dirt, we might begin to realize, is also organic and fertile, and everything, includ-ing the visitors, can grow a little in such circumstances.

To return to the contrast between Happenings and plays, the second important difference is that a Happening has no plot, no obvious "philos-ophy," and is materialized in an improvisatory fashion, like jazz, and like much contemporary painting, where one does not know exactly what is going to happen next. The action leads itself any way it wishes, and the artist controls it only to the degree that it keeps on "shaking" right. A modern play rarely has such an impromptu basis, for plays are still *first written*. A Happening is *generated in action* by a headful of ideas or a flimsily-jotted-down score of "root" directions.

A play assumes words to be the almost absolute medium. A Happening will frequently have words, but they may or may not make literal sense. If they do, their sense is not part of the fabric of "sense" which other non-verbal elements (noise, visual stuff, actions, etc.) convey. Hence, they have a brief, emergent and sometimes detached quality. If they do not make "sense," then they are heard as the *sound* of words instead of the meaning conveyed by them. Words, however, need not be used at all: a Happening might consist of a swarm of locusts being dropped in and around the performance space. This element of chance with respect to the medium itself is not to be expected from the ordinary theater.

Indeed, the involvement in chance, which is the third and most prob-lematical quality found in Happenings, will rarely occur in the conven-

tional theater. When it does, it usually is a marginal benefit of *interpretation*. In the present work, chance (in conjunction with improvisation) is a deliberately employed mode of operating that penetrates the whole composition and its character. It is the vehicle of the spontaneous. And it is the clue to understanding how control (setting up of chance techniques) can effectively produce the opposite quality of the unplanned and apparently uncontrolled. I think it can be demonstrated that much contemporary art, which counts upon inspiration to yield that admittedly desirable verve or sense of the un-selfconscious, is by now getting results which appear planned and academic. A loaded brush and a mighty swing always seem to hit the ball to the same spot.

The word "chance," then, rather than "spontaneity," is a key term, for it implies risk and fear (thus reestablishing that fine *nervousness* so pleasant when something is about to occur). It also better names a *method* which becomes manifestly unmethodical if one considers the pudding more a proof than the recipe.

Traditional art has always tried to *make it good every time*, believing that this was a *truer* truth than life. When an artist directly utilizes chance he hazards failure, the "failure" of being less Artistic and more Life-like. "Art" produced by him might surprisingly turn out to be an affair that has all the inevitability of a well-ordered, middle-class Thanksgiving dinner (I have seen a few remarkable Happenings which were "bores" in this sense). But it could be like slipping on a banana peel, or Going to Heaven.

Simply by establishing a flexible framework of the barest kind of limits, such as the selection of only five elements out of an infinity of possibilities, almost anything can happen. And something always does, *even things that are unpleasant*. Visitors to a Happening are now and then not sure what has taken place, when it has begun or when it has ended, or even when things have gone "wrong." For by going "wrong," something far more "right," more revelatory, has many times emerged. It is this sort of sudden near-miracle which presently seems to be made more likely by chance procedures.

If one grasps the import of that word "chance" and *accepts* it (no easy achievement in our culture), then its methods need not invariably cause one's work to reduce to either chaos or a statistical indifference lacking in concreteness and intensity, as in a table of random numbers. On the contrary, the identities of those artists who employ such techniques are very clear. It is odd that by giving up certain hitherto privileged aspects of the Self, so that one cannot always "correct" something according to one's taste, the work and the artist frequently come out on top. And when they come out on the bottom, it is a very concrete bottom!

The final point I should like to make about Happenings as against plays was mentioned earlier, and is, of course, implicit in all the discussion—

that is, their impermanence. By composing in such a way that the unforeseen has a premium placed upon it, no Happening can be reproduced. The few performances given of each work are considerably different from each other; and the work is over before habits begin to set in. In keeping with this, the physical materials used to create the environments of Happenings are of the most perishable kind: newspapers, junk, rags, old wooden crates knocked together, cardboard cartons cut up, real trees, food, borrowed machines, etc. They cannot last for long in whatever arrangement they are put. A Happening is thus at its freshest, while it lasts, for better or worse.

Here we need not go into the considerable history behind such values as are embodied in Happenings. It is sufficient to say that the passing, the changing, the natural, even the willingness to fail, are not unfamiliar. They reveal a spirit that is at once passive in its acceptance of what may be, and heroic in its disregard of security. One is also left exposed to the quite marvelous experience of being *surprised.* This is, in essence, a continuation of the tradition of Realism.

JIM DINE (1935-), / CLAES OLDENBURG (1929-), ROBERT WHITMAN (1935-)

Statements by Jim Dine, Claes Oldenburg, and Robert Whitman in Michael Kirby, ed., *Happenings: An Illustrated Anthology*, New York, 1965

Kirby's book includes an excellent historical introduction to the genre, statements by the artists, together with summaries, scripts, and descriptions of several productions by each of these three artists, as well as Kaprow and Grooms. Besides the difference already referred to, there is a further fundamental distinction between the happenings of Dine, Oldenburg, and Whitman, and those of Kaprow. The latter is opposed to any vestige of theater in his events and he seeks to abolish the separation between art and life even, on occasion, to the extent of doing away with an audience. Initially, the small audience of colleagues and friends was for Kaprow, as well as for most of the other artists, especially Oldenburg, an actual part of the whole performance, either directly or in a more general spectator-performance relationship.

★ ★ ★

Jim Dine

I cannot talk about theater because I have no background except acting out everything in everyday life. That is a complete, comprehensive background, because it happened every day of my life. The Happenings then

17. Jim Dine, *The Car Crash*. Happening, November 1960, Reuben Gallery, New York. The man in the silver suit is Dine. (*Photo: Courtesy Robert R. McElroy*)

became an extension of that, rather than an extension of my painting. The visual side of the Happenings was the extension of my painting, but there were other things involved, since I think on two levels. I think on the visual level, which has nothing to do with the way one talks. But these things had to get across with talking, too—as literary ideas seen in a visual way—so that there were two levels. And my only preparation for that was acting out everything through my life. I felt that it was the most natural thing to do—to do the Happenings. When I did *The Car Crash*, it related to my paintings only because I was doing a Happening then, and that is what I was painting about, and I thought it would be nice to tie them in. There was no other relationship.

Kaprow once said, "You're the one who does the funny Happenings." He likes classification—that there was someone who did "funny Happenings." But they were not funny. . . .

The first "Happening" I did was called *The Smiling Workman*, at the Judson Church. . . . There was a table with three jars of paint and two brushes on it, and the canvas was painted white. I came around it with one light on me. I was all in red with a big, black mouth: all my face and head were red, and I had a red smock on, down to the floor. I painted "I love what I'm doing" in orange and blue. When I got to "what I'm doing," it was going very fast, and I picked up one of the jars and drank the paint, and then I poured the other two jars of paint over my head, quickly, and dove, physically, through the canvas. The light went off. It was like a thirty-second moment of intensity. It was like a drawing. I did not have to think about it. Claes said, "We're going to have these Happenings," and I said, "O.K. I'd like to do one." And that is the one I was going to do. It was just a thought I had. . . . For me, it was the most pure that I did.

I did not think it was funny. . . . I do not think obsession is funny or that not being able to stop one's intensity is funny. . . .

The next one I did was called *The Vaudeville Show*, which was a crowd-pleaser and one that was quite pleasing to me to do. I had a stage built. It was like an old-time stage with two flats of canvas on each side, and over the top it said, "Jim Dine's Vaudeville" in Dayglow color. There was a tape recording made for that. It was all kinds of crazy things: organ music, me talking—it was a collage on tape. I came out with a red suit on and cotton all over me, my face painted yellow. To the music that was going on, I pulled the cotton off and just let it fall to the floor until there was no cotton on me. Then I walked out. As soon as I walked out, inanimate objects became actors. Two people behind the flats operated a dance of strung cabbages and carrots and lettuce and celery. That stopped quickly, and red paint was poured down the flats on each side and onto the floor. That was another "act." The final act was: I came out with my

red suit on and a straw hat on this time. On each arm I had a nude girl made out of cardboard so that each of my arms became their inner arms. These were made like puppets—Javanese puppets. I did a dance. I do not even understand how I did that dance. I could never do it now. But I did this dance that people cheered. And they tore my clothes off. Encores! And I ripped off my tie and threw it to the audience. It was an incredible scene. In the sense of audience participation, I have never felt it stronger—with someone else or with me. People remember it as a fantastic night. It was the same night Whitman put on *E.G.*, which I was in. Mine was the finale.

The next one was *The Car Crash*, and the final Happening I did was called *The Shining Bed*. . . . That was my best one—the one I liked the best. It was the most beautiful one.

. . . Now I feel that I would never want to appear in my own works again, but then it was important because I did not trust anyone else, and I did not feel that what I was doing was of a public enough nature to even tell the people what to do. That is where I think the clue is to the fact that they were so personal and so much related to acting out one's life rather than art because I was not able to even transmit my ideas to anyone else to have them do it.

The name "Happening" was a great crowd-pleaser. People knew what they were going to see. If it said "Happening," they were going to see Whitman, Dine, Oldenburg, or Kaprow. People sometimes say about my painting, "That's a real Happening." It is ridiculous. It is Kaprow's word, and it does not refer to me. I do not really know what it meant. But if it meant what he did, it was not what I was doing, so it was not true of me.

What I did was not understood for the most part. I do not feel that there was enough of a perspective between art and life in them. I felt they were too closely allied with me. That would be all right in paintings because people would have time to look at them, but these were too temporary. Everybody I ever talked to was completely misinterpreting them.

I stopped doing Happenings because I felt anyone could do anything and be liked. It was becoming so chic. The audiences were laughing at everything. And I also felt that it was taking too much from my painting, which I really wanted to do.

Claes Oldenburg

What I do as a "happening" is part of my general concern, at this time, to use more or less altered "real" material. This has to do with *objects*, such as typewriters, Ping-Pong tables, articles of clothing, ice-cream cones, hamburgers, cakes, etc., etc.—whatever I happen to come into contact with. The "happening" is one or another method of using *objects in mo-*

tion, and this I take to include people, both in themselves and as agents of object motion.

To present this material, I have worked out some structures and techniques which parallel those of the presentation of the static object. The static object is shown by me as one of a number of related objects, in a particular "real" place—itself an object. For example, *The Store* (1961, New York), containing 120 items approximately, within a real store (107 East 2nd St., New York). . . . I present in a "happening" anywhere from thirty to seventy-five events, or happenings (and many more objects), over a period of time from one-half to one and a half hours, in simple spacial relationships—juxtaposed, superimposed—like those of *The Store.* The event is made simple and clear, and is set up either to repeat itself or to proceed very slowly, so that the tendency is always to a static object. . . .

An individual event may be "realistic," and this may be quite direct, evolving on the spot with a player and certain materials and objects, or a reconstruction (of something I might have observed the day before or read about or dreamed, or of which someone else may have brought the account) or it may be, at an opposite extreme, an enigmatic, fantastic event, with altered objects and altered (costumed) persons. I mix realistic and fantastic events, as the imagination does, and I consider the imaginary event as real as the "real" one.

In the process of altering an object or event, I use various methods, some of which are purely whimsical, others having a rationalization, such as the alteration of real (tangible) furniture into its appearance (visual perspective).

The effect of my "happenings" will be missed if my specific intention and technique are not understood. Spectators will look for development where none is intended, or be bored by the repetition. Or the term "happening" by its vagueness will raise an expectation unlike the effect encountered; for example, spontaneous effect or an improvisation or a spectacle of some sort.

My aim is the perfection of the details of the events rather than any composition (except in the later *Ray Gun Theater* with its "poetic" arrangement of incidents), and the composition is merely a practical structure (usually "real" f.ex. "snapshots" "blackouts" "circus"—a structure which is an object in itself).

The audience is considered an object and its behavior as events, along with the rest. The audience is taken to differ from the players in that its possibilities are not explored as far as that of the players (whose possibilities are not explored as far as my own). The place of the audience in the structure is determined by seating and by certain simple provocations.

The place in which the piece occurs, this large object, is, as I have indicated, part of the effect, and usually the first and most important

factor determining the events (materials at hand being the second and players the third). "Place" may have any extent, a room or a nation, and may have any character whatsoever: old, new, clean, dirty, water or land, whatever is decided.

Robert Whitman

The thing about theater that most interests me is that it takes time. Time for me is something material. I like to use it that way. It can be used in the same way as paint or plaster or any other material. It can describe other natural events.

I intend my works to be stories of physical experience and realistic, naturalistic descriptions of the physical world. Description is done in terms of experience. If somebody says something is red, then everybody knows what that means because they have seen it. They have had that experience. A story is a record of experience or the creation of experience in order to describe something. The story of something is its description, the way it got that way, its nature. The intention of these works has to do with either re-creating certain experiences that tell a story, or presenting experiences that tell a story, or showing them. You can re-create it or present it or show it. You can expose things. All these things have to do with making them available: you make them available to the observer, so called.

The stories do not come from the objects, necessarily. There might not be a story if there were not people. It is in the nature of what we do to listen to people and watch them and see what they are doing, respond to them. If I am making an object, and I want to find the story of that object, one way to do it is to see what people do when they are involved with it, have people involved with it, and be involved with it myself.

At a certain point, fantasy is an object in the physical world. It is like a street or rain. It is a product of physical events. It is a part of nature that can be described. The fantasy exists as an object, as a central physical entity, and as part of the story that you tell about other objects.

Since time is the material I use to describe these things and is essential to their nature, the chronological order of a piece develops naturally. I can let the order of events develop in a practical way. If you build anything you have got to start somewhere. You cannot start building a house on the second floor. Once you have the basic house built from the ground up, you can finish off this room or that room in any order. There is a certain rigid order in the nature of the piece and there are other things that can be practical matters or matters of choice.

Time is the medium that I use to demonstrate what I know about, what I think people need to know about.

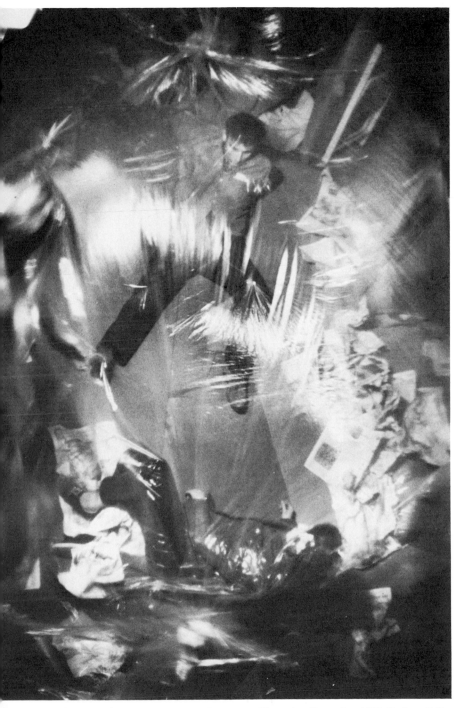

18. Robert Whitman, *The American Moon*. Happening, November-December 1960, Reuben Gallery, New York. Lucas Samaras and Simone Forti Whitman in this view. (*Photo: Robert R. McElroy*)

JASPER JOHNS (1930-) / JOHN CAGE (1912-)

John Cage is included in this anthology because he is important not only for his influence on artists but for his own remarkable work as composer, writer, and printmaker. From his earliest teachings of musical composition, Cage abolished barriers between art forms, demonstrating the applicability of his theories to visual as well as musical expressions.

 In this essay on Jasper Johns, Cage quotes extensively from the artist who, together with Robert Rauschenberg in the mid-fifties when Abstract Expressionism was still the dominant mode, brought objects back into avant-garde painting, either as images (e.g., a flag) or as actual things (e.g., a stuffed goat). By the mid-sixties, both young artists were celebrated either as the fathers of Pop Art or its first practitioners, a categorizing that found no favor with Johns (see his comments in the "What Is Pop Art?" interviews below). See also John Cage, "On Robert Rauschenberg, Artist, and His Work," *Metro 2* (1961), pp. 36–51, in which he quotes several remarks by Rauschenberg, including one that became holy writ to thousands of art students: "Painting relates to both art and life. Neither can be made. (I try to act in that gap between the two.)" Too often that crucial *"gap between the two"* was overlooked.

★ ★ ★

Excerpted from John Cage, "Jasper Johns: Stories and Ideas," in *Jasper Johns,* catalogue of an exhibition organized by Alan R. Solomon at the Jewish Museum, New York, 1964

Passages in italics are quotations from Jasper Johns found in his notebooks and published statements.

On the porch at Edisto. Henry's records filling the air with Rock-'n-Roll. I said I couldn't understand what the singer was saying. Johns (laughing): That's because you don't listen.

Beginning with a flag that has no space around it, that has the same size as the painting, we see that it is not a painting *of* a flag. The roles are reversed: beginning with the flag, a painting was made. Beginning, that is, with structure, the division of the whole into parts corresponding to the parts of a flag, a painting was made which both obscures and clarifies the underlying structure. A precedent is in poetry, the sonnet: by means of language, caesurae, iambic pentameter, license and rhymes to obscure and clarify the grand division of the fourteen lines into eight and six. The sonnet and the United States flag during that period of history when there

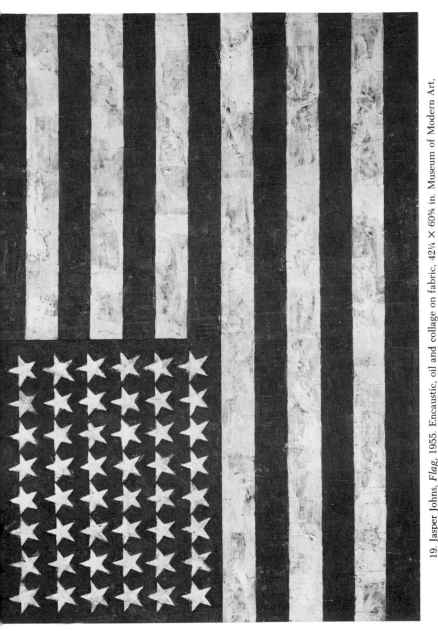

19. Jasper Johns, *Flag*, 1955. Encaustic, oil and collage on fabric, 42¼ × 60⅝ in. Museum of Modern Art, New York, Gift of Philip Johnson.

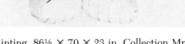

20. Robert Rauschenberg, *Canyon*, 1959. Combine painting, 86½ × 70 × 23 in. Collection Mr. and Mrs. Michael Sonnabend, New York.

were forty-eight? These are houses, Shakespeare in one, Johns in the other, each spending some of his time living.

I thought he was doing three things (five things he was doing escaped my notice).

... There are various ways to improve one's chess game. One is to take back a move when it becomes clear that it was a bad one. Another is to accept the consequences, devastating as they are. Johns chooses the latter even when the former is offered. Say he has a disagreement with others; he examines the situation and comes to a moral decision. He then proceeds, if to an impasse, to an impasse. When all else fails (and he has taken the precaution of being prepared in case it does), he makes a work of art devoid of complaint.

Sometimes I see it and then paint it. Other times I paint it and then see it. Both are impure situations, and I prefer neither.

Right conduct. He moved from objecting to not objecting. Things beneath other people to do are not that way for him. America.... When Johns explained that they were not beer cans but had taken him much time and effort to make, that if she examined them closely she would notice among other things fingerprints, that moreover she might also observe that they were not the same height (i.e., had not come off an assembly line), why, he asks, was she won over? Why does the information that someone has done something affect the judgment of another? Why cannot someone who is looking at something do his own work of looking? Why is language necessary when art so to speak already has it in it? "Any fool can tell that that's a broom." The clothes (conventions) are underneath. The painting is as naked as the day it was born.

What did I say in Japan? That the Mona Lisa with mustache or just anything plus a signature equals addition, that the erased de Kooning is additive subtraction, that we may be confident that someone understands multiplication, division, calculus, trigonometry?

... Leaning back, his chair on two legs, smiling, Johns said: My beer cans have no beer in them. Coming forward, not smiling, with mercy and no judgment he said: I had trouble too; it seemed it might be a step backward. Whenever the telephone rings, asleep or awake he never hesitates to answer.

An object that tells of the loss, destruction, disappearance of objects. Does not speak of itself. Tells of others. Will it include them? Deluge.

Why this palaver about structure? Particularly since he doesn't need to have any, involved as he is with process, knowing that the frame that will be put around the all that he makes will not make the environment invisible? Simply in order to make clear that these flags-numbers-letters-targets are not subjects? (That he has nothing to say about them proves that they are not subjects rather than that he as a human being is absent from them. He is present as a person who has noticed that. *At every point in nature there is something to see.* And so: *My work contains similar possibilities for the changing focus of the eye.*) Structures, not subjects—if only that will make us pause long enough in our headstrong passage through history to realize that Pop Art, if deduced from his work, represents a misunderstanding, if embarked upon as the next step after his, represents a nonsequitur. He is engaged with the endlessly changing ancient task: the imitation of nature in her manner of operation. The structures he uses give the dates and places (some less confined historically and geographically than others). They are the signature of anonymity. When, dealing with operative nature, he does so without structure, he sometimes introduces signs of humanity to intimate that we, not birds for instance, are part of the dialogue. Someone, that is, must have said Yes (*No*), but since we are not now informed we answer the painting affirmatively. Finally, with nothing in it to grasp, the work is weather, an atmosphere that is heavy rather than light (something he knows and regrets); in oscillation with it we tend toward our ultimate place: zero, gray disinterest.

. . . He had found a printed map of the United States that represented only the boundaries between them. (It was not topographical nor were rivers or highways shown.) Over this he had ruled a geometry which he copied enlarged on a canvas. This done, freehand he copied the printed map, carefully preserving its proportions. Then with a change of tempo he began painting quickly, all at once as it were, here and there with the same brush, changing brushes and colors, and working everywhere at the same time rather than starting at one point, finishing it and going on to another. It seemed that he was going over the whole canvas accomplishing nothing, and, having done that, going over it again, and again incompletely. And so on and on. Every now and then using stencils he put in the name of a state or the abbreviation for it, but having done this represented in no sense an achievement, for as he continued working he often had to do again what he had already done. Something had happened which is to say something had not happened. And this necessitated the repetitions, Colorado, Colorado, Colorado, which were not the same being different colors in different places. I asked how many processes he was involved in. He concentrated to reply and speaking sincerely said: It is all one process.

. . . Make something, a kind of object which as it changes or falls apart (dies as it were) or increases in its parts (grows as it were) offers no clue as to what its state or form or nature was at any previous time. Physical and Metaphysical Obstinacy. Could this be a useful object? . . .

The thermostats are fixed to the radiators but lead ineffectually to two bare wires. The Jaguar repaired and ready to run sits in a garage unused. It has been there since October. An electrician came to fix the thermostats but went away before his work was finished and never returned. The application for the registration of the car has not been found. It is somewhere among the papers which are unfiled and in different places. For odd trips a car is rented. If it gets too hot, a window is opened. The freezer is full of books. The closet in the guest room is full of furniture. There is, and anyone knows there is, a mystery, but these are not the clues. *The relationship between the object and the event. Can the 2 be separated? Is one a detail of the other? What is the meeting? Air?*

The situation must be Yes-and-No not either-or. *Avoid a polar situation.* A target is not a paradox. Ergo: when he painted it he did not use a circular canvas. . . . A painting is not a record of what was said and what the replies were but the thick presence all at once of a naked self-obscuring body of history. All the time has been put in one (structured?) space. He is able, even anxious, to repair a painting once it is damaged. A change in the painting or even someone looking at it reopens the conversation. Conversation goes on faithful to time, not to the remarks that earlier occurred in it. . . . *Three academic ideas which have been of interest to me are what a teacher of mine (speaking of Cézanne and Cubism) called "the rotating point of view" (Larry Rivers recently pointed to a black rectangle, two or three feet away from where he had been looking in a painting, and said, ". . . like there's something happening over there too"); Marcel Duchamp's suggestion "to reach the Impossibility of sufficient visual memory to transfer from one like object to another the memory imprint"; and Leonardo's idea . . . that the boundary of a body is neither a part of the enclosed body nor a part of the surrounding atmosphere.*
A target needs something else. Anything in fact will do to be its opposite. Even the space in the square in which it is centrally placed. This undivided seemingly left over area miraculously produces a duplex asymmetrical structure. Faces. . . .

Focus. Include one's looking. Include one's seeing. Include one's using. It and its use and its action. As it is, was, might be (each as a single tense, all as one). A = B. A is B. A represents B (do what I do, do what I say).

. . . We wonder whether, if chinaberry trees meant the same to us as they do to him (Spanish moss too, and the seashore and the flat land near it that makes him think the world is round, Negroes, the chigger-ridden forest and swamps that limit the cemeteries and playgrounds, the churches, the schools, his own house, in fact, all up on stilts against probable inundation, azaleas and oleanders, palm trees and mosquitoes, the advent of an outlandish bird in the oak outside the screened porch, the oak that has the swing with an automobile tire for sitting, the swing that needs repair [the ropes are frayed], the shark's teeth, the burrs in the sand on the way to the beach, the left-handed and right-handed shells, and grits for breakfast)—well, we just wonder.

. . . The cans of ale, *Flashlight*, the coffee can with brushes: these objects and the others were not found but were made. They were seen in some other light than that of day. We no longer think of his works when we see around us the similar objects they might be thought to represent. Evidently these bronzes are here in the guise of works of art, but as we look at them we go out of our minds, transformed with respect to being.

All flowers delight him. He finds it more to the point that a plant after being green should send up a stalk and at its top burst into color than that he should prefer one to others of them. The highest priority is given, if he has one out of the ground, to putting a plant in the earth. Presented with bulbs from the south, impatient for them to bloom, he initiated a plan for a sped-up succession of seasons: putting them to freeze on the terrace and then in the warmth of an oven. Flowers, however, are not left to die in a garden. They are cut and as many varieties as are blooming are placed together in a fierce single arrangement, whether from the garden, the roadside or the florist's: one of these, two of those, etc. (Do not be fooled: that he is a gardener does not exclude him from hunting; he told me of having found the blue Lactarius in the woods at Edisto.) Besides making paintings that have structures, he has made others that have none (*Jubilee*, for instance). I mean that were two people to tell what the division of that rectangle is into parts they would tell two different things. The words for the colors and the fact that a word is not appropriately colored ("You are the only painter I know who can't tell one color from another"), these facts exercise our faculties but they do not divide the surface into parts. One sees in other words a map, all the boundaries of which have been obscured (there was in fact no map); or we could say one sees the field below the flag: the flag, formerly above, was taken away. Stupidly we think of abstract expressionism. But here we are free of struggle, gesture, and personal image. Looking closely helps, though the paint is applied so sensually that there is the danger of falling in love. We moderate each glance with a virtuous degree of blindness. . . .

5

Pop Art

Gene Swenson's interviews with eight Pop artists in two issues of *Art News* constitute one of the primary documents of Pop Art—the movement that shook the art world in the early sixties. In the first installment, it was announced that Oldenburg would be interviewed in the second part, but for some reason (perhaps, as the artist suggests, he may have been away) he was not included and was replaced by Stephen Durkec, who was not represented in any of the major Pop shows.

The first group exhibition in the United States bringing together the artists for whom the sobriquet "Pop" was soon universally adopted was the *New Realists* show at the Sidney Janis Gallery, November 1–December 1, 1962. That presentation (which included Europeans) was followed by Lawrence Alloway's *Six Painters and the Object* at the Guggenheim Museum, March 14–June 12, 1963, and Alice Denney's *The Popular Image* exhibition, at the Washington Gallery of Modern Art, April 18–June 2, 1963, whose catalogue (essay by Alan Solomon) was accompanied by a recording of interviews with the artists conducted by Billy Klüver.

While these individual Pop artists differed from each other even more than the Action Painters had, they did share several general characteristics in the early years: their subject matter was taken directly from our commercially abundant everyday world; their images were second-hand, from newspapers, magazines, TV, and other advertisements; and their style owed much to the immediate impact, the brash simplification, and eye-catching color of commercial art. By the mid-sixties, Lichtenstein's comics, Oldenburg's hamburgers, and Warhol's Campbell soup cans had become almost as familiar as the products they started from.

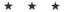

★ ★ ★

Excerpted from G. R. Swenson, "'What Is Pop Art?' Answers from 8 Painters," Part I, *Art News* (November 1963)

JIM DINE (1935-)

What is your attitude to Pop Art?

J.D.: I don't feel very pure in that respect. I don't deal exclusively with the

21. Jim Dine, *Shoe*, 1961. Oil on canvas, 56 × 64½ in. Private collection.
Courtesy Sonnabend Gallery, New York.

popular image. I'm more concerned with it as a part of my landscape. . . .
Pop art is only one facet of my work. More than popular images I'm
interested in personal images, in making paintings about my studio, my
experience as a painter, about painting itself, about color charts, the pal-
ette, about elements of the realistic landscape—but used differently.

The content of a Pollock or a de Kooning is concerned with paint, paint
quality, color. Does this tie you to them in theory?

J.D.: I tie myself to Abstract Expressionism like fathers and sons. As for
your question, no. No, I'm talking about paint, paint quality, color charts
and these things objectively, as objects. . . . It always felt right to use ob-
jects, to talk about that familiarity in the paintings . . . to recognize bill-
boards, the beauty of that stuff. It's not a unique idea—Walker Evans
photographed them in 1929. It's just that the landscape around you starts
closing in and you've got to stand up to it.

Your paintings look out and still make a statement about art?

J.D.: Yes, but a statement about art the way someone else talks about new
Detroit cars, objectively, as another kind of thing, a subject. . . .

Abstract Expressionism tended to look in?

J.D.: Yes.

Is this the difference between your work and theirs?

J.D.: I don't know what the difference is. Certainly Abstract Expressionism
influenced me, particularly Motherwell. I think he's continually growing
and making problems. . . . And I love the eccentricity of Edward Hopper,
the way he puts skies in. For me he's more exciting than Magritte as a
Surrealist. He is also like a Pop artist—gas stations and Sunday mornings
and rundown streets, without making it Social Realism. . . . It seems to me
that those who like Hopper would be involved with Pop somehow. Or
those who like Arthur Dove—those paintings of sounds, fog horns, the
circle ideas that were meant to be other things. There's a real awareness
of things, an outward awareness . . . the statement about bridging the gap
between art and life is, I think, a very nice metaphor or image . . . but I
don't believe it. Everybody's using it now. I think it misleads. . . . There's
art and there's life. I think life comes to art but if the object is used, then
people say the object is used to bridge that gap—it's crazy. The object is
used to make art, just like paint is used to make art.

ROBERT INDIANA (1928-)

What is Pop?

R.I.: Pop is everything art hasn't been for the last two decades. It is basically a U-turn back to a representational visual communication. . . . It is an abrupt return to Father after an abstract fifteen-year exploration of the Womb. Pop is a reenlistment in the world. It is shuck the Bomb. It is the American Dream, optimistic, generous and naive. . . . Pure Pop culls its techniques from all the present-day communicative processes. . . .

Will Pop replace Abstract Expressionism?

R.I.: In the eternal What-Is-New-in-American-Painting shows, yes; in the latest acquisitions of the avant-garde collectors, yes; in the American Home, no. Once the hurdle of its non-objectivity is overcome, A-E is prone to be as decorative as French Impressionism. There is a harshness and matter-of-factness to Pop that doesn't exactly make it the interior decorator's Indispensable Right Hand.

Is Pop here to stay?

R.I.: Give it ten years perhaps; if it matches A-E's fifteen or twenty, it will be doing well in these accelerated days of mass-medium circulation. In twenty years it must face 1984. . . .

Is Pop easy art?

R.I.: Yes, as opposed to one eminent critic's dictum that great art must necessarily be *difficult* art. Pop is Instant Art. . . . Its comprehension can be as immediate as a Crucifixion. Its appeal may be as broad as its range; it is the wide-screen of the Late Show. It is not the Latin of the hierarchy, it is vulgar. . . .

Is Pop love?

R.I.: Pop is love in that it accepts all . . . all the meaner aspects of life, which, for various aesthetic and moral considerations, other schools of painting have rejected or ignored. Everything is possible in Pop. Pop is still pro-art, but surely not art for art's sake. Nor is it any Neo-Dada anti-art manifestation: its participants are not intellectual, social and artistic malcontents with furrowed brows and fur-lined skulls.

Is Pop America?

R.I.: Yes. America is very much at the core of every Pop work. British Pop, the first-born, came about due to the influence of America. The

22. Robert Indiana, *The American Dream, I*, 1961. Oil on canvas, 6 ft. × 60⅛ in. Museum of Modern Art, New York, Larry Aldrich Foundation Fund.

generating issue is Americasm [sic], that phenomenon that is sweeping every continent. French Pop is only slightly Frenchified; Asiatic Pop is sure to come (remember Hong Kong). The pattern will not be far from the Coke, the Car, the Hamburger, the Jukebox. It is the American Myth. For this is the best of all possible worlds.

ROY LICHTENSTEIN (1923-)

What is Pop Art?

R.L.: I don't know—the use of commercial art as subject matter in painting, I suppose. It was hard to get a painting that was despicable enough so that no one would hang it—everybody was hanging everything. . . . The one thing everyone hated was commercial art; apparently they didn't hate that enough either.

Is Pop Art despicable?

R.L.: . . . Well, it *is* an involvement with what I think to be the most brazen and threatening characteristics of our culture, things we hate, but which are also powerful in their impingement on us. I think art since Cézanne has become extremely romantic and unrealistic, feeding on art. . . . It has had less and less to do with the world, it looks inward. . . . Pop Art looks out into the world; it appears to accept its environment, which is not good or bad, but different—another state of mind. . . . There are certain things that are usable, forceful and vital about commercial art. We're using those things— but we're not really advocating stupidity, international teenagerism and terrorism. . . .

Antagonistic critics say that Pop Art does not transform its models. Does it?

R.L.: Transformation is a strange word to use. It implies that art transforms. It doesn't, it just plain forms. . . . I think my work is different from comic strips—but I wouldn't call it transformation; I don't think that whatever is meant by it is important to art. What I do is form, whereas the comic strip is not formed in the sense I'm using the word; the comics have shapes but there has been no effort to make them intensely unified. The purpose is different, one intends to depict and I intend to unify. And my work is actually different from comic strips in that every mark is really in a different place, however slight the difference seems to some. The difference is often not great, but it is crucial. . . .

23. Roy Lichtenstein, *O.K. Hot Shot*, 1963. Oil and magna on canvas, 80 × 68 in. Private collection, Turin. (*Photo: Courtesy Leo Castelli Gallery, New York*)

A curator at the Modern Museum has called Pop Art fascistic and militaristic.

R.L.: The heroes depicted in comic books are fascist types, but I don't take them seriously in these paintings—maybe there is a point in not taking them seriously, a political point. I use them for purely formal reasons, and that's not what those heroes were invented for . . . Pop Art has very immediate and of-the-moment meanings which will vanish—that kind of thing is ephemeral—and Pop takes advantage of this "meaning," which is not supposed to last, to divert you from its formal content. I think the formal statement in my work will become clearer in time. Superficially, Pop seems to be all subject matter, whereas Abstract Expressionism, for example, seems to be all aesthetic. . . .

Is Pop Art American?

R.L.: Everybody has called Pop Art "American" painting, but it's actually industrial painting. America was hit by industrialism and capitalism harder and sooner and its values seem more askew . . . I think the meaning of my work is that it's industrial, it's what all the world will soon become. Europe will be the same way, soon, so it won't be American; it will be universal.

ANDY WARHOL (1928-)

A.W.: Someone said that Brecht wanted everybody to think alike. I want everybody to think alike. But Brecht wanted to do it through Communism, in a way. Russia is doing it under government. It's happening here all by itself. . . . Everybody looks alike and acts alike, and we're getting more and more that way.
I think everybody should be a machine.
I think everybody should like everybody.

Is that what Pop Art is all about?

A.W.: Yes. It's liking things.

And liking things is like being a machine?

A.W.: Yes, because you do the same thing every time. You do it over and over again.

And you approve of that?

A.W.: Yes, because it's all fantasy. It's hard to be creative and it's also hard

not to think what you do is creative or hard not to be called creative be-
cause everybody is always talking about that and individuality. Every-
body's always being creative. And it's so funny when you say things aren't,
like the shoe I would draw for an advertisement was called a "creation" but
the drawing of it was not. But I guess I believe in both ways. . . .

Is Pop Art a fad?

A.W.: Yes, it's a fad, but I don't see what difference it makes. . . . I think
somebody should be able to do all my paintings for me. I haven't been
able to make every image clear and simple and the same as the first one. I
think it would be so great if more people took up silk screens so that no
one would know whether my picture was mine or somebody else's. . . .

Was commercial art more machine-like?

A.W.: No, it wasn't. I was getting paid for it, and did anything they told
me to do. If they told me to draw a shoe, I'd do it, and if they told me to
correct it, I would—I'd do anything they told me to do, correct it and do
it right. I'd have to invent and now I don't; after all that "correction,"
those commercial drawings would have feelings, they would have a style.
The attitude of those who hired me had feeling or something to it; they
knew what they wanted, they insisted; sometimes they got very emotion-
al. The process of doing work in commercial art was machine-like, but the
attitude had feeling to it.

Why did you start painting soup cans?

A.W.: Because I used to drink it. I used to have the same lunch every day,
for twenty years, I guess, the same thing over and over again. . . .

. . . My show in Paris is going to be called "Death in America." I'll show
the electric-chair pictures and the dogs in Birmingham and car wrecks
and some suicide pictures.

Why did you start these "Death" pictures?

A.W.: I believe in it. Did you see the *Enquirer* this week? It had "The
Wreck that Made Cops Cry"—a head cut in half, the arms and hands just
lying there. It's sick, but I'm sure it happens all the time. I've met a lot of
cops recently. They take pictures of everything, only it's almost impossi-
ble to get pictures from them.

When did you start with the "Death" series?

A.W.: I guess it was the big plane crash picture, the front page of a newspa-
per: 129 DIE. I was also painting the *Marilyns*. I realized that everything I
was doing must have been Death. It was Christmas or Labor Day—a holi-
day—and every time you turned on the radio they said something like, "4

24. Andy Warhol, *Car Crash* (or 5 *Deaths 17 Times*), 1963. Silkscreen on canvas, 104 × 82 in. Private collection. (*Photo: Courtesy Leo Castelli Gallery, New York*)

million are going to die." That started it. But when you see a gruesome picture over and over again, it doesn't really have any effect. . . .

Is "Pop" a bad name?

A.W.: The name sounds so awful. Dada must have something to do with Pop—it's so funny, the names are really synonyms. . . . Johns and Rauschenberg—Neo-Dada for all these years, and everyone calling them derivative and unable to transform the things they use—are now called progenitors of Pop. It's funny the way things change. I think John Cage has been very influential, and Merce Cunningham, too, maybe. . . . Who knows? Maybe Jap and Bob were Neo-Dada and aren't any more. History books are being rewritten all the time. It doesn't matter what you do. Everybody just goes on thinking the same thing, and every year it gets more and more alike. Those who talk about individuality the most are the ones who most object to deviation, and in a few years it may be the other way around. Someday everybody will think just what they want to think, and then everybody will probably be thinking alike; that seems to be what is happening.

Excerpted from G. R. Swenson, " 'What Is Pop Art?' Answers from 8 Painters," Part II, *Art News* (February 1964)

JASPER JOHNS (1930-)

What is Pop Art?

J.J.: There has been an attempt to say that those classified under that term use images from the popular representations of things. Isn't that so?

Possibly. But people like Dine and Indiana—even you were included in the exhibitions . . .

J.J.: I'm not a Pop artist! Once a term is set, everybody tries to relate anybody they can to it because there are so few terms in the art world. Labeling is a popular way of dealing with things. . . .

It has been said that the new attitude toward painting is "cool." Is yours?

J.J.: Cool or hot, one way seems just about as good as another. . . . I've taken different attitudes at different times. That allows different kinds of actions. In focusing your eye or your mind, if you focus in one way, your actions will tend to be of one nature; if you focus another way, they will be different. I prefer work that appears to come out of a changing fo-

cus—not just one relationship or even a number of them but constantly changing and shifting relationships to things in terms of focus. Often, however, one is very single-minded and pursues one particular point; often one is blind to the fact that there is another way to see what is there.

Are you aspiring to objectivity?

J.J.: My paintings are not simply expressive gestures. Some of them I have thought of as facts, or at any rate there has been some attempt to say that a thing has a certain nature. Saying that, one hopes to avoid saying I feel this way about this thing; one says this thing is this thing, and one responds to what one thinks is so.

I am concerned with a thing's not being what it was, with its becoming something other than what it is, with any moment in which one identifies a thing precisely and with the slipping away of that moment, with at any moment seeing or saying and letting it go at that.

What would you consider the difference between subject matter and content, between what is depicted and what it means?

J.J.: Meaning implies that something is happening; you can say meaning is determined by the use of the thing, the way an audience uses a painting once it is put in public. When you speak of what is depicted, I tend to think in terms of an intention. But the intention is usually with the artist. "Subject matter"? Where would you focus to determine subject matter?

What a thing is. In your *Device* paintings it would be the ruler.

J.J.: Why do you pick ruler rather than wood or varnish or any other element? What it is—subject matter, then—is simply determined by what you're willing to say it is. What it means is simply a question of what you're willing to let it do.

There is a great deal of intention in painting; it's rather unavoidable. But when a work is let out by the artist and said to be complete, the intention loosens. Then it's subject to all kinds of use and misuse and pun. Occasionally someone will see the work in a way that even changes its significance for the person who made it; the work is no longer "intention," but the thing being seen and someone responding to it. They will see it in a way that makes you think, that is a possible way of seeing it. Then you, as the artist, can enjoy it—that's possible—or you can lament it. If you like, you can try to express the intention more clearly in another work. But what is interesting is anyone having the experiences he has.

Are you talking about the viewer or the artist?

J.J.: I think either. We're not ants or bees; I don't see that we ought to take limited roles in relationship to things. I think one might just as well pre-

tend that he is the center of what he's doing and what his experience is, and that it's only he who can do it.

If you cast a beer can, is that a comment?

J.J.: On what?

On beer cans or society. When you deal with things in the world, social attitudes are connected with them—aren't they?

J.J.: Basically, artists work out of rather stupid kinds of impulses and then the work is done. After that the work is used. In terms of comment, the work probably has it, some aspect which resembles language. Publicly a work becomes not just intention, but the way it is used. If an artist makes something—or if you make chewing gum and everybody ends up using it as glue, whoever made it is given the responsibility of making glue, even if what he really intends is chewing gum. You can't control that kind of thing. As far as beginning to make a work, one can do it for any reason.

If you cast a beer can, you don't have to have a social attitude to beer cans or art?

J.J.: No. It occurs to me you're talking about *my* beer cans, which have a story behind them. I was doing at that time sculptures of small objects—flashlights and light bulbs. Then I heard a story about Willem de Kooning. He was annoyed with my dealer, Leo Castelli, for some reason, and said something like, "That son-of-a-bitch; you could give him two beer cans and he could sell them." I heard this and thought, "What a sculpture—two beer cans." It seemed to me to fit in perfectly with what I was doing, so I did them—and Leo sold them.

Should an artist accept suggestions—or his environment—so easily?

J.J.: I think basically that's a false way of thinking. Accept or reject, where's the ease or the difficulty? I don't put any value on a kind of thinking that puts limits on things. I prefer that the artist does what he does than that, after he's done it, someone says he shouldn't have done it. I would encourage everybody to do more rather than less. I think one has to assume that the artist is free to do what he pleases so that whatever he does is his own business, that he had choices, that he could do something else.

But shouldn't the artist have an attitude to his subject, shouldn't he transform it?

J.J.: Transformation is in the head. If you have one thing and make another thing, there is no transformation, but there are two things. I don't think you would mistake one for another.

. . . Weren't you just saying that art should not be used as a social force?

J.J.: For myself I would choose to be as much as possible outside that area. It's difficult because we are constantly faced with social situations and our work is being used in ways we didn't ask for it to be used. We see it being done. We're not idiots.

Then is it being misused in a social situation?

J.J. My point of view tends to be that work is being misused in *most* situations. Nevertheless I find it a very interesting possibility, that one can't control the situation, the way one's work is viewed, that once one offers it to be seen then anybody is able to see it as he pleases.

TOM WESSELMANN (1931-1981)

What is Pop Art?

T.W.: I dislike labels in general and Pop in particular, especially because it over-emphasizes the material used. There does seem to be a tendency to use similar materials and images, but the different ways they are used denies any kind of group intention. . . .

What is the purpose of juxtaposing different kinds of representations?

T.W.: If there was any single aspect of my work that excited me, it was that possibility—not just the differences between what they were, but the aura each had with it. They each had such a fulfilled reality; the reverberations seemed a way of making the picture more intense. A painted pack of cigarettes next to a painted apple wasn't enough for me. They are both the same kind of thing. But if one is from a cigarette ad and the other a painted apple, they are two different realities and they trade on each other; lots of things—bright strong colors, the qualities of materials, images from art history or advertising—trade on each other. This kind of relationship helps establish a momentum throughout the picture—all the elements are in some way very intense. . . .

 Some of the worst things I've read about Pop Art have come from its admirers. They begin to sound like some nostalgia cult—they really worship Marilyn Monroe or Coca-Cola. The importance people attach to things the artist uses is irrelevant. My use of elements from advertising came about gradually. One day I used a tiny bottle picture on a table in one of my little nude collages. It was a logical extension of what I was doing. I use a billboard picture because it is a real, special representation

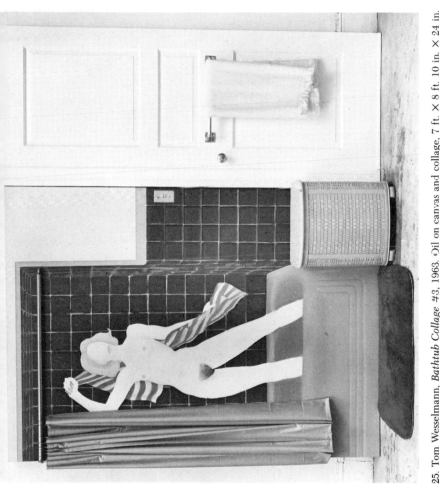

25. Tom Wesselmann, *Bathtub Collage #3*, 1963. Oil on canvas and collage, 7 ft. × 8 ft. 10 in. × 24 in. Museum Ludwig, Cologne. Courtesy Sidney Janis Gallery, New York.

of something, not because it is from a billboard. Advertising images excite me mainly because of what I can make from them. Also I use real objects because I need to use objects, not because objects need to be used. But the objects remain part of a painting because I don't make environments. My rug is not to be walked on. . . .

What influences have you felt in your work from, say, Dada?

T.W.: When I first came across it, I respected it and thought it was pretty good; but it didn't have anything to do with me. As my work began to evolve I realized—not consciously, it was like a surprise—that maybe it had something to do with my work.

It was the same with Rauschenberg. When I saw his painting with the radios in it I thought it was fine, O.K., but it had no effect on me. It ceased to exist for me except in Rauschenberg's world. Much later I got interested in the addition of movement to painting, so a part of the painting was attached to a motor. An interest in using light and sound followed—I put in a television. But not only for the television image—who cares about television images?—but because I cared about the dimension it gave to painting, something that moved, and gave off light and sound. I used a radio and when I did I felt as if I were the first who'd ever used a radio. It's not that I think of that as an accomplishment—it's just that Rauschenberg didn't seem an immediate factor in it. He was, of course; his use of objects in paintings made it somehow legitimate; but I used a radio for my own reasons. . . .

Do you mean that collage materials permit you to use an image and still be neutral toward the object represented?

T.W.: I think painting is essentially the same as it has always been. It confuses me that people expect Pop Art to make a comment or say that its adherents merely accept their environment. I've viewed most of the paintings I've loved—Mondrians, Matisses, Pollocks—as being rather dead-pan in that sense. All painting is fact, and that is enough; the paintings are charged with their very presence. The situation, physical ideas, physical presence—I feel that is the comment.

JAMES ROSENQUIST (1933-)

J.R.: I think critics are hot blooded. They don't take very much time to analyze what's in the painting. . . .

I have some reasons for using commercial images that these people

probably haven't thought about. If I use anonymous images—it's true my images have not been hot blooded images—they've been anonymous images of recent history. In 1960 and 1961 I painted the front of a 1950 Ford. I felt it was an anonymous image. I wasn't angry about that, and it wasn't a nostalgic image either. Just an image. I use images from old magazines—when I say old, I mean 1945 to 1955—a time we haven't started to ferret out as history yet. If it was the front end of a new car there would be people who would be passionate about it, and the front end of an old car might make some people nostalgic. The images are like no-images. There is a freedom there. If it were abstract, people might make it into something. If you paint Franco-American spaghetti, they won't make a crucifixion out of it, and also who could be nostalgic about canned spaghetti? They'll bring their reactions but, probably, they won't have as many irrelevant ones. . . .

The images are now, already, on the canvas and the time I painted it is on the canvas. That will always be seen. That time span, people will look at it and say, "Why did he paint a '50 Ford in 1960, why didn't he paint a '60 Ford?" . . . The immediacy may be lost in a hundred years, but don't forget that by that time it will be like collecting a stamp. . . . If it bothers to stand up—I don't know—it will belong to a stamp collector, it will have nostalgia then. But still that time reference will mean something. . . .

As time goes by the brutality of what art is, the idea of what art can be, changes; different feelings about things become at home, become accepted, natural. . . . [Brutality is] a new vision or method to express something, its value geared right to the present time. . . .

When I was a student, I explored paint quality. Then I started working, doing commercial painting and I got all of the paint quality I ever wanted. I had paint running down to my armpits. . . .

I'm amazed and excited and fascinated about the way things are thrust at us, the way this invisible screen that's a couple of feet in front of our mind and our senses is attacked by radio and television and visual communications, through things larger than life, the impact of things thrown at us, at such a speed and with such a force that painting and the attitudes toward painting and communication through doing a painting now seem very old fashioned. . . .

When I use a combination of fragments of things, the fragments or objects or real things are caustic to one another, and the title is also caustic to the fragments. . . .

I treat the billboard image as it is, so apart from nature. I paint it as a reproduction of other things; I try to get as far away from the nature as possible. . . .

When I first started thinking like this, feeling like this, from my outdoor painting, painting commercial advertising, I would bring home col-

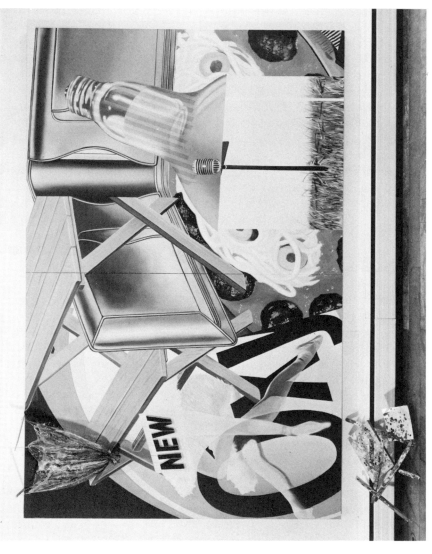

26. James Rosenquist, *Nomad*, 1963. Oil on canvas, plastic paint, wood, 84 × 210 in. Albright-Knox Art Gallery, Buffalo, N.Y. Gift of Seymour H. Knox.

ors that I liked, associations that I liked using in my abstract painting, and I would remember specifics by saying this was a dirty bacon tan, this was a yellow T-shirt yellow, this was a Man-Tan suntan orange and—I always remember Franco-American spaghetti orange, I can't forget it—so I felt it as a remembrance of things, like a color chart, like learning an alphabet. Other people talk about painting nothing. You just can't do it. I paint something as detached as I can and as well as I can; then I have one image, that's it. But in a sense the image is expendable; I have to keep the image so that the thing doesn't become an attempt at a grand illusion, an elegance. . . .

If I use a lamp or a chair, that isn't the subject, it isn't the subject matter. The relationships may be the subject matter, the relationships of the fragments I do. The content will be something more, gained from the relationships. If I have three things, their relationship will be the subject matter; but the content will, hopefully, be fatter, balloon to more than the subject matter. One thing, though, the subject matter isn't popular images, it isn't that at all.

CLAES OLDENBURG (1929-)

Like Lichtenstein, Warhol, Dine, et al., Oldenburg had had one-man exhibitions of his work prior to the early Pop group shows. On December 1, 1961, Oldenburg opened "The Store" at 107 East 2nd Street, New York. In the back rooms he prepared his plaster over chicken wire, enamel-painted pies, hamburgers, dresses, shirts, and so on, which he displayed and sold up front. The previous summer, a few of his plaster commodities had been included in the Martha Jackson Gallery *Environments, Situations, Spaces* show, in the catalogue of which a section from his famous "I am for an art . . ." appeared. Its kinship with Kaprow's Pollock piece cited above did not escape Oldenburg's notice; in fact, he called my attention to Kaprow's essay. However, he had comparable ideas at the same time, expressed in poetry, prose, sketches, paintings, and sculpture. No critic has explicated Oldenburg's work so lucidly, nor in such vivid language, rich in metaphor, as the artist himself in his several books, exhibition catalogues, essays, interviews, published and unpublished studio notes and diaries.°

°See the bibliographies in Barbara Rose, *Claes Oldenburg*, New York: Museum of Modern Art, 1970, and *Claes Oldenburg: Teckningar, akvareller och grafik/Drawings, watercolors and prints*, Stockholm: Moderna Museet, 1977 (also published in Dutch and English, and in French for showings at the Stedelijk, Amsterdam, and Beaubourg, Paris, respectively).

★ ★ ★

Claes Oldenburg, "I am for an art . . .," from *Store Days, Documents from the Store (1961) and Ray Gun Theater (1962),* selected by Claes Oldenburg and Emmett Williams, New York, 1967. Copyright Claes Oldenburg

I am for an art that is political-erotical-mystical, that does something other than sit on its ass in a museum.

I am for an art that grows up not knowing it is art at all, an art given the chance of having a starting point of zero.

I am for an art that embroils itself with the everyday crap & still comes out on top.

I am for an art that imitates the human, that is comic, if necessary, or violent, or whatever is necessary.

I am for an art that takes its form from the lines of life itself, that twists and extends and accumulates and spits and drips, and is heavy and coarse and blunt and sweet and stupid as life itself.

I am for an artist who vanishes, turning up in a white cap painting signs or hallways.

I am for art that comes out of a chimney like black hair and scatters in the sky.

I am for art that spills out of an old man's purse when he is bounced off a passing fender.

I am for the art out of a doggy's mouth, falling five stories from the roof.

I am for the art that a kid licks, after peeling away the wrapper.

I am for an art that joggles like everyones knees, when the bus traverses an excavation.

I am for art that is smoked, like a cigarette, smells, like a pair of shoes.

I am for art that flaps like a flag, or helps blow noses, like a handkerchief.

I am for art that is put on and taken off, like pants, which develops holes, like socks, which is eaten, like a piece of pie, or abandoned with great contempt, like a piece of shit.

I am for art covered with bandages. I am for art that limps and rolls and runs and jumps. I am for art that comes in a can or washes up on the shore.

I am for art that coils and grunts like a wrestler. I am for art that sheds hair.

I am for art you can sit on. I am for art you can pick your nose with or stub your toes on.

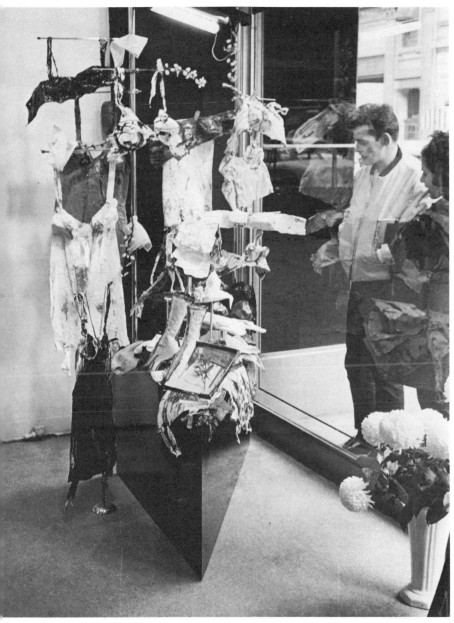

27. Claes Oldenburg, *Lingerie Counter*, 1962 (Ludwig Museum) in window of *New Realist* exhibition, Sidney Janis Gallery, 1962. (*Photo: Ellen H. Johnson*)

I am for art from a pocket, from deep channels of the ear, from the edge of a knife, from the corners of the mouth, stuck in the eye or worn on the wrist.

I am for art under the skirts, and the art of pinching cockroaches.

I am for the art of conversation between the sidewalk and a blind mans metal stick.

I am for the art that grows in a pot, that comes down out of the skies at night, like lightning, that hides in the clouds and growls. I am for art that is flipped on and off with a switch.

I am for art that unfolds like a map, that you can squeeze, like your sweetys arm, or kiss, like a pet dog. Which expands and squeaks, like an accordion, which you can spill your dinner on, like an old tablecloth.

I am for an art that you can hammer with, stitch with, sew with, paste with, file with.

I am for an art that tells you the time of day, or where such and such a street is.

I am for an art that helps old ladies across the street.

I am for the art of the washing machine. I am for the art of a government check. I am for the art of last wars raincoat.

I am for the art that comes up in fogs from sewer-holes in winter. I am for the art that splits when you step on a frozen puddle. I am for the worms art inside the apple. I am for the art of sweat that develops between crossed legs.

I am for the art of neck-hair and caked tea-cups, for the art between the tines of restaurant forks, for the odor of boiling dishwater.

I am for the art of sailing on Sunday, and the art of red and white gasoline pumps.

I am for the art of bright blue factory columns and blinking biscuit signs.

I am for the art of cheap plaster and enamel. I am for the art of worn marble and smashed slate. I am for the art of rolling cobblestones and sliding sand. I am for the art of slag and black coal. I am for the art of dead birds.

I am for the art of scratchings in the asphalt, daubing at the walls. I am for the art of bending and kicking metal and breaking glass, and pulling at things to make them fall down.

I am for the art of punching and skinned knees and sat-on bananas. I am for the art of kids' smells. I am for the art of mama-babble.

I am for the art of bar-babble, tooth-picking, beer-drinking, egg-salting, in-sulting. I am for the art of falling off a barstool.

I am for the art of underwear and the art of taxicabs. I am for the art of ice-cream cones dropped on concrete. I am for the majestic art of dog-turds, rising like cathedrals.

I am for the blinking arts, lighting up the night. I am for art falling, splashing, wiggling, jumping, going on and off.

I am for the art of fat truck-tires and black eyes.

I am for Kool-art, 7-UP art, Pepsi-art, Sunshine art, 39 cents art, 15 cents art, Vatronol art, Dro-bomb art, Vam art, Menthol art, L&M art, Exlax art, Venida art, Heaven Hill art, Pamryl art, San-o-med art, Rx art, 9.99 art, Now art, New art, How art, Fire sale art, Last Chance art, Only art, Diamond art, Tomorrow art, Franks art, Ducks art, Meat-o-rama art.

I am for the art of bread wet by rain. I am for the rats' dance between floors. I am for the art of flies walking on a slick pear in the electric light. I am for the art of soggy onions and firm green shoots. I am for the art of clicking among the nuts when the roaches come and go. I am for the brown sad art of rotting apples.

I am for the art of meowls and clatter of cats and for the art of their dumb electric eyes.

I am for the white art of refrigerators and their muscular openings and closings.

I am for the art of rust and mold. I am for the art of hearts, funeral hearts or sweetheart hearts, full of nougat. I am for the art of worn meat-hooks and singing barrels of red, white, blue and yellow meat.

I am for the art of things lost or thrown away, coming home from school. I am for the art of cock-and-ball trees and flying cows and the noise of rectangles and squares. I am for the art of crayons and weak grey pencil-lead, and grainy wash and sticky oil paint, and the art of wind-shield wipers and the art of the finger on a cold window, on dusty steel or in the bubbles on the sides of a bathtub.

I am for the art of teddy-bears and guns and decapitated rabbits, ex-ploded umbrellas, raped beds, chairs with their brown bones broken, burning trees, firecracker ends, chicken bones, pigeon bones and boxes with men sleeping in them.

I am for the art of slightly rotten funeral flowers, hung bloody rabbits and wrinkly yellow chickens, bass drums & tambourines, and plastic pho-nographs.

I am for the art of abandoned boxes, tied like pharaohs. I am for an art of watertanks and speeding clouds and flapping shades.

I am for U.S. Government Inspected Art, Grade A art, Regular Price

art, Yellow Ripe art, Extra Fancy art, Ready-to-eat art, Best-for-less art, Ready-to-cook art, Fully cleaned art, Spend Less art, Eat Better art, Ham art, pork art, chicken art, tomato art, banana art, apple art, turkey art, cake art, cookie art.

ROY LICHTENSTEIN (1923-)

Lichtenstein's unpublished statement about Pop art dates from the same time as Gene Swenson's interviews. In crisp, straightforward language, the most classic of the Pop artists presents an art-historically informed and illuminating analysis of the (then) so disturbingly new art idiom and its implications.

★　★　★

Talk given at College Art Association annual meeting, Philadelphia, January 1964

Although there was never an attempt on the part of Pop artists to form a movement (in fact in 1961 very few of these artists knew each other or were familiar with each other's work), there does seem to have been some critical point demanding expression which brought us to depart from whatever directions we were pursuing and to move toward some comment involving the commercial aspect of our environment.

There are many ways of looking at a phenomenon, of course, particularly a phenomenon as amorphous as an art movement, and there are many levels on which it can be discussed. I'm not sure an artist would have any more insight, that he could express in words, than a critic or an historian. But let me discuss one aspect that comes to my mind.

Aside from all of the influences which one can think of, and I have in mind movements and actual art products such as the three-dimensional Absinthe-Glass of Picasso, the Purist painting of Ozenfant and Le Corbusier, the use of actual common objects in collage, the Dada movement, the paintings of Stuart Davis, the paintings of Léger, the beer cans, targets and flags of Jasper Johns, the collages of Rauschenberg, the use of American objects in the happenings of Kaprow, Oldenburg, Dine, Whitman, Samaras and others. Aside from all these decided influences, and influences they were—particularly the happenings and environments, since both Oldenburg and Dine proceeded directly from happenings to Pop Art—it is at another level that I wish to describe the emergence of Pop Art.

Pop may be seen as a product of two twentieth century tendencies: one

from the outside—the subject matter; and the other from within—an esthetic sensibility. The subject matter, of course, is commercialism and commercial art; but its contribution is the isolation and glorification of "Thing." Commercial art is not our art, it is our subject matter and in that sense it is nature; but it is considered completely at odds with the major direction of art during and since the Renaissance and particularly at odds with our directly preceding movement—Abstract Expressionism. Commercial art runs contrary to a major art current in the sense that it concentrates on *thing* rather than *environment;* on *figure* rather than *ground.*

The esthetic sensibility to which I refer is anti-sensibility—*apparent* anti-sensibility. Anti-sensibility obviously is at odds with such concurrent and friendlier attitudes as contemplation, nuance, mystery and Zen, etc. Historical examples of anti-sensibility art—even recent examples—are hard to point to. The anti-sensibility façade fades and the sensibilities prevail. But if we can remember our first confrontation with certain modern works, the newer work seems cheapened, insensitive, brash and barbarous. It is not the rougher paint handling I refer to, but apparent lack of nuance and adjustment: for instance, our first look at *Les Demoiselles d'Avignon* of Picasso, or our first look at Mondrian or Pollock, or if we compare a Cubist collage or a Franz Kline with almost any old master painting. Compare a Daumier with a Botticelli. Courbet's audience saw him as brash and artless in the mid-nineteenth century and Van Gogh and the Fauves of course were seen in this light. But the modern works referred to here are not primarily anti-sensibility art—they represent many other qualities; but they do contain a bit of this element which is more strongly represented in Pop Art.

But works of art cannot really be the product of blunted sensibilities—it is only a style or posture. It is, however, the real quality of our subject matter—the particular awkward, bizarre and expedient commercial art styles which Pop Art refers to and amplifies. Since works of art cannot really be the product of blunted sensibilities, what seems at first to be brash and barbarous turns in time to daring and strength, and the concealed subtleties soon become apparent.

Anti-sensibility is the stance most characteristic, I think, of recent art in the sense that it is most unlike the Renaissance tendencies of transition, logical unfolding, purposeful nuance, and elegance. Although the anti-sensibilities stance appears as mindless, mechanical, gross and abrupt or as directed by prior or non-art decisions, its real meaning, I feel, lies in the artist's personal sensation of performing a difficult feat of bravado while really respecting all of the sensibilities. This is its meaning if it is successful—in Pop Art or any other style.

It may also have other meanings: Brassy courage, competition with the

visual objects of modern life, naive American freshness, and so on.

In a strained analogous way perhaps we can see the twentieth century tendency toward anti-sensibility in art joining the readymade real insensibility of our commercial environment to form Pop Art.

6

Minimal Art

DONALD JUDD (1928-)

Excerpted from Donald Judd, "Specific Objects," *Arts Yearbook 8* (1965)

Judd's "Specific Objects" was the first major article by one of the origi-
nators of "minimalism" describing the kind of work soon to be given
that name. His bare fact prose, so appropriate to the work in question,
was familiar to readers of *Arts magazine*, for which he regularly wrote
reviews from 1959 to 1965.° "Specific Objects" appeared only a few
months before the ground-breaking exhibition *Primary Structures:
Younger American and British Sculptors* at the Jewish Museum, New
York, of April–June 1966. Kynaston McShine's title for the kind of
work he brought together as an emerging movement was less appealing
than the more negative-sounding "minimal art" to the art public, by
whom and for whom new directions are labeled.

The first illustration in Judd's article was Oldenburg's *Soft Light
Switches*, 1964, thereby underlining a fact that every serious contem-
porary art student should recognize: Pop and minimal art have many
elements in common, especially the powerful reduction, the oneness,
the inherent, monumental style, and the use of new materials, embrac-
ing factory production.

★ ★ ★

Half or more of the best new work in the last few years has been nei-
ther painting nor sculpture. Usually it has been related, closely or distant-
ly, to one or the other. The work is diverse, and much in it that is not in
painting and sculpture is also diverse. But there are some things that oc-
cur nearly in common. . . .

The objections to painting and sculpture are going to sound more intol-
erant than they are. There are qualifications. The disinterest in painting
and sculpture is a disinterest in doing it again, not in it as it is being done
by those who developed the last advanced versions. . . .

The main thing wrong with painting is that it is a rectangular plane
placed flat against the wall. A rectangle is a shape itself; it is obviously the

°See Donald Judd, *Complete Writings, 1959–1975.* Halifax: Nova Scotia College of Art,
and New York: New York University Press, 1976.

whole shape; it determines and limits the arrangement of whatever is on or inside of it. . . .

Most sculpture is made part by part, by addition, composed. The main parts remain fairly discrete. They and the small parts are a collection of variations, slight through great. There are hierarchies of clarity and strength and of proximity to one or two main ideas. . . .

There is little of any of this in the new three-dimensional work. So far the most obvious difference within this diverse work is between that which is something of an object, a single thing, and that which is open and extended, more or less environmental. There isn't as great a difference in their nature as in their appearance, though. Oldenburg and others have done both. There are precedents for some of the characteristics of the new work. The parts are usually subordinate and not separate in Arp's sculpture and often in Brancusi's. Duchamp's Ready-mades and other Dada objects are also seen at once and not part by part. . . . Duchamp's bottle-drying rack is close to some of it [the new work]. The work of Johns and Rauschenberg and assemblage and low-relief generally, Ortman's reliefs for example, are preliminaries. Johns's few cast objects and a few of Rauschenberg's works, such as the goat with the tire, are beginnings. . . .

Painting and sculpture have become set forms. . . . The use of three dimensions isn't the use of a given form. There hasn't been enough time and work to see limits. So far, considered most widely, three dimensions are mostly a space to move into. The characteristics of three dimensions are those of only a small amount of work, little compared to painting and sculpture. . . . Since its range is so wide, three-dimensional work will probably divide into a number of forms. At any rate, it will be larger than painting and much larger than sculpture, which, compared to painting, is fairly particular, much nearer to what is usually called a form, having a certain kind of form. Because the nature of three dimensions isn't set, given beforehand, something credible can be made, almost anything. Of course something can be done within a given form, such as painting, but with some narrowness and less strength and variation. Since sculpture isn't so general a form, it can probably be only what it is now—which means that if it changes a great deal it will be something else; so it is finished.

Three dimensions are real space. That gets rid of the problem of illusionism and of literal space, space in and around marks and colors—which is riddance of one of the salient and most objectionable relics of European art. The several limits of painting are no longer present. A work can be as powerful as it can be thought to be. Actual space is intrinsically more powerful and specific than paint on a flat surface. Obviously, anything in three dimensions can be any shape, regular or irregular, and can have any relation to the wall, floor, ceiling, room, rooms or exterior or none at all. Any material can be used, as is or painted.

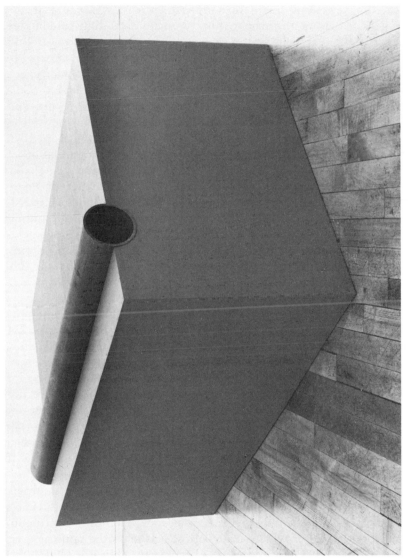

28. Donald Judd, *Untitled*, 1963. Light cadmium red oil on wood and iron pipe, 19½ × 45 × 30½ in. Collection Philip Johnson.

A work needs only to be interesting. Most works finally have one quality. In earlier art the complexity was displayed and built the quality. In recent painting the complexity was in the format and the few main shapes, which had been made according to various interests and problems. A painting by Newman is finally no simpler than one by Cézanne. In the three-dimensional work the whole thing is made according to complex purposes, and these are not scattered but asserted by one form. It isn't necessary for a work to have a lot of things to look at, to compare, to analyze one by one, to contemplate. The thing as a whole, its quality as a whole, is what is interesting. The main things are not diluted by an inherited format, variations of a form, mild contrasts and connecting parts and areas. European art had to represent a space and its contents as well as have sufficient unity and aesthetic interest. Abstract painting before 1946 and most subsequent painting kept the representational subordination of the whole to its parts. Sculpture still does. In the new work the shape, image, color and surface are single and not partial and scattered. There aren't any neutral or moderate areas or parts, any connections or transitional areas. The difference between the new work and earlier painting and present sculpture is like that between one of Brunelleschi's windows in the Badia di Fiesole and the façade of Palazzo Rucellai, which is only an undeveloped rectangle as a whole and is mainly a collection of highly ordered parts.

The use of three dimensions makes it possible to use all sorts of materials and colors. Most of the work involves new materials, either recent inventions or things not used before in art. Little was done until lately with the wide range of industrial products. Almost nothing has been done with industrial techniques and, because of the cost, probably won't be for some time. Art could be mass-produced, and possibilities otherwise unavailable, such as stamping, could be used. Dan Flavin, who uses fluorescent lights, has appropriated the results of industrial production. Materials vary greatly and are simply materials—formica, aluminum, cold-rolled steel, Plexiglas, red and common brass, and so forth. They are specific. If they are used directly, they are more specific. Also, they are usually aggressive. There is an objectivity to the obdurate identity of a material. Also, of course, the qualities of materials—hard mass, soft mass, thickness of $\frac{1}{32}$, $\frac{1}{16}$, $\frac{1}{8}$ inch, pliability, slickness, translucency, dullness—have unobjective uses. The vinyl of Oldenburg's soft objects looks the same as ever, slick, flaccid and a little disagreeable, and is objective, but it is pliable and can be sewn and stuffed with air and kapok and hung or set down, sagging or collapsing. Most of the new materials are not as accessible as oil on canvas and are hard to relate to one another. They aren't obviously art. The form of a work and its materials are closely related. In earlier work

the structure and the imagery were executed in some neutral and homo-geneous material. Since not many things are lumps, there are problems in combining the different surfaces and colors and in relating the parts so as not to weaken the unity.

Three-dimensional work usually doesn't involve ordinary anthropo-morphic imagery. If there is a reference it is single and explicit. In any case the chief interests are obvious. Each of Bontecou's reliefs is an image. The image, all of the parts and the whole shape are coextensive. The parts are either part of the hole or part of the mound which forms the hole. The hole and the mound are only two things, which, after all, are the same thing. The parts and divisions are either radial or concentric in re-gard to the hole, leading in and out and enclosing. The radial and concen-tric parts meet more or less at right angles and in detail are structure in the old sense, but collectively are subordinate to the single form. Most of the new work has no structure in the usual sense, especially the work of Oldenburg and Stella. Chamberlain's work does involve composition. The nature of Bontecou's single image is not so different from that of images which occurred in a small way in semi-abstract painting. The image is primarily a single emotive one, which alone wouldn't resemble the old imagery so much, but to which internal and external references, such as violence and war, have been added. The additions are somewhat pictorial, but the image is essentially new and surprising; an image has never before been the whole work, been so large, been so explicit and aggressive. The abatised orifice is like a strange and dangerous object. The quality is in-tense and narrow and obsessive. The boat and the furniture that Kusama covered with white protuberances have a related intensity and obsessive-ness and are also strange objects. Kusama is interested in obsessive repeti-tion, which is a single interest. Yves Klein's blue paintings are also narrow and intense.

The trees, figures, food or furniture in a painting have a shape or con-tain shapes that are emotive. Oldenburg has taken this anthropomorphism to an extreme and made the emotive form, with him basic and biopsycho-logical, the same as the shape of an object, and by blatancy subverted the idea of the natural presence of human qualities in all things. And further, Oldenburg avoids trees and people. All of Oldenburg's grossly anthro-pomorphized objects are man made—which right away is an empirical matter. Someone or many made these things and incorporated their pref-erences. As practical as an ice-cream cone is, a lot of people made a choice, and more agreed, as to its appearance and existence. This interest shows more in the recent appliances and fixtures from the home and espe-cially in the bedroom suite, where the choice is flagrant. Oldenburg exag-gerates the accepted or chosen form and turns it into one of his own. Nothing made is completely objective, purely practical or merely present.

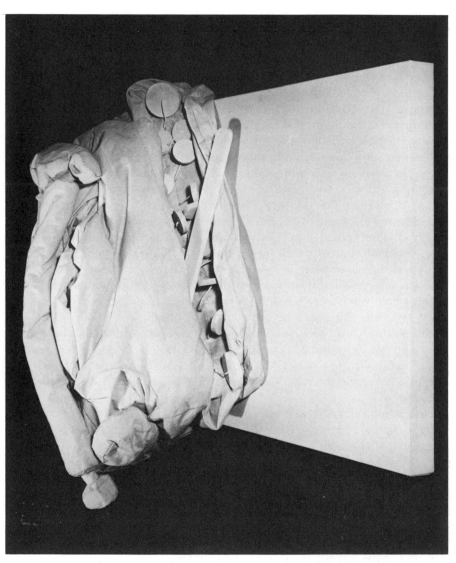

29. Claes Oldenburg, *Soft Typewriter (Model "Ghost" Typewriter)*, 1963. Cloth, kapok, wood, 27½ × 26

Oldenburg gets along very well without anything that would ordinarily be called structure. The ball and cone of the large ice-cream cone are enough. The whole thing is a profound form, such as sometimes occurs in primitive art. Three fat layers with a small one on top are enough. So is a flaccid, flamingo switch draped from two points. Simple form and one or two colors are considered less by old standards. If changes in art are compared backwards, there always seems to be a reduction, since only old attributes are counted and these are always fewer. But obviously new things are more, such as Oldenburg's techniques and materials. Oldenburg needs three dimensions in order to simulate and enlarge a real object and to equate it and an emotive form. If a hamburger were painted it would retain something of the traditional anthropomorphism. George Brecht and Robert Morris use real objects and depend on the viewer's knowledge of these objects.

The composition and imagery of Chamberlain's work is primarily the same as that of earlier painting, but these are secondary to an appearance of disorder and are at first concealed by the material. The crumpled tin tends to stay that way. It is neutral at first, not artistic, and later seems objective. When the structure and imagery become apparent, there seems to be too much tin and space, more chance and casualness than order. The aspects of neutrality, redundancy and form and imagery could not be coextensive without three dimensions and without the particular material. The color is also both neutral and sensitive and, unlike oil colors, has a wide range. Most color that is integral, other than in painting, has been used in three-dimensional work. Color is never unimportant, as it usually is in sculpture.

Stella's shaped paintings involve several important characteristics of three-dimensional work. The periphery of a piece and the lines inside correspond. The stripes are nowhere near being discrete parts. The surface is farther from the wall than usual, though it remains parallel to it. Since the surface is exceptionally unified and involves little or no space, the parallel plane is unusually distinct. The order is not rationalistic and underlying but is simply order, like that of continuity, one thing after another. A painting isn't an image. The shapes, the unity, projection, order and color are specific, aggressive and powerful.

ROBERT MORRIS (1931-)

A lucid though brief characterization of minimal art by Robert Morris (1931-), one of its founding fathers, appears below under Process Art in his "Anti Form" article. He analyzes minimalism further in compar-

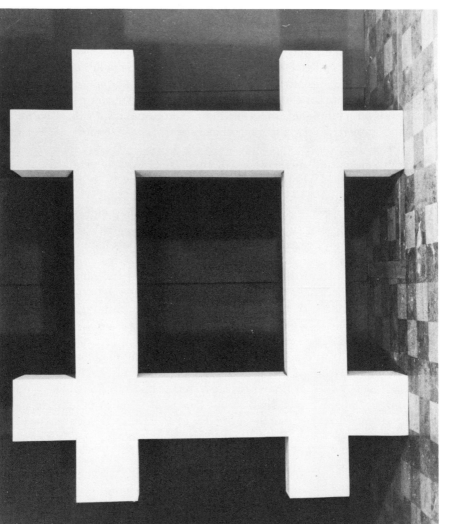

30. Robert Morris. *Barrier* 1962. Plywood 72 in. high. Destroyed. (Photo: Courtesy Leo Castelli Gallery, New York)

ing it with the later work presented in his essay, "The Present Tense of Space" (in the Site and Architectural Sculpture section). In his earlier statement of the minimal aesthetic ("Notes on Sculpture," *Artforum* [February 1966], he had explained the gestalt character of "unitary forms," a concept quickly taken up by art faculties and students across the country. Educated, as has been the wont with many of our artists, more in liberal arts than in professional art schools, at home with philosophical concepts, literature, and art history (his M.A. thesis was on Brancusi), Morris was a compelling spokesman and theoretician of several new art forms during the sixties and seventies.

FRANK STELLA (1936-) / DONALD JUDD (1928-)

This interview by Glaser was broadcast on WBAI-FM Radio station in February 1964; the published text incorporates later statements by Don Judd. Dan Flavin took part in the program, but he spoke little, which perhaps explains why his remarks were not included.

Frank Stella's declaration, "My painting is based on the fact that only what can be seen there *is* there," is a cornerstone of the minimalist doctrine. Equally important is Judd's insistence on abolishing compositional arrangement of relational parts.

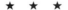

Excerpted from Bruce Glaser, "Questions to Stella and Judd," edited by Lucy R. Lippard, *Art News* (September 1966)

STELLA: . . . When I first showed, Coates in *The New Yorker* said how sad it was to find somebody so young right back where Mondrian was thirty years ago. And I really didn't feel that way.

GLASER: You feel there's no connection between you and Mondrian?

STELLA: There are obvious connections. You're always related to something. I'm related to the more geometric, or simpler, painting, but the motivation doesn't have anything to do with that kind of European geometric painting. I think the obvious comparison with my work should be Vasarely, and I can't think of anything I like less. . . .

JUDD: There's an enormous break between that work and other present work in the U.S., despite similarity in patterns or anything. The scale itself is just one thing to pin down. Vasarely's work has a smaller scale and a great deal of composition and qualities that European geometric paint-

ing of the twenties and thirties had. He is part of a continuous development from the thirties, and he was doing it himself then.

STELLA: The other thing is that the European geometric painters really strive for what I call relational painting. The basis of their whole idea is balance. You do something in one corner and you balance it with something in the other corner. Now the "new painting" is being characterized as symmetrical. Ken Noland has put things in the center and I'll use a symmetrical pattern, but we use symmetry in a different way. It's non-relational. In the newer American painting we strive to get the thing in the middle, and symmetrical, but just to get a kind of force, just to get the thing on the canvas. The balance factor isn't important. We're not trying to jockey everything around.

GLASER: What is the "thing" you're getting on the canvas?

STELLA: I guess you'd have to describe it as the image, either the image or the scheme. Ken Noland would use concentric circles; he'd want to get them in the middle because it's the easiest way to get them there, and he wants them there in the front, on the surface of the canvas. If you're that much involved with the surface of anything, you're bound to find symmetry the most natural means. As soon as you use any kind of relational placement for symmetry, you get into a terrible kind of fussiness which is the one thing that most of the painters now want to avoid. When you're always making these delicate balances, it seems to present too many problems; it becomes a sort of arch. . . .

GLASER: Why do you want to avoid compositional effects?

JUDD: Well, those effects tend to carry with them all the structures, values, feelings of the whole European tradition. It suits me fine if that's all down the drain. . . .

Vasarely's composition has the effect of order and quality that traditional European painting had, which I find pretty objectionable. . . . The objection is not that Vasarely's busy, but that in his multiplicity there's a certain structure which has qualities I don't like.

GLASER: What qualities?

JUDD: The qualities of European art so far. They're innumerable and complex, but the main way of saying it is that they're linked up with a philosophy—rationalism, rationalistic philosophy.

GLASER: Descartes?

JUDD: Yes.

GLASER: And you mean to say that your work is apart from rationalism?

JUDD: Yes. All that art is based on systems built beforehand, *a priori* systems; they express a certain type of thinking and logic which is pretty much discredited now as a way of finding out what the world's like.

GLASER: Discredited by whom? By empiricists?

JUDD: Scientists, both philosophers and scientists.

GLASER: What is the alternative to a rationalistic system in your method? It's often said that your work is preconceived, that you plan it out before you do it. Isn't that a rationalistic method?

JUDD: Not necessarily. That's much smaller. When you think it out as you work on it, or you think it out beforehand, it's a much smaller problem than the nature of the work. *What* you want to express is a much bigger thing than *how* you may go at it. . . .

GLASER: Could you be specific about how your own work reflects an anti-rationalistic point of view?

JUDD: The parts are unrelational.
. . . When you start relating parts, in the first place, you're assuming you have a vague whole—the rectangle of the canvas—and definite parts, which is all screwed up, because you should have a definite *whole* and maybe no parts, or very few. The parts are always more important than the whole.

GLASER: And you want the whole to be more important than the parts?

JUDD: Yes. The whole's it. The big problem is to maintain the sense of the whole thing.
. . . And that's not especially unusual. Painting's been going toward that for a long time. A lot of people, like Oldenburg for instance, have a "whole" effect to their work.

STELLA: But we're all still left with structural or compositional elements. The problems aren't any different. I still have to compose a picture, and if you make an object you have to organize the structure. I don't think our work is that radical in any sense because you don't find any really new compositional or structural element. I don't know if that exists. It's like the idea of a color you haven't seen before. Does something exist that's as radical as a diagonal that's not a diagonal? Or a straight line or a compositional element that you can't describe?

GLASER: So even your effort, Don, to get away from European art and its traditional compositional effects, is somewhat limited because you're still going to be using the same basic elements that they used.

JUDD: No, I don't think so. I'm totally uninterested in European art and I think it's over with. It's not so much the elements we use that are new as their context. For example, they might have used a diagonal, but no one there ever used as direct a diagonal as Morris Louis did.

STELLA: Look at all the Kandinskys, even the mechanical ones. They're sort of awful, but they have some pretty radical diagonals and stuff. Of course, they're always balanced.

JUDD: When you make a diagonal clear across the whole surface, it's a very different thing.

STELLA: But none the less, the idea of the diagonal has been around for a long time.

JUDD: That's true; there's always going to be something in one's work that's been around for a long time, but the fact that compositional arrangement isn't important is rather new.

. . . Twentieth-century painting has been concerned mainly with emphasizing the artist's presence in the work, often with an unfinished quality by which one can participate in the experience of the artist, the process of painting the picture. You deny all this, too; your work has an industrial look, a non-man-made look.

STELLA: The artist's tools or the traditional artist's brush and maybe even oil paint are all disappearing very quickly. We use mostly commercial paint, and we generally tend toward larger brushes. In a way, Abstract Expressionism started all this.

. . . What happened, at least for me, is that when I first started painting I would see Pollock, de Kooning, and the one thing they all had that I didn't have was an art school background. They were brought up on drawing and they all ended up painting or drawing with the brush. They got away from the smaller brushes and, in an attempt to free themselves, they got involved in commercial paint and house-painting brushes. Still it was basically drawing with paint, which has characterized almost all twentieth-century painting. The way my own painting was going, drawing was less and less necessary. It was the one thing I wasn't going to do. I wasn't going to draw with the brush.

. . . I found out that I just didn't have anything to say in those terms. I didn't want to make variations; I didn't want to record a path. I wanted to get the paint out of the can and onto the canvas. I knew a wise guy who used to make fun of my painting, but he didn't like the Abstract Expressionists either. He said they would be good painters if they could only keep the paint as good as it is in the can. And that's what I tried to do. I tried to keep the paint as good as it was in the can.

GLASER: Are you implying that you are trying to destroy painting?

STELLA: It's just that you can't go back. It's not a question of destroying anything. If something's used up, something's done, something's over with, what's the point of getting involved with it?

. . . I always get into arguments with people who want to retain the old values in painting—the humanistic values that they always find on the canvas. If you pin them down, they always end up asserting that there is something there besides the paint on the canvas. My painting is based on the fact that only what can be seen there *is* there. It really is an object. Any painting is an object and anyone who gets involved enough in this finally has to face up to the objectness of whatever it is that he's doing. He is making a thing. All that should be taken for granted. If the painting were lean enough, accurate enough or right enough, you would just be able to look at it. All I want anyone to get out of my paintings, and all I ever get out of them, is the fact that you can see the whole idea without any confusion . . . What you see is what you see.

GLASER: That doesn't leave too much afterwards, does it?

STELLA: I don't know what else there is. It's really something if you can get a visual sensation that is pleasurable, or worth looking at, or enjoyable, if you can just make something worth looking at. . . .

GLASER: You've been quoted, Frank, as saying that you want to get senti-mentality out of painting.

STELLA: I hope I didn't say that. I think what I said is that sentiment wasn't necessary. I didn't think then, and I don't now, that it's necessary to make paintings that will interest people in the sense that they can keep going back to explore painterly detail. One could stand in front of any Abstract Expressionist work for a long time, and walk back and forth, and inspect the depths of the pigment and the inflection and all the painterly brushwork for hours. But I wouldn't particularly want to do that and also I wouldn't ask anyone to do that in front of my paintings. To go further, I would like to prohibit them from doing that in front of my painting. That's why I make the paintings the way they are, more or less. . . .

GLASER: You seem to be after an economy of means, rather than trying to avoid sentimentality. Is that nearer it?

STELLA: Yes, but there's something awful about that "economy of means." I don't know why, but I resent that immediately. I don't go out of my way to be economical. It's hard to explain what exactly it is I'm motivated by, but I don't think people are motivated by reduction. It would be nice if we were, but actually, I'm motivated by the desire to make something, and I go about it in the way that seems best.

JUDD: You're getting rid of the things that people used to think were

31. Frank Stella, *Ileana Sonnabend*, 1963. Oil on canvas, 89 × 127 in. Collection of the artist. (*Photo: Courtesy Leo Castelli Gallery, New York*)

essential to art. But that reduction is only incidental. I object to the whole reduction idea, because it's only reduction of those things someone doesn't want. If my work is reductionist it's because it doesn't have the elements that people thought should be there. But it has other elements that I like. . . .

STELLA: You want to get rid of things that get you into trouble. As you keep painting you find things are getting in your way a lot and those are the things that you try to get out of the way. You might be spilling a lot of blue paint and because there's something wrong with that particular paint, you don't use it any more, or you find a better thinner or better nails. There's a lot of striving for better materials, I'm afraid. I don't know how good that is.

JUDD: There's nothing sacrosanct about materials.

STELLA: I lose sight of the fact that my paintings are on canvas, even though I know I'm painting on canvas, and I just see my paintings. I don't get terribly hung up over the canvas itself. If the visual act taking place on the canvas is strong enough, I don't get a very strong sense of the material quality of the canvas. It sort of disappears. I don't like things that stress the material qualities. I get so I don't even like Ken Noland's paintings (even though I like them a lot). Sometimes all that bare canvas gets me down, just because there's so much of it; the physical quality of the cotton duck gets in the way.

GLASER: Another problem. If you make so many canvases alike, how much can the eye be stimulated by so much repetition?

STELLA: That really is a relative problem because obviously it strikes different people different ways. I find, say, Milton Resnick as repetitive as I am, if not more so. The change in any given artist's work from picture to picture isn't that great. Take a Pollock show. You may have a span of ten years, but you could break it down to three or four things he's done. In any given period of an artist, when he's working on a particular interest or problem, the paintings tend to be a lot alike. It's hard to find anyone who isn't like that. It seems to be the natural situation. And everyone finds some things more boring to look at than others. . . .

GLASER: Frank, your stretchers are thicker than the usual. When your canvases are shaped or cut out in the center, this gives them a distinctly sculptural presence.

STELLA: I make the canvas deeper than ordinarily, but I began accidentally. I turned one-by-threes on edge to make a quick frame, and then I liked it. When you stand directly in front of the painting it gives it just enough depth to hold it off the wall; you're conscious of this sort of shad-

ow, just enough depth to emphasize the surface. In other words, it makes it more like a painting and less like an object, by stressing the surface.

JUDD: I thought of Frank's aluminum paintings as slabs, in a way. . . .

GLASER: Nobody's really attempted to develop some new terminology to deal with the problems of these paintings.

STELLA: But that's what I mean. Sometimes I think our paintings *are* a little bit different, but on the other hand it seems that they're still dealing with the same old problems of making art. I don't see why everyone seems so desperately in need of a new terminology, and I don't see what there is in our work that needs a new terminology either to explain or to evaluate it. It's art, or it wants to be art, or it asks to be considered as art, and therefore the terms we have for discussing art are probably good enough. You could say that the terms used so far to discuss and evaluate art are pretty grim; you could make a very good case for that. But none the less, I imagine there's nothing specific in our work that asks for new terms, any more than any other art.

CARL ANDRE (1935-)

Andre defines the term "minimal" as he understands it, and the degree to which he accepts its applicability to himself as an artist who has "drained and rid himself of the . . . cultural over-burden that stands shadowing and eclipsing art. . . ." The sculpture Andre constructs, within those terms, is clearly "minimal"—stripped down, purified. Following Brancusi's lead, he transformed the traditional base or pedestal into a work of sculpture itself. But Andre carried his premises to an extreme by placing bricks, or even lower-profiled square sheets of metal, one by one, uniformly adjacent to each other, right on the floor by our feet. In these floor pieces, and in his bales of hay or rocks assembled out-of-doors, sculpture's traditional vertical thrust became horizontal extension, for which his term "sculpture as place" is appropriate.

★ ★ ★

Excerpted from Phyllis Tuchman, "An Interview with Carl Andre," *Artforum* (June 1970)

P.T.: Is there a content expressed in your sculptures?

C.A.: I think art is expressive but it is expressive of that which can be expressed in no other way. Hence, to say that art has meaning is mistaken because then you believe that there is some message that the art is carry-

ing like the telegraph, as Noel Coward said. Yes, art is expressive, but it is expressive of that which can be expressed in no other way. So, it cannot be said to have a meaning which is separable from its existence in the world. No explicit meanings, no, not in mind when I address myself to the work, not at all. What is quite the opposite is that I find that my greatest difficulty and the really most painful and difficult part of my work is draining and ridding my mind of that burden of meanings which I've absorbed through the culture—things that seem to have something to do with art but don't have anything to do with art at all. That's the one aspect of the term "minimal" art that I have always prized and I always considered myself, to that extent, a minimal artist. When people talked about minimal art, I didn't realize that they were talking about sculptures and the work. I thought they were talking about the artists. Because what the idea "minimal art" really means to me is that the person has drained and rid himself of the burden, the cultural over-burden that stands shadowing and eclipsing art. The duty of the artist is to rid himself of that burden. I think it's an extremely difficult thing to do. I would not say that I have achieved it, because every time you work, you have to do it all over again, to rid yourself of this dross. I suppose for a person who is not an artist or not attempting art, it is not dross, because it is the common exchange of everyday life. But I think art is quite apart from that and you have to really rid yourself of those securities and certainties and assumptions and get down to something which is closer and resembles some kind of blankness. Then one must construct again out of this reduced circumstance. That's another way, perhaps, of an art poverty; one has to impoverish one's mind. This is not a repudiation of the past or such things, but it is really getting rid of what I describe as dross.

P.T.: You don't consider yourself a conceptual artist, do you?

C.A.: I am certainly no kind of conceptual artist because the physical existence of my work cannot be separated from the idea of it. That's why I said I had no art ideas, I only have art desires. To speak of ideas as conceptions in a philosophical sense and then to speak of ideas for art, well that is to speak about two utterly different things. I think what we really mean to do is apply ourselves to the language we use in the most rigorous sense. As Confucius said, when he was asked what he would do if he were made the prime minister of the duchy where he lived, "The first thing I would do is call things by their right names." This is why I wish to separate myself entirely from any conceptual art or even with ideas in art. My art springs from my desire to have things in the world which would otherwise never be there. By nature, I am a materialist, an admirer of Lucretius. It is exactly these impingements upon our sense of touch and so forth that I'm interested in. The sense of one's own being in the world con-

32. Carl Andre, *64 Steel Square*, 1967. Hot-rolled steel, 64 units, each ⅜ × 8 × 8 in.; overall ⅜ × 64 × 64 in. Collection Jan and Ingeborg van der Marck, Miami.

firmed by the existence of things and others in the world. This, to me, is far beyond being as an idea. This is a recognition, a state of being, a state of consciousness—and I don't wish at all to be portrayed as mystic in that. I don't think that it's mystical at all. I think it's a true awareness that doesn't have anything to do with mysticism or religion. It has to do with life as opposed to death and a feeling of the true existence of the world in oneself. This is not an idea. An idea is a much lower category on my scale in that awareness, that consciousness.

DAN FLAVIN (1933-)

Dan Flavin, another major innovator of the kind of art that came to be called "minimal," uses the medium of light. For an analysis of Flavin's work, see Bochner's essay below: "Serial Art Systems: Solipsism" (see also Dan Flavin, ". . . in daylight or cool white, an autobiographical sketch," *Artforum* [December 1965]). But, unlike the usual run of light sculptures, Flavin's do not flicker, dance, or dazzle. Simply unadorned, unconcealed fluorescent light fixtures, they are "just there." However, by fixing lighted fluorescent tubes to the wall, which he first did in 1963, Flavin modifies the architecture of the room to create a total environment as fully as do the "installation" artists of today. When lighted, the fixtures become invisible and, separated from its functional context, Flavin's sculpture carries the mystic significance of light as pure spirit. It is not surprising that he and Barnett Newman held each other in high esteem and understanding.

As a matter of fact, I have found that all minimal art, to the extent that it is successful, means something other than what it ostensibly "is." It carries associations with it and has the power to touch the observer, in spite of the core minimalists' (Stella, Judd, Morris) assertions to the contrary in their early statements.

7

Systemic and Conceptual Art

Sol LeWitt's "Sentences" was preceded by his "Paragraphs on Art," *Artforum* (June 1967), in which he had expressed similar ideas in a less stripped-down form. Although LeWitt is often called the father of conceptual art, his dicta, as well as his austere, pure, almost invariably white sculpture, suggest that "systemic" would be a more accurate and specific designation. The system in his sculpture (and the wall paintings too), established beforehand, determines the form, as Mel Bochner makes clear in his analysis of a LeWitt work.

SOL LEWITT (1928-)

Conceptual art clearly overlaps with minimal in a living, organic relationship. Taken to the extreme, the reductive tendency eventually leads to the total elimination of the art object—a position reached by the strictly conceptual Art-Language group, for whose publications LeWitt prepared his "Sentences." One of LeWitt's fundamental differences from that terminally conceptual group (see the Kosuth piece below) is clearly stated in his concluding sentence: "These sentences comment on art, but are not art."

Sol LeWitt, "Sentences on Conceptual Art" (1969), from Alicia Legg, *Sol LeWitt,* New York: Museum of Modern Art, 1978, reprinted with slight revisions from the original publication in *0-9* (New York, 1969) and *Art Language* (England, May 1969)

1. Conceptual artists are mystics rather than rationalists. They leap to conclusions that logic cannot reach.
2. Rational judgments repeat rational judgments.
3. Irrational judgments lead to new experience.
4. Formal art is essentially rational.
5. Irrational thoughts should be followed absolutely and logically.
6. If the artist changes his mind midway through the execution of the piece he compromises the result and repeats past results.

7. The artist's will is secondary to the process he initiates from idea to completion. His willfulness may only be ego.

8. When words such as painting and sculpture are used, they connote a whole tradition and imply a consequent acceptance of this tradition, thus placing limitations on the artist who would be reluctant to make art that goes beyond the limitations.

9. The concept and idea are different. The former implies a general direction while the latter is the component. Ideas implement the concept.

10. Ideas can be works of art; they are in a chain of development that may eventually find some form. All ideas need not be made physical.

11. Ideas do not necessarily proceed in logical order. They may set one off in unexpected directions, but an idea must necessarily be completed in the mind before the next one is formed.

12. For each work of art that becomes physical there are many variations that do not.

13. A work of art may be understood as a conductor from the artist's mind to the viewer's. But it may never reach the viewer, or it may never leave the artist's mind.

14. The words of one artist to another may induce an idea chain, if they share the same concept.

15. Since no form is intrinsically superior to another, the artist may use any form, from an expression of words (written or spoken) to physical reality, equally.

16. If words are used, and they proceed from ideas about art, then they are art and not literature; numbers are not mathematics.

17. All ideas are art if they are concerned with art and fall within the conventions of art.

18. One usually understands the art of the past by applying the convention of the present, thus misunderstanding the art of the past.

19. The conventions of art are altered by works of art.

20. Successful art changes our understanding of the conventions by altering our perceptions.

21. Perception of ideas leads to new ideas.

22. The artist cannot imagine his art, and cannot perceive it until it is complete.

23. The artist may misperceive (understand it differently from the artist) a work of art but still be set off in his own chain of thought by that misconstrual.

24. Perception is subjective.

25. The artist may not necessarily understand his own art. His perception is neither better nor worse than that of others.

26. An artist may perceive the art of others better than his own.

27. The concept of a work of art may involve the matter of the piece or the process in which it is made.

28. Once the idea of the piece is established in the artist's mind and the final form is decided, the process is carried out blindly. There are many side effects that the artist cannot imagine. These may be used as ideas for new works.

29. The process is mechanical and should not be tampered with. It should run its course.

30. There are many elements involved in a work of art. The most important are the most obvious.

31. If an artist uses the same form in a group of works, and changes the material, one would assume the artist's concept involved the material.

32. Banal ideas cannot be rescued by beautiful execution.

33. It is difficult to bungle a good idea.

34. When an artist learns his craft too well he makes slick art.

35. These sentences comment on art, but are not art.

MEL BOCHNER (1940-)

This 1967 incunabulum of systemic theory was written by a young artist trained in dialectical thinking, himself a foremost creator of strictly systemic, procedural work. Bochner's logic almost carried him to the point of no object (see the 1972 interview with him in Ellen Johnson's *Modern Art and the Object*, London & New York, 1976). Nevertheless, whether he always willed it or not, his work has a visually commanding character, increasingly pronounced and richer in recent years.

★ ★ ★

Excerpted from Mel Bochner, "Serial Art Systems: Solipsism," *Arts magazine* (Summer 1967)

If it can be safely assumed that all things are equal, separate, and unrelated, we are obliged to concede that they (things) can be named and described but never defined or explained. If, furthermore, we bracket-out all questions which, due to the nature of language, are undiscussible (such as why did this or that come to exist or what does it mean), it will then be possible to say that the entire being of an object, in this case an art object, is in its appearance. Things being whatever it is they happen to be, all we can know about them is derived directly from how they appear.

Criticism has traditionally consisted of one of three approaches: "impressionistic" criticism which has concerned itself with the effects of the work of art on the observer—individual responses; "historical" criticism which has dealt with an *a posteriori* evolution of forms and techniques—what is between works; "metaphorical" criticism which has contrived numerous analogies—most recently to scientism. What has been generally neglected is a concern with the object of art in terms of its own material individuality—the thing itself.

Two criteria are important if such an attempt is to be made. First, the considerations should be concrete (deal with the facts of the thing itself). Second, they should be simplificatory (provide an intellectually economic structure for the group of facts obtained). The latter is necessary because description alone can never adequately locate things. In fact, it very often confers upon them an enigmatic position. Nonetheless it offers more interesting possibilities than the impressionistic, historic or metaphoric approach.

Everything that exists is three-dimensional and "takes up" space (space considered as the medium in which the observer lives and moves). Art objects are qualitatively different from natural life yet are co-extensive with it. This results in the unnaturalness of all art (a factor of its intrusion).

The above is relevant to an examination of certain three-dimensional art being done today, especially the works of Carl Andre, Dan Flavin and Sol LeWitt. Their works cannot be discussed on either stylistic or metaphoric grounds. What they can be said to have in common, though, is a heightened artificiality due to the clearly visible and simply ordered structure they use. These orders and *how* the resultant pieces exist in their environments are what I would like to examine.

Carl Andre uses convenient, commercially available objects such as bricks, styrofoam planks, ceramic magnets, cement blocks, wooden beams. Their common denominators are density, rigidity, opacity, uniformity of composition, and roughly geometric shape. A number of *a priori* decisions govern his various pieces. One and only one kind of object is used in each. Individual pieces are specifically conceived for the conditions of the place in which they are to occur. (Although in no way connected with environment art, both Andre and Flavin exhibit an acute awareness of the phenomenology of rooms.) The arrangement of the designated units is made on an orthogonal grid by use of simple arithmetic means. . . . The principal means of cohesion in Andre's pieces is weight (gravity), the results of another *a priori*, the use of no adhesives or complicated joints. This necessitates their appearance on the floor in horizontal configurations such as rows or slabs. . . . Height is the negligible dimension in these recent pieces which is probably due somewhat to the instability of unadhered stacks. At

33. Mel Bochner, *Theorem of Pythagoras*, 1974. Charcoal on paper, 38 × 50 in. Collection Mr. and Mrs. Jerry Spiegel, Kings Point, N.Y. (*Photo: Courtesy Sonnabend Gallery, New York*)

any rate this causes the pieces to exist below the observer's eye level. They are made to be "looked down upon," impinging very slightly on common space. However, it is just this persistent slightness which is essentially unavoidable and their bald matter-of-factness that makes them in a multiple sense *present*.

These artists are further differentiated (as all artists are) by their individual methodology, which in relation to the methodology of the past can only be termed serial. Serial or systematic thinking has generally been considered the antithesis of artistic thinking. Systems are characterized by regularity, thoroughness and repetition in execution. They are methodical. It is their consistency and the continuity of application that characterizes them. Individual parts of a system are not in themselves important but are relevant only in how they are used in the enclosed logic of the whole series.

One of the first artists to make use of a basically progressional procedure was Dan Flavin. A salient example of this is his 1964 *Nominal Three—to Wm. of Ockham* ("Posit no more entities than are necessary"—Wm. of Ockham). The simple series involved can be graphically visualized as $[1 + (1 + 1) + (1 + 1 + 1)]$.

Flavin, however, is difficult to come to terms with in even a quasi-objective discussion. For, although his placement of fluorescent lamps parallel and adjacent to one another in varying numbers or sizes is "flat-footed" and obvious, the results are anything but. It is just these "brilliant" results that confound and compound the difficulties.

In his most recent exhibition he restricted his units to cool-white lamps in 8′, 6′ and 2′ lengths . . . placed in . . . corners . . . and . . . walls. . . . The fixtures themselves which amount to only a low relief projection from the wall were obliterated by their own light and cross shadows. But they intensely accentuate all the phenomena of the room . . . the tilted floor, false wall, leaning door, excessively baroque fireplace. . . . The gaseous light . . . is indescribable except as space if, once again, we consider space as a medium. Flavin "fills" the space in direct proportion to his illumination of it. . . .

Up until about fifteen years ago all light came as points. All sources of illumination, including the sun, were singular and radiated from a point source. With the proliferation of fluorescent lighting a perceptual revolution occurred with probably deeper significance than the invention of the light bulb (which still created chiaroscuro shadows). Light now occurs in long straight lines obliterating shadows. It can, in effect, surround. For Flavin (who does not "use" light in the sense of the so-called "light-artists") this is an important factor. It is due to this that he attains such a high degree of artificiality and unnaturalness (what Bertolt Brecht referred to as "the alienation effect"). Of these three artists his is the most drastic artifice.

34. Dan Flavin, *Installation*, Kornblee Gallery, New York, January 7–February 2, 1967. Fluorescent lights, each 8 ft. × 6½ in.

35. Sol LeWitt, *Serial Project #1 Set A*, 1966. Baked enamel and aluminum. Private collection, Holland. (*Photo: Courtesy John Weber Gallery, New York*)

Schopenhauer speaks of the solipsist as "a madman shut up in an impregnable blockhouse." Sartre refers to solipsism as "the reef," for it "amounts to saying that outside me nothing exists." But while we may not be able to prove the existence of "others," we nonetheless encounter them. A problem only arises when the self and outside the self are considered as two separate substances; then solipsism is the inescapable predicament. . . .

Sol LeWitt's work takes a particularly flat, non-emphatic position. His complex, multi-part structures are the consequence of a rigid logic system which excludes individual personality factors as much as possible. As a system it serves to enforce the boundaries of his work as "things-in-the-world" separate from both maker and observer.

LeWitt's recent West Coast exhibition (one-quarter of the proposal he exhibited at the Dwan, N.Y., *Scale Models* exhibition) is an interesting example of conceptual art. . . .° First a governing set of decisions are made. The first cause is an open frame square placed on the floor in the center of a larger square ratio 1:9, which in extension becomes a cube within a cube ratio 1:27. The next limitation which is made are the three height variables:

1. LOW—the height of the cross section of the bar of which the entire ensemble is constructed.
2. MEDIUM—the height of one cube (arbitrary).
3. HIGH—three times the height of number two.

Then the combinations of open frame and closed volume are considered in the four binomial possibilities: open inside–open outside; open inside–closed outside; closed inside–open outside; closed inside–closed outside. There are no mathematics involved in operations such as these. Happily there seems to be little or no connection between art and mathematics. . . . When numbers are used it is generally as a convenient regulating device, a logic external to both the time and place of application.

When one encounters a LeWitt, although an order is immediately intuited, how to apprehend or penetrate it is nowhere revealed. Instead one is overwhelmed with a mass of data—lines, joints, angles. The pieces situate in centers usurping most of the common space, yet their total volume (the volume of the bar itself) is negligible. Their immediate presence in reality as separate and unrelated things is asserted by the demand that we go around them. What is most remarkable is that they are seen moment to

° Editor's note: In a revised version of this article (published in Gregory Battcock, *Minimal Art, A Critical Anthology* [New York, 1968], p. 101), Bochner replaced the term "conceptual art" with "seriality."

moment spatially (due to a mental tabulation of the entirety of other views) yet do not cease at every moment to be flat.

Some may say, and justifiably, that there is a "poetry" or "power" or some other quality to this work which an approach such as the above misses. But, aspects such as those exist for individuals and are difficult to deal with using conventional meanings for words. Others may claim that given this they are still bored. If this is the case, their boredom may be the product of being forced to view things not as sacred but as they probably are—autonomous and indifferent.

JOSEPH KOSUTH (1945-)

Kosuth, American representative of the British Art-Language group, is strictly non-visual, even when he includes images in his work (for example, *One and Three Chairs*, 1968, consisting of a photograph of a chair, the dictionary definition of the word, and an actual chair). Each such Platonic demonstration—indeed, all of his work—is subtitled "Art as Idea, as Idea." "Exhibitions" of strict conceptual art are no feasts for the eye, but exercises for the mind; the viewer is offered words on placards on the wall and in tracts and books on tables. Nevertheless, Kosuth concludes this essay with a statement that could have been written by the visually seductive painter Ad Reinhardt: "Art's only claim is for art. Art is the definition of art." A two-headed demonstration of a basic premise, or two people separated by a common language?

★ ★ ★

Excerpted from Joseph Kosuth, "Art After Philosophy," originally published in *Studio International* (October 1969); reprinted in Ursula Meyer, *Conceptual Art*, New York, 1972.

Aesthetic considerations are indeed *always* extraneous to an object's function or "reason-to-be." Unless of course, that object's reason-to-be is strictly aesthetic. An example of a purely aesthetic object is a decorative object, for a decoration's primary function is "to add something to, so as to make more attractive; adorn; ornament,"[1] and this relates directly to taste. And this leads us directly to "formalist" art and criticism.[2] Formalist art (painting and sculpture) is the vanguard of decoration, and, strictly

[1] *Webster's New World Dictionary of the American Language.*

[2] The conceptual level of the work of Kenneth Noland, Jules Olitski, Morris Louis, Ron Davis, Anthony Caro, John Hoyland, Dan Christensen, et al., is so dismally low that any that is there is supplied by the critics promoting it. This is seen later.

speaking, one could reasonably assert that its art condition is so minimal that for all functional purposes it is not art at all, but pure exercises in aesthetics. Above all things Clement Greenberg is the critic of taste. Behind every one of his decisions is an aesthetic judgment, with those judgments reflecting his taste. And what does his taste reflect? The period he grew up in as a critic, the period "real" for him; the fifties.[3]

How else can one account for, given his theories—if they have any logic to them at all—his disinterest in Frank Stella, Ad Reinhardt, and others applicable to his historical scheme? Is it because he is "basically unsympathetic on personally experiential grounds"?[4] Or, in other words, "their work doesn't suit his taste"?

But in the philosophic *tabula rasa* of art, "if someone calls it art," as Don Judd has said, "it's art." Given this, formalist painting and sculpture can be granted an "art condition," but only by virtue of their presentation in terms of their art idea (e.g., a rectangular-shaped canvas stretched over wooden supports and stained with such and such colors, using such and such forms, giving such and such a visual experience, etc.). If one looks at contemporary art in this light, one realizes the minimal creative effort taken on the part of formalist artists specifically, and all painters and sculptors (working as such today) generally.

. . . Formalist criticism is no more than an analysis of the physical attributes of particular objects that happen to exist in a morphological context. But this doesn't add any knowledge (or facts) to our understanding of the nature or function of art. And neither does it comment on whether or not the objects analyzed are even works of art, in that formalist critics always bypass the conceptual element in works of art. Exactly why they don't comment on the conceptual element in works of art is precisely because formalist art is only art by virtue of its resemblance to earlier works of art. It's a mindless art. Or, as Lucy Lippard so succinctly described Jules Olitski's paintings: "they're visual *Muzak*."[5]

Formalist critics and artists alike do not question the nature of art, but as I have said elsewhere:

Being an artist now means to question the nature of art. If one is questioning the nature of painting, one cannot be questioning the nature of art. If an artist ac-

[3] Michael Fried's reasons for using Greenberg's rationale reflect his background (and most of the other formalist critics') as a "scholar," but more of it is due to his desire, I suspect, to bring his scholarly studies into the modern world. One can easily sympathize with his desire to connect, say, Tiepolo with Jules Olitski. One should never forget, however, that a historian loves history more than anything, even art.

[4] Lucy Lippard uses this quotation in a footnote to Ad Reinhardt's retrospective catalogue, January 1967, p. 28.

[5] Lucy Lippard, "Constellation by Harsh Daylight: The Whitney Annual," *Hudson Review*, vol. 21, no. 1 (Spring 1968).

cepts painting (or sculpture) he is accepting the tradition that goes with it. That's because the word art is general and the word painting is specific. Painting is a *kind* of art. If you make paintings you are already accepting (not questioning) the nature of art. One is then accepting the nature of art to be the European tradition of a painting-sculpture dichotomy.[6]

The function of art, as a question, was first raised by Marcel Duchamp. In fact it is Marcel Duchamp whom we can credit with giving art its own identity. . . . The event that made conceivable the realization that it was possible to "speak another language" and still make sense in art was Marcel Duchamp's first unassisted Ready-made. With the unassisted Ready-made, art changed its focus from the form of the language to what was being said. Which means that it changed the nature of art from a question of morphology to a question of function. This change—one from "appearance" to "conception"—was the beginning of "modern" art and the beginning of conceptual art. All art (after Duchamp) is conceptual (in nature) because art only exists conceptually. . . .

Art "lives" through influencing other art, not by existing as the physical residue of an artist's ideas. The reason that different artists from the past are "brought alive" again is because some aspect of their work becomes "usable" by living artists. That there is no "truth" as to what art is seems quite unrealized.

What is the function of art, or the nature of art? If we continue our analogy of the forms art takes as being art's *language,* one can realize then that a work of art is a kind of *proposition* presented within the context of art as a comment on art. We can then go further and analyze the types of "propositions."

. . . One begins to realize that art's "art condition" is a conceptual state. That the language forms that the artist frames his propositions in are often "private" codes or languages is an inevitable outcome of art's freedom from morphological constrictions; and it follows from this that one has to be familiar with contemporary art to appreciate it and understand it. Likewise one understands why the "man in the street" is intolerant to artistic art and always demands art in a traditional "language." (And one understands why formalist art sells "like hot cakes.")

. . . The characteristic mark of a purely logical inquiry is that it is concerned with the formal consequences of our definitions (of art) and not with questions of empirical fact.

To repeat, what art has in common with logic and mathematics is that it is a tautology; i.e., the "art idea" (or "work") and art are the same and can be appreciated as art without going outside the context of art for verification.

. . . Advance information about the concept of art and about an artist's

[6] In Arthur R. Rose, "Four Interviews," *Arts magazine* (February 1969).

concepts is necessary to the appreciation and understanding of contempo-
rary art. . . .

Here then I propose rests the viability of art. In an age when traditional
philosophy is unreal because of its assumptions, art's ability to exist will
depend not only on its *not* performing a service—as entertainment, visual
(or other) experience, or decoration—which is something easily replaced
by kitsch culture, and technology, but, rather, it will remain viable by *not*
assuming a philosophical stance; for in art's unique character is the capac-
ity to remain aloof from philosophical judgments. It is in this context that
art shares similarities with logic, mathematics, and, as well, science. But
whereas the other endeavors are useful, art is not. Art indeed exists for its
own sake.

In this period of man, after philosophy and religion, art may possibly be
one endeavor that fulfills what another age might have called "man's
spiritual needs." Or, another way of putting it might be that art deals
analogously with the state of things "beyond physics" where philosophy
had to make assertions. And art's strength is that even the preceding sen-
tence is an assertion, and cannot be verified by art. Art's only claim is for
art. Art is the definition of art.

AGNES DENES (1938-)

Agnes Denes maintains a brilliant course between the visual and the
conceptual. The biologic, philosophical, social systems that she investi-
gates and demonstrates are invariably presented in a precise, elegant
form. Although very different from LeWitt's and Bochner's work, De-
nes's conceptual art is also systemic, as she herself avers: "It is the con-
cept that dictates the mode of presentation." There is a pronounced
mystical tinge to the extraordinarily ambitious intellectual programs
she sets herself, which is echoed in the role she ascribes to the visual
arts: "We must . . . accept the possibility that there may be no language
to describe the ultimate reality, beyond the language of visions."

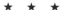

Excerpted from Agnes Denes, "Evolution and the Creative Mind," a lecture
first delivered at the Smithsonian Institution, Washington, D.C., 1976. Copy-
right Agnes Denes, 1978.

My art exists in a dynamic, evolutionary world of rapidly changing
concepts and measures, where the appearances of things, facts and events
are assumed manifestations of reality and distortions are the norm. . . .

Although I deal with difficult concepts, my work remains visual. The
process of "visualization" is doubly important since aspects of the work

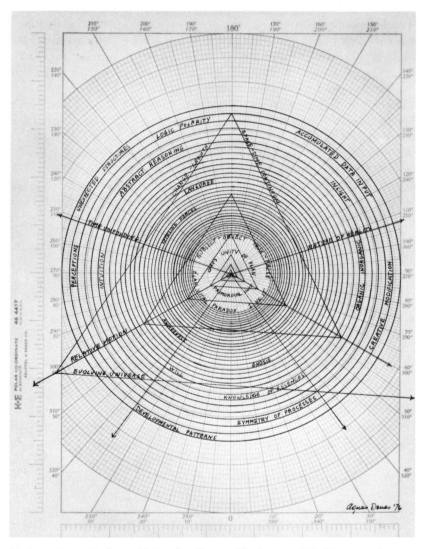

36. Agnes Denes, *Evolution II. Paradox, Essence: The System*, 1976. Ink on graph paper,
14½ × 17 in. (*Photo: Courtesy Agnes Denes*)

explore invisible systems, underlying structures and patterns inherent in our existence. . . .

I incorporate science, philosophy and all those disciplines that enrich my work and are so necessary to any worthwhile human activity in the world today.

I communicate my ideas in whatever form is most true to the concept. It is the concept that dictates the mode of presentation. My projects take several years to complete and they are in a constant state of flux. The work follows an evolutionary attitude and process. It questions, dissects, re-evaluates and reconstructs through the conscious use of instinct, intellect and intuition.

. . . By questioning our existence as well as existence itself, we create an art universal in terms of all humanity. Personally, I am fascinated by our human position of being somewhere in the middle of this "existence." We live on an average galaxy; we can't see too far or too close, can't stand too much cold or too much heat. We don't live too long, and yet, we can look out to the edge of the universe into light years and penetrate the atom chasing quarks and another world within. The world seems to begin at the surface of our skin; there is a world beyond it and a world within, and the distance is about the same. I like that.

Once we abandon Newtonian static physics and accept Einstein's four-dimensional principles of relativity, we question reality and know that even the laws of nature may undergo evolutionary changes. We even invented the uncertainty principle, although we use it for other reasons.

We haven't begun to understand the implications of this new, relativistic existence, where everything we had known and had believed now seems to be wrong. In this new dynamic world, objects become processes and forms are patterns in motion. Matter is a form of energy and our own human substance is but spinning velocity. There is no solid matter and no empty space; time becomes an earthbound reality but remains an enigma in the fourth dimension. We must create a new language, consider a transitory state of new illusions and layers of validity and accept the possibility that there may be no language to describe ultimate reality, beyond the language of visions.

In our limited existence, evolution provides answers as to where we've been and where we are going: a future prediction based on previous phenomena. The universe contains systems, systems contain patterns. The purpose of the mind is to locate these patterns and to seek the inherent potential for new systems of thought and behavior.

My work touches on the various stages of the development of my species, re-evaluates and makes new comparisons in order to enhance perception and awareness, to form new insights and new methods of reasoning. . . .

This analytical attitude probes the structural and philosophical significance of an invisible world where elusive processes, transformations and

37. Agnes Denes, *Pyramid Series: Probability Pyramid—The People Paradox*, 1980. Ink on vellum, 36 × 48 in. (*Photo: Courtesy Agnes Denes*)

interactions of phenomena go unseen, buried in the substance of time and space. I am referring to known or unknown events hidden from recognition either by their nature of spatio-temporal limitations or by our being unaware of their existence and functions.

I believe that art is the essence of life, as much as anything can be a true essence. It is extracted from existence by a process. Art is a reflection on life and an analysis of its structure. As such, art should be a great moving force shaping the future.

ROBERT IRWIN (1928-)

Robert Irwin's multi-faceted ideas and activities made it difficult to decide where to place him—with site/architectural sculpture because of his recent work in public spaces and the earlier lyric installations, which hover at the very edge of imperceptibility, or in the wider context of his intellectual speculations? I finally opted for "conceptual" as sufficiently expansive to embrace his art-oriented investigations in philosophy and the natural and social sciences. Listening to him talk is something like listening to Buckminster Fuller's inspired expositions of his personal philosophy. The visual aspects of Irwin's art, which deals with perception, are so delicate and exact that for many years he would not allow photographs of his work to be published.

★ ★ ★

Robert Irwin, "Set of Questions," presented at an international symposium on "Art Education at the Higher Level," held in Montreal, Canada, 1980.

In the overall scheme of human activities, what is the unique contribution of art that justifies its distinction?

Why art? And what is the subject of art?

Can such an inquiry take the form of an analysis of art?

A dissolving or taking apart to find at the center, core, or bottom of the matter some spatially located thingness . . . as essence.

And when we have discovered this essence of art, can we then assume we hold a solution . . . one satisfying a system of art?

What is involved in such a transposition from process to system? . . . Gain and loss.

Or can we simply begin and end our inquiry, as some have suggested, by holding the distinction *art* to be the same as a measure of its practices and institutions?

Similarly, could we hold the subject, the physical world, to be the same

as the practices, laws, and institutions of physics?

Or can we begin, as others have suggested, by regarding art as a mode of communication, "anchored in concrete social relations"?

But what do we mean by communication? Communication of what?

Phrases like . . . "to communicate" . . . "to symbolize" . . . "to represent" . . . imply, both in their definitions as words and in their usage as language, that there is *something* that precedes these procedures.

Further it would seem implicit that this *something* is well enough understood to be reformed as those symbols and representations that go to make up this communication.

Add to this the broad assumption that what it is we understand is worth the telling—and you have defined a very complex process that precedes communication.

This idea of understanding—whether as thinking or feeling something—clearly indicates a process of becoming, that is, a process of forming.

What is the nature of this becoming?

Since it is not yet a communication—an inter-subjective action—it must be considered both a subjective and individual action.

But now there are two distinct phases in our inquiry:

A subjective realm of individual consciousness (private access) and an objective realm of inter-subjective–collective consciousness (public access) operating simultaneously with regards to *needs, methods,* and *criteria.*

Are we now saddled with a paradox that must be resolved one way or another?

Or . . . could we say they are mutually complementary by their very contradictions, since each would seem to accomplish *just* what it is the other concedes?

For all its complications . . . there is nothing mysterious here—for we all certainly live in both—that is, unless you should decide to use the particular criteria of either realm to bond the actions of the other.

Does this indicate there is more than one meaning, or at least . . . more than one phase of meaning construction?

Do we think of our everyday activities as meaningful? Probably not.

But if I should open my eyes one morning and things are not as I expected them to be—what then?—haven't I lost something of value?

And where would I begin in reforming my horizon? Would I buy a book on perception?

But isn't this process of reforming to some degree what we do every day of our lives?

And doesn't it begin with those simple distinctions between the qualities of things and non-things carried through the addition of some simple motive to gain a simple value distinction?

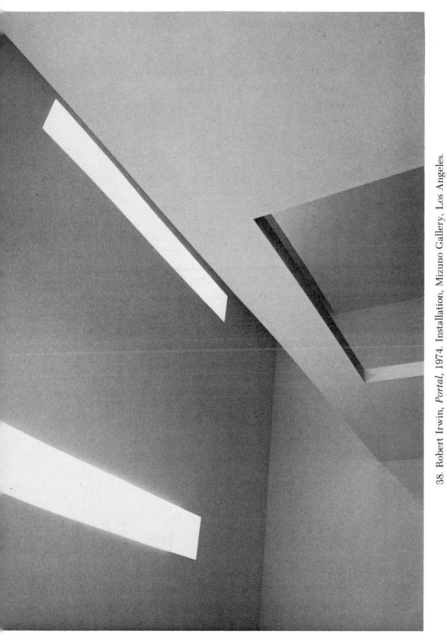

38. Robert Irwin, *Portal*, 1974. Installation, Mizuno Gallery, Los Angeles.

To make a long story short: Could we assume that meaning is preceded by a progression through simple distinction, simple and compound value, and transposed through an objective schematization to become meaning?

Having once gained the collective form—meaningful action—can we henceforth dispense with distinction and value?

Was that a fair assumption? Is that really how we form our world, in intimate perceptual acts?

Or is it more likely formed for us, preconditioned by our expectations and roles as cultural beings?

If a philosopher, a physicist, a social scientist, and an artist were to look at the same thing—to what degree would they see the same thing?

How would you characterize their similarities or explain their differences?

Are you tempted to say the artist's view will be colored by his/her aesthetics?

But what do we mean by that?

Aesthetics seems to imply so much that from any practical point of view it would seem to imply nothing.

What then did Messieurs Watson and Crick mean, upon seeing the double helix for the first time, by exclaiming, "It must be right, it's too beautiful"?

And how could we come to accept Einstein's theory of time and space, when it's not even visible to us; and further, do so while the preponderance of objective evidence for decades weighed against it?

What are the grounds for such an intuition?

Is this the area of referencing Chomsky had in mind with his "deep structures," or Polyani with his "tacit dimensions," or De Chardin in his "meta-consciousness"?

Can there be more than one frame of reference?

And what would be the reason for such a complexity?

Let me try an example:

The clock on the wall . . . tells us the time. What is the frame of reference for its doing so?

On the other hand, does the clock tell us what we are telling time for? And what would be the frame of reference for that?

But neither the clock nor the reason *resolves* the questions of what time *is*. What would be the reference for that?

Now, if I were to say to you that the subject of art, like time—has potentially as many meanings as there are encounters with its incidences in the world . . . and that, like the clock, each of its objects is a conditional solution . . .

Would that necessarily be a metaphysical riddle . . . or rather a statement of fact?

8

Photo-Realist Painting and Super-Realist Sculpture

Realism, like everything else under the sun, is ever new and ever old. The ancient tradition of realism goes back through Greece and Rome, in painting to the caves of Lascaux and in sculpture at least as far back as Egypt (compare the *Sheik el Beled* from nearly 5,000 years ago with Duane Hanson's *Man with Pipes [Plumber]*). However, the particular branch of New Realist painting which the following selections are limited to has a special twist—its direct dependence on the photograph. Although photographs have been used by painters since the mid-nineteenth century, they were not followed so closely or used in the same way as they now are by Photo-Realist painters like Bechtle, Estes, Flack, and Close. It is astonishing how much individuality of style and expression one meets among the many contemporary painters who work from photographs. From the very first step of the process, in which they take their photographs—as all four of these painters do—their personality is inevitably revealed in the choice of subject, lighting, angle of view, cropping, and so on. Richard Estes chooses store windows, most often, with their multiple reflections and transmissions of images, for his delicately precise paintings, as cool, crisp, and silvery as Ingres's.

Chuck Close's paintings are abruptly different from Estes's in several respects: enormous wall-sized, rather than easel, pictures; palette limited to black and white until 1971, when he introduced color; ostensible subject exclusively portraits, and only of his friends, never commissions. But Close's true subject is photography itself or, more accurately, the photographic processes, such as focus and color separation. Nonetheless, although he says: "I'm not concerned with painting people or with making humanist paintings," the powerful impact of his enormous stark images cannot be divorced from the fact that they are images of human faces. Propagandists the world over know the mesmerizing power of gigantic-sized portrait photographs.

Another aspect of photography could be called Audrey Flack's true subject: the intensification of colors perceived when a slide is projected through a lighted lantern onto a white surface. However, the objects Flack chooses to paint are entirely personal and as important to her as the brilliantly colored light that emanates from her canvases. *Jolie Ma-*

145

dame of 1971–72 and her other still lifes (dating from as far back as the early sixties) of perfume bottles, cosmetic jars, jewelry, and related objects on a woman's dressing table, could be construed as early examples of feminist subject matter, although the artist did not always make an issue of it. *Royal Flush* and similar compositions are also self-referential, alluding to her family's obsessive interest in gambling.

Like Close, Flack also paints with an air brush, but she uses it primarily as a tool to heighten the saturation of color-light. In her statement she explains the advantages of this instrument, which she employs principally (but not exclusively) in her painting.

Richard McLean, one of several California Photo-Realists, said of Robert Bechtle: "He was the pioneer out here in the serious use of the photograph in painting" (interview in *Art International* [September 1974]). Bechtle attributes the strength of the Photo-Realist movement in California to the influence of several figurative painters in the Bay Area, particularly Richard Diebenkorn, during the years when he included human figures in his abstracted interiors and landscapes.

Duane Hanson's colored sculptures are so extreme in their verisimilitude as to unnerve the viewer who comes upon one unawares, as I did once at a crowded Documenta opening, even going over to talk with Hanson's *Artist Seated*. Although George Segal also makes casts (or rather, molds) from the living model, his haunting plaster figures are more remote and far less lifelike than Duane Hanson's. This is largely because, until recently, he used the single-mold system, whereby the exactly reproductive surface (that is, the imprint of the body) is on the inside of his thin molds, and he retained the unreal white of the plaster. Even now, when his figures are occasionally positive casts (double-mold system) and colored, they are still unreal-looking, either because they are colored unnaturalistically—often entirely one color, as flesh, hair, clothes all blue—or, if the face is flesh-tinted, it is still unmistakably plaster, whose rough, irregular surface, unmodified, is clearly identifiable under the paint.

RICHARD ESTES (1936-)

Excerpted from Linda Chase and Ted McBurnett, Interview with Richard Estes in "The Photo-Realists: 12 Interviews," *Art in America* (Special Issue, November–December 1972)

Were you always a figurative painter?

R.E.: Yes, I was a figurative painter even in school. We had a lot of models—drawing class in the morning and painting class in the afternoon. That's what I enjoyed doing. I sort of worked my way out of doing figures to this [indicating painting], which has no figures in it.

When did you start using photographs?

R.E.: I guess when I got out of school. I didn't have any more models, so I had to use photographs.

Did you originally use photographs with people in them?

R.E.: Yes, I got involved in doing groups of people. I was doing crowds. I never really thought it was right.... Much too literal. It had too much story, as if it were trying to be an illustration....

Are there figures in these photographs?

R.E.: In some of them, but I take them out. They are too distracting. The painting of the subway car happened by accident because I got on the wrong train. I rode to the end of the line and there was no one left. I was sitting there waiting for the train to go back so I could get on the right train, and I decided to take some pictures.

Do you take more than one photograph for each painting?

R.E.: I find it's a good idea to take several photographs, to get a lot more information....

Would you basically have a photograph that looks like each painting and use the others for reference?

R.E.: Usually I would. If you take several photographs several things can happen, like cars going by or the light changing....

Are you trying to reproduce the photograph on the canvas?

R.E.: I'm not trying to reproduce the photograph. I'm trying to use the photograph to do the painting.

Would it be possible to make the same paintings from life?

R.E.: You couldn't do it. It's not possible. The great thing about the photograph is that you can stop things—this is one instant. You certainly couldn't do that if you went out there and set yourself up in front of it.

How do you think your painting is affected by the photograph?

R.E.: I can't see how I could do one without the other—or maybe I could do the photograph without the painting, but I couldn't do the painting without the photograph. Taking the photograph is the first step. The idea

occurs and is involved with the photograph. That's the creation of it almost, and the painting is just the technique of transmitting, or finishing it up so to speak. I am not trying to enlarge the photograph. I am making a painting, basically, and just using all these other things to do it.

Do you draw from slides?

R.E.: I project the slides to look at them, blow up details so I can see very clearly exactly what's happening. I don't project them on the canvas though.

How do you use focus in your work?

R.E.: There are certain things that have to be fuzzy that are naturally fuzzy. The eye sees like that. When I look at things, some are out of focus. But I don't like to have some things out of focus and others in focus because it makes very specific what you are supposed to look at, and I try to avoid saying that. I want you to look at it all. Everything is in focus.

Are you interested in photography apart from the paintings?

R.E.: No. I think I hit upon this more through photography than painting, but I couldn't really carry it far enough with photography, make an object of it, shall we say. You have a little slide and that's not quite right. Slides are much nicer than prints, but it's just simply impossible to look at slides. They are too small, and if you project them they lose that quality, and if you have prints made they are too flat. It loses something—surface. There's a lot of things in painting that you have more control over than you have in a photograph. You can't just ask the people to go away so you can take a picture, or move this car over there. In a painting you can make this line a little stronger, change the depth, things like that.

Do you change the photograph a lot?

R.E.: I don't try to change things, I try to make it a little clearer, that's all—to show what's happening. If something is in front of something else, I try to really make it look in front of it. Sometimes a photograph, if you really examine it, can be not very realistic. It doesn't really explain the way things really are or how they really look. . . . Sometimes it flattens things out and sometimes it doesn't. And there is no consistency in the way it flattens things out. It's not organized. . . .

. . . In New Realist paintings, everything seems to be standing still.

R.E.: I think that's true of all painting. It's always standing still—but maybe it seems that way in New Realist painting because if you paint inanimate objects like a car, whether it's moving or whether it's still, it doesn't look any different. Whereas, if you paint figures there are certain things

39. Richard Estes, *Store Front*, 1971. Oil on canvas, 32⅝ × 44³/₁₆ in. Collection Sydney and Frances Lewis Foundation, Virginia. (*Photo: Courtesy Allan Stone Gallery, New York*)

we associate with movement. It's an intellectual thing you read into it. . . .

Many New Realists were abstract painters to begin with. Do you think that has had any effect?

R.E.: They were trained that way. The kind of painting they are doing owes a lot to that kind of training. They couldn't really be doing the same kind of painting if they hadn't had that. Maybe that's what's behind the coldness of it, I don't know—a cold, abstract way of looking at things, without any comment or commitment.

Do you think that is particularly an American thing?

R.E.: Yes, certain American painting has always had a kind of starkness. I think what we have here is a very raw kind of life.

Is there a relationship between Pop Art and New Realism?

R.E.: I always liked Pop. I think there is a relationship in the sense that it suggested the way we are doing things. The use of subject matter. But, the trouble with Pop was that it made too much comment. A very sophisticated intellectual game type thing. . . .

Do you think New Realist painters have been affected by media?

R.E.: It has to affect the way you see things. Your whole life affects what you do. Even if you don't watch TV, you are affected by it. We see things photographically. We accept the photograph as real. But, maybe if you showed a photograph to someone in a primitive society who had never seen a photograph, he might not recognize what it was. . . .

Are you trying for a smooth, clean effect?

R.E.: No. I don't try to make it look smooth. It is just what happens.

Your paintings seem to have the effect of making the viewer see things differently, making the subject beautiful or interesting. Is that your intention?

R.E.: I have no conscious intention of making people see differently. I don't enjoy looking at the things I paint, so why should you enjoy it? I enjoy painting it because of all the things I can do with it. I'm not trying to make propaganda for New York, or anything. I think I would tear down most of the places I paint.

Do you think it's true that beautiful things often don't make very interesting subjects?

R.E.: That's true. Even if I were going to paint figures I wouldn't look for beautiful people to paint. It's interesting, it's very difficult to paint trees

too. It's funny, all the things I was trained to paint—people and trees, landscapes and all that—I can't paint. We're living in an urban culture that never existed even fifty years ago.

ROBERT BECHTLE (1932-)

Excerpted from Brian O'Doherty, Interview with Robert Bechtle in "The Photo-Realists: 12 Interviews," *Art in America* (Special Issue, November–December 1972)

How do you feel about being included in the Neo-Realist or Photo-Realist group?

R.B.: We are not really a group; we're all doing individual things. Until recently there was so little significant realist painting compared to abstract painting that it was very easy to group the realists together under a label as if they were working toward common goals. So people would tend to be thrown together as realists when, philosophically, they were quite far apart.

Do you feel you have anything in common with [Ralph] Goings and [Richard] McLean?

R.B.: Yes, we seem to be working along similar lines. The three of us have certain similarities in background. We were undergraduates at the California College of Arts and Crafts in Oakland at about the same time, although we didn't really know each other then. McLean and I have talked a good deal about what we have been doing and why. It's been interesting to talk to some of the people I haven't known and to discover that many of their reasons for working the way they do are very close to my own. One reason mentioned was the need to get away from a lot of the stylistic clichés of the then current painting scene. I mean the scene of seven or eight years ago. Malcolm Morley put it that he was "looking for a house in which no one was living," an area where he could function quite uniquely as himself. I think we've all done that in one way or another. We backed into a series of situations by deciding *not* to do something. It seemed the only way you could get away from style and "Art" was to paint things as they really looked.

Is there a critical element in these decisions, no matter how negatively arrived at?

R.B.: Yes, I think so. Most of us made a personal decision that what had

been happening in painting was relatively closed off to us, that too many people had been there before us and that there were too many predictables. Realism became a way of getting away from that in the sense that you didn't feel the ground was already broken. That sounds strange, since realism seems so traditional. Yet, when you think of it, the real tradition today is modernism, and it is now almost one century old.

Is New Realism a reactionary occasion?

R.B.: I don't think so. It's not avant garde in the way we've come to understand the term, but it's not reactionary in the sense of trying to go back someplace. I don't think it attempts to maintain the old realistic tradition in any way. Quite the contrary. A lot of abstract art is present in what we're doing.

Did you start as an Abstract Expressionist painter?

R.B.: More or less, though I was never very good at it. When I was in school in the fifties, that was the exciting thing. Of course, here in the Bay Area it took a different direction because of the development of the figurative school from about 1955. I was a graduate student when Diebenkorn was making the change to figuration. I got caught up in all of that and was strongly influenced by it, as were many of us on the West Coast. I came to my own way of looking at things partly as an outgrowth of that style of the fifties and partly as a reaction against it. There were in it implications of the significance of subject matter that became important to me. On the other hand, there were elements particular to expressionism that I tried very consciously to get away from.

Did photographs help you do that?

R.B.: Not really. Photographs came later, and they helped me to paint things I couldn't paint without them. But originally people sat for me or I worked from setups in a very traditional way. Deliberately so, like saying that if you're going to paint something then set your easel up in front of it and paint it the way it really looks. Don't try to generalize.

What's your attitude toward photography?

R.B.: It's complicated. I try to think of it as a tool. That's how I started using it, to enable me to paint things that I couldn't paint otherwise. You can't very well paint a car by setting your easel up on the street for three months. But of course the use of photographs starts to affect the way you think and see too. It can't really be just a tool.

How does the photograph affect your way of thinking?

R.B.: I found, for example, that I was allowing the way I would crop with

the camera to affect the way I was cropping paintings. I felt I had to pull away from it and back off to what I thought was a less photographic kind of format.

So you edit the photograph severely?

R.B.: For one thing, I take my own photographs, so I do a lot of editing right there with the camera. Hopefully I don't have to do too much in the way of changing once I get the slide back, though I often have to eliminate irrelevant details, or correct lens distortion. Sometimes I will piece a painting together from several slides, but I prefer not to.

Do you work from the slide on the canvas?

R.B.: Only to start with, only to block in.

You project it?

R.B.: Yes, I project it and draw outlines. Then I work from the image projected in a tabletop slide viewer. Once the outline has been drawn and necessary corrections have been made it's just a matter of painting from the slide as though I were looking at the actual scene.

Does the photograph push you into areas you didn't want to go to?

R.B.: There's a lot of danger there. The danger of making finished photographs, for one. I have to be careful that they are really lousy photographs that will allow the completion to take place in the painting. If the photograph is too good and can stand as a finished work of art by itself, there is no reason to make a painting from it. I also feel I must try to avoid a too candid kind of photography; it's very easy for that quality to creep in when using a 35mm camera.

Does it have to do with a casualness of subject matter that allows the viewer to fill in?

R.B.: Probably. A certain "dumbness" really. It isn't really casual because they're very structured two-dimensionally and formal in that sense. When I'm photographing a car in front of a house I try to keep in mind what a real estate photographer would do if he were taking a picture of the house and try for that quality. It's just a record of the thing. . . . I'm after a kind of openness where I'm not giving the viewer any clues about how he is supposed to react to the picture. . . .

Do you share Richard McLean's liking for Eakins?

R.B.: Very much. At least the earlier things—the rowing pictures and hunting scenes.

40. Robert Bechtle, 62 Chevy, 1970. Oil on canvas, 45 × 52 in. Courtesy O. K. Harris Works of Art.

Do you have an attitude toward the state of time that photographs present?

R.B.: I suppose my attitude has to do with a fairly traditional notion of what manner of time and motion is proper to painting. There are a lot of things you can photograph in motion, for instance, which make sense as a photograph but which become false in a painting because painting is essentially a static art. I try to find and use that particular static quality to advantage, to make something happen, perhaps, that doesn't happen in a photograph.

Does the bland Bay Area light affect your painting?

R.B.: The light in California does tend to be bland and bright; it's not particularly dramatic. Somehow this light quality supported the idea of neutrality I'm looking for. I find it difficult to deal with subjects that have dramatic light—late afternoon, for example. I've wanted to, but feel it's a little romantic for where I am right now.

You seem to favor frontal lighting.

R.B.: Yes, the kind of lighting that you can't identify with a particular time. It's simply an all-pervasive light that bathes the forms enough to identify the things in the picture.

Frontal lighting flattens the painting; does this make you more conscious of surface?

R.B.: I try to avoid being too conscious of it. I don't think it's necessary since the awareness of surface and picture plane is so much a part of our background. This, I suppose, is one of the main differences between realist painting in 1972 and traditional nineteenth-century painting. There's a completely different attitude toward surface. The equalized surface is so different from the older tradition of treating a head, say, more carefully than the background—which implied that the head was more important than the background. Also, the space now tends to be a projecting rather than a receding space. We set up a shallow space just in from the actual surface of the canvas, and the activity seems to project forward from there.

Is the all-overness of New Realism an important part of it—spending as much time on a patch of sky as on the face?

R.B.: Yes. Because the sky is just as important a component of that surface as what is done in the face. Each area, at least in theory, has to receive an equal amount of attention. Of course you may spend more time and energy painting the face than you will painting the sky, but that shouldn't

show when the painting is finished. It also has to do with a desire to avoid editorializing about the relative importance of the objects in the painting.

Is there any social comment in your choice of subject matter?

R.B.: No, not really, though I am certainly aware of the social implications of the subjects. I can identify with my subject in a sense—I like it and I hate it. There is a realization that my roots are there. It deals with a very middle-class life style which I tried to get away from when I was younger. But eventually I had to admit to myself that that was who I was and, like it or not, had to deal with it. So I do relate to those things I paint— suburban houses, cars, relatives. Yet on the other hand I try to preserve a kind of neutrality which doesn't tell the viewer what to think about all this. I'm not making a social comment about the middle class; I'm not saying that what I picture is good or bad. It's up to the viewer to make his own response.

That goes back to that neutrality. You feel strongly about leaving it open.

R.B.: I find it fascinating that I can paint something which is very specif- ic—a particular car or a particular person at an identifiable location—that is just as open to various interpretations as an abstract painting.

When you talk about leaving it open and feeling strongly about it at the same time, that brings you into the precincts of the great classical tradi- tion, doesn't it—Ingres, David, Vermeer?

R.B.: I'm very conscious of Vermeer, of course. I also admire Degas and Winslow Homer and Edward Hopper.

How do you feel your work relates to Pop?

R.B.: Pop was the catalyst that helped me make the transition from the Diebenkorn influence we had here and the kind of thing I'm doing now. In terms of subject matter, that's fairly obvious, but there's also the slight- ly irreverent attitude toward the tradition of Modern Art. Pop also led to an awareness of commercial art techniques—which is where the license for the use of photographs and projectors came from for me.

Have you any feelings about the critical response or lack of it in New York to the New Realism?

R.B.: We're so far removed here from the New York scene that we really don't think about it that much. I'm sure there are many people who view a return to realism as a threat, as backsliding. I suppose they feel that it attacks the notions they've been nurturing a long, long time. It's under- standable, but I would be disappointed if it were otherwise. Realism has

been just about the only direction where one could still stir up a bit of controversy or hostility.

Do you have any particular feeling when you see your work reproduced in a photograph?

R.B.: I'm always curious as to how closely it will go back to the original photograph. I suppose if it goes back to it very accurately, I've been reasonably successful with the mechanics of making the painting. The reproduced photograph of the painting has nothing really to do with the painting. The painting can only be seen as a painting when you are in the presence of it. That's true of any painting, but it's probably more the case with realism since when it returns to the original photograph a lot of the point of the whole thing goes with it. I assume that people are sophisticated enough, at least people who look at art magazines, to realize that they are looking at a photograph of a painting which has none of the quality of the painting itself. I'm not really too concerned, one way or the other, as long as I can keep straight the difference for myself.

AUDREY FLACK (1931-)

Excerpted from the manuscript for Audrey Flack's book *Audrey Flack on Painting*, New York: Abrams, 1981, this text differs slightly from the published version

There is no such thing as color. It does not exist in and of itself. All through my life as an artist until I began to experiment with the air brush I accepted color as a fact—something to be squeezed out of a tube and resupplied when the tube was empty. It could be a crayon, a pastel chalk, jars of Rich Art tempera, but always "color" was "color." "Cadmium Red" was a fact. I was well aware of the subtle differences between brands—Shiva Alizarin Crimson was oilier than Winsor & Newton Alizarin. Winsor & Newton Cadmium Red was richer than Grumbacher Cadmium Red. My concept was that color was a material substance. It is not!

Color should be thought of in terms of light. Webster's dictionary says that color is "the sensation resulting from stimulation of the retina of the eye by light waves of certain lengths." My definition of color is that "color is created by light waves of various lengths hitting a particular surface. The surface may be absorbent, reflective, textured, or smooth. Each sur-

face will affect the wave lengths differently and thereby create different colors. These wave lengths will affect the retina and the eye will perceive color."

Each color has its own wave length, or better still, each wave length has its own color. The light which Newton separated into seven distinct colors, with individual wave lengths, is called a spectrum . . . red, orange, yellow, green, blue, indigo, violet. Light travels at 186,000 miles per second in wave lengths and as it travels it *vibrates*. It is these reflective rays or vibrations we perceive as color. Objects themselves are colorless. They appear to be colored because they absorb certain wave lengths and reflect others.

In 1969, while analyzing a projected slide on a white smoothly sanded canvas, I noticed that what appeared to be color really was dots of red, yellow, and blue, mingled together to produce all other shades. Nowhere was there a flat opaque mass of color; rather there were dots or globules which gave the effect of color. As I stood in my semi-darkened studio I realized that all of this color was being produced by a single light (250 watt halogen bulb) being projected through a gelatinous slide. Without the light there would be no color. Physicists use the term "excited." They say color becomes excited by light. Color is not stable, it changes as light changes . . . daylight . . . bluish light . . . sunlight . . . moonlight . . . neon light . . . bright light . . . semi-shade . . . darkened room . . . hazy or misty light . . . clear filtered light, etc. It is chameleon-like, changing with the properties of light.

When I began working with the air brush, I realized that spraying (Cadmium Red light, for instance) produces a completely different color than applying it with a brush. Spraying produces small beads of color and the density of the application affects the intensity of the color. No matter how densely I sprayed the surface, it still appeared different from the painted Cadmium Red light. Both were acrylic, both were applied to a similar surface, but the air-brushed paint appeared foamy, lighter, smoother, and alive in another way. Yet the colors came from the same jar of paint. Light was reflecting differently being bounced off thousands of tiny particles than off a brush-painted surface.

I had had the experience of seeing full color reproductions in fine art books—and then seeing the original paintings which pale in comparison to the reproductions. I didn't want that to happen to my work. I also realized how accustomed our eyes have become to intense color—Koda-color blue sky is hardly natural; TV color is not realistic.

My experiments with color, light and the air brush affected the way I painted. Working in a semi-darkened room necessitated pre-mixing colors. I was consistently amazed to see that colors mixed in a dimly lit room,

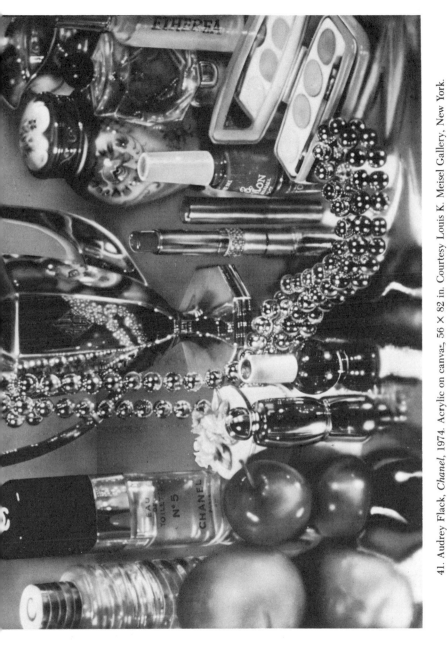

41. Audrey Flack, *Chanel*, 1974. Acrylic on canvas, 56 × 82 in. Courtesy Louis K. Meisel Gallery, New York.

which matched exactly the projected image color, were between five and ten shades off in full light.

My thought process gradually changed. I began thinking in terms of light rather than color. I would select a pigment and apply it to a surface which I knew would reflect light. Conversely if I wanted a dark, I would select a pigment with non-reflective qualities and apply it to an absorbent surface. In many cases the color of the pigment was secondary and I could pick any one of many colors to achieve the desired effect.

Several paintings were made with a 3-color process using Acra Violet, Cadmium Yellow and Pthalocyanine Blue.

The red sprayed over yellow became orange (various shades), over the blue it became shades of violet and indigo. Pthalocyanine Blue over base yellow and red becomes all shades of greens, reds, violets. The entire spectrum is possible. The colors seem to get mixed in the air . . . the final mix takes place on the canvas.

When visible light is refracted we get a rainbow ranging from short wave lengths to long wave lengths . . . violet, indigo, blue, green, yellow, orange, red. This field of energy is all around us. What one perceives as a result of this energy is illusion. Only the energy itself is real. Color does not exist in actuality. It is only a sensation in our consciousness.

CHUCK CLOSE (1940-)

Excerpted from an interview by Linda Chase and Robert Feldman in "The Photo-Realists: 12 Interviews," *Art in America* (Special Issue, November–December 1972)

How did you start making these paintings?

C.C.: I was really disgusted with the paintings I'd been making, and I was really disgusted with my education—because I'd been such a good student, and to be a good student you have to be a performing artist. You know what you can do and you are rewarded for it. I'd been told that I had a "good hand"—which basically meant I made good art marks. My hand moves in ways that made these art marks quite easily, and I could imitate other people's art marks, so what I made was art. The other thing I was told was that I had a "good sense of color," whatever that is. I guess it means that I know magenta and red don't clash. So for a long time my paintings were full of personal cliché marks, very eclectic and full of these pat color solutions. So I just stopped. Made a clear break. I decided I didn't want to make those paintings anymore; I wanted to do something

different, to force myself to make new solutions. So, I decided to work from photographs, not because that's what I wanted my art to be about, but because no matter how interesting a shape was, if it wasn't in the photograph I couldn't use it.

So you consciously made yourself into a different kind of painter?

c.c.: Yes. It wasn't that what I was doing was not me, but that it was only one aspect of the things I was thinking about. And since it had become so habitual, even the strongest things about my work were tainted by the lazy habitual things. It seemed better to get rid of it all.

How do you choose the subject matter?

c.c.: I paint my friends because they put up with it. . . . People are important to other people, so they're important to me. Also, likeness is a by-product of the way I work. Another reason I use my friends instead of a totally anonymous photograph is that it would really bother me if it didn't come out right. It would bother me even more if I did a lousy job of translating the photograph of someone I know.

What about the painting you did of yourself? Was that done for a special reason?

c.c.: I had just made a 22-foot painting of a nude which had hot spots—highly symbolic areas which won over the other areas. Also, the painting was too small; it was 22 feet long, but the pieces were too small. I wanted to get away from hot subject matter, and I wanted bigger scale, so I needed some part of the body. The head seemed to be the most obvious, and I just happened to be the only person in the room.

Was that the first one you did?

c.c.: Yes. Actually what I was doing was photographing the painting, and I had some film left and photographed myself to see what it might be like to make a painting of the head. I liked the photo and made the painting. Maybe I make it sound like the subject matter is totally unimportant to me. That's actually not true.

I go to a great deal of trouble to get the specific kind of photograph that is going to have the kind of information that's interesting to me: texture, elaborate depth of field—and the distance I shoot them from is important. I don't want the eyes to follow you like in a traditional portrait, but I also don't want them to be staring through people. If the camera is about 6 feet away from the subject, it turns out about right.

There seems to be some critical disdain for artists who work from photographs.

c.c.: Yes. I think sometimes people think that just because you use a photograph there is only one kind of painting that could be made. Just as many different kinds of paintings can be made from a photograph as from life. You look at certain things rather than others, and some people prefer a greater degree of fidelity to the information on the photograph than others.

Are you interested in reproducing the photograph?

c.c.: I am trying to make it very clear that I am making paintings from photographs and that this is not the way the human eye sees it. If I stare at this it's sharp, and if I stare at that it's sharp too. The eye is very flexible, but the camera is a one-eye view of the world, and I think we know what a blur looks like only because of photography. It really nailed down blur. It's this elusive thing, and the camera gives you information that was too difficult to deal with otherwise.

How do you get your extreme range of focus?

c.c.: At first I just had everything from the nose back to the cheeks sharp, and that defined the back edge of the focus. Then I decided that I wanted to make it a much shallower depth of field, and have the tip of the nose begin to blur, and I would have a sandwich. I would establish both dimensions of the focus. In the first one it obviously happened by accident, but I liked what happened. I liked the fact that I wasn't thinking of the cheek in relation to the ear and trying to decide which was closer and which farther away—a kind of traditional "things in front, things in the middle, things in the back" kind of reading—that if a person were simply panning across or scanning the cheek and some informational change took place, he would realize that he was moving back and forth in space. To the degree that something is out of focus, other areas that are similarly out of focus are on the same level in space. It gives me different constants to deal with. It's different to make a blurry soft thing than it is to make a hard thing.

Your paintings have an automatic composition?

c.c.: Right. I have nailed down the size; my black-and-white paintings are all the same size, and the color paintings are all the same, and I have a system for how the head is going to fit into the rectangle. The head is going to be so big, it's going to come so close to the top edge, and it's going to be centered left and right. I just didn't want to worry about composition as I had for so long. One of the reasons I wanted to make these paintings originally was that I had worried for so long about pulling paintings off. I would have good days and bad days. The painting would be up, it would be down. I would be fixing one corner and the whole

42. Chuck Close, *Frank*, 1969. Acrylic on cavas, 9 × 7 ft. The Minneapolis Institute of Arts.

other corner would go to pieces. I was thinking about painting as "first aid," and when I got the painting patched up I would call it quits. I decided to determine what the attitude was and try to maintain it and just go through the painting. Every day I got more done, and eventually it would be completed. If it wasn't good it was the whole painting that was not good.

Why did you start the color paintings?

c.c.: After a while with the black-and-white paintings I began to get into cliché marks again, so I decided to change the problem. But I didn't want to change everything, so I decided I would alter one variable and try color. The minimum number of colors to get full color is three, so I had the transfers made and started trying color. I used to have five or six favorite colors that I would use. Now I use three colors and I have to use all three. I can't prefer one to the other. Every square inch has some of all three. One result is that I'm mixing colors I never made in my life. I find it very liberating to accept things from the start as the eventual issues in the painting.

Some people would think of that as more restricting than liberating.

c.c.: Right, but every limitation I have made has just opened things up and made it much more possible to make decisions. When everything in the world was a possibility I only tried three things or four things over and over. . . . I didn't take advantage of that supposed freedom, and once I decided I was going to have relatively severe limitations, everything opened up . . . I was never happy inventing interesting shapes and interesting color combinations because all I could think of was how other people had done it. . . . Now there is no invention at all; I simply accept the subject matter. I accept the situation. There is still invention. It's a different kind of invention. It's "how to do it," and I find that, as a kind of invention, much more interesting. I do think approaching a painting that way—with any kind of self-imposed discipline—ultimately affects the subject matter. That's what sustains me. I'm not concerned with painting people or with making humanist paintings.

DUANE HANSON (1925–)

Excerpted from Linda Chase and Ted McBurnett, Interview with Duane Hanson in "The Photo-Realists: 12 Interviews," *Art in America* (Special Issue, November–December 1972)

How long does it take to make a body cast?

D.H.: I try to do it in less than three hours—one leg and then the other leg, up to the neck, the arms, the head.

Do you do it with their clothes on or off?

D.H.: Well, with the clothes off. We have a little wrap around them.

Then you put the clothes on them?

D.H.: Yes.

Do you go out and buy clothes for the figures?

D.H.: Sometimes, especially when you have something as large as that fat lady over there. I have to go to great lengths to buy them. Twenty-five dollars for her bathing suit. You can't just go to a thrift shop. This lady vacuuming is my aunt. Those are the clothes she actually wears. She gave me those. I like to do a type like that, it's so funny. She was a good sport to give the clothes to me. Otherwise you just pick the clothing up at a thrift shop. The clothes for the boxers cost over one hundred dollars.

Are you going to make the boxers' shoes look old?

D.H.: Well, they always use new equipment. I am going to dirty them up a little bit. I may also bloody them up a little bit, but you have to be careful about that. Like the soldiers I did. I almost sold them to a museum in Canada, but they had too much blood on them. . . .

Have you ever painted?

D.H.: I never painted in my life. That's why it's very difficult. When I started to paint them, I used to mix a little paint in the resin. Then I would go over that with a little color and make the highlights. I used acrylics at first, but they dry so fast and then they change colors. I got rid of that and went to oil paints. There is a little change there; they get a little darker, but not much. The main thing is the flesh.

Do you paint them entirely?

D.H.: Yes, but painting on a three-dimensional surface is difficult. When you paint the lower part and then stand up and look at it it looks different, so you have to try it from all angles. It drives me nuts. It's got to blend and be the right value and tone. It's really fun, but it wears me out.

Are these techniques that you have come up with yourself?

D.H.: Yes.

Does John de Andrea paint his figures?

43. Duane Hanson, *Worker with Pipes (Plumber),* 1977. Cast vinyl, polychromed in oil, lifesize. Collection Lewis Pollock, Waltham, Mass. (*Photo: Courtesy O. K. Harris Works of Art, New York*)

D.H.: Yes, he sprays his. I think I may spray mine some day because the way I work I do get a little texture. But I like the way I am working at this time, because I get stronger colors. I used to care more about things like that. Who cares whether you take a brush or use a spray or whether you model it in clay or take the mold off somebody's body? The end result is what's important. I could take clay and model the figure but it would take six months, and I just don't have six months for one figure. Anyway, who would care? Who would know the difference? What's the use? Whatever means fits the end you want, that's what you ought to use. I think you can get all wound up in things that don't matter. . . .

Do you feel that your sculpture or the way you think about it relates to the media or to photography?

D.H.: Well, there is certain imagery that I identify with. I will see a picture in the newspaper, especially sports and action. Sometimes you see a gruesome sight like an accident or a war scene where the imagery is powerful, but if I try to copy the poses it doesn't work. I tried that once with football players and it just didn't work out, so I use the picture as a point of departure. With everyday scenes, I just imagine those.

One of Ivan Karp's definitions of New Realism is that it doesn't make any comment; it's objective.

D.H.: Yes, he is referring to the paintings. In a way I fit in and in a way I don't. New Realist painting reflects everyday life or what we are thinking about, whatever it is you recognize, imagery you are confronted with. But it's not like Pop Art, it's more reserved; it's just taking it with no comment. To me that wasn't enough. I wanted to comment and was criticized that I was doing it for shock. For me, I feel that I have to identify with those lost causes, revolutions and so forth. I am not satisfied with the world. Not that I think you can change it, but I just want to express my feelings of dissatisfaction. Everybody feels dissatisfied. If the artist doesn't reflect that, if he says, "Oh no, this doesn't exist," I don't think he is being honest. I try to be honest about what I feel myself, and what others feel, and express it. If art can't reflect life and tell us more about life, I don't think it's an art that will be very lasting and durable. In other words, decoration. Something that looks nice to hang on the wall. It still gives us pleasure, but how meaningful is it? It's just the happy reflection of a world that doesn't exist.

9

Earth and Process Art

In October 1968, the Dwan Gallery in New York, acknowledging a trend that had been brewing for some time, presented an *Earthworks* show with exhibits by Andre, Heizer, Morris, Oldenburg, Oppenheim, Smithson, and others. Early the following year, an *Earth Art* exhibition was held at the Andrew Dickson White Museum, Cornell University, at which the artists, including Europeans, did actual outdoor projects, as well as indoor installations, thus establishing one of several alternatives to the art-commodity system (others include street art, performance, and video). Earth work constitutes a kind of direct dialogue with nature; some of it is arrogant, scarring the land, but more often there is a balanced give and take. Robert Smithson, who died so cruelly young in an air crash while working on his *Amarillo Ramp*, preferred to construct his pieces in areas that had been ruined or exhausted, virtually recycling them, as in his famous *Spiral Jetty* at Great Salt Lake, Utah. Like the earth work itself, his *Spiral Jetty* film is one of the classics of its genre. His numerous essays, poetic, scientific, provocative, dense, have been compiled and edited by his widow, the artist Nancy Holt: *The Writings of Robert Smithson*, New York, 1979.

Earth art is related to minimalism in its "unitary" forms and bold, aggressive character. While the earth artists share a fundamental aim— to extend the limits of art—the need to break away from the buyable/ sellable commodity aspect of the gallery system was not a motivating force for all of them, as is clear from the *Avalanche* discussion below.

ROBERT SMITHSON (1938-1973)

Excerpted from "The Spiral Jetty," in Gyorgy Kepes, ed., *Arts of the Environment,* New York, 1972

> *Red is the most joyful and dreadful thing in the physical universe; it is the fiercest note, it is the highest light, it is the place where the walls of this world of ours wear the thinnest and something beyond burns through.*
>
> —G. K. CHESTERTON

169

My concern with salt lakes began with my work in 1968 on the Mono Lake Site-Nonsite in California.[1] Later I read a book called *Vanishing Trails of Atacama* by William Rudolph which described salt lakes (salars) in Bolivia in all stages of desiccation, and filled with micro bacteria that give the water surface a red color. . . . Because of the remoteness of Bolivia and because Mono Lake lacked a reddish color, I decided to investigate the Great Salt Lake in Utah.

. . . I called the Utah Park Development and spoke to Ted Tuttle, who told me that water in the Great Salt Lake north of the Lucin Cutoff, which cuts the lake in two, was the color of tomato soup. That was enough of a reason to go out there and have a look. . . . We visited Charles Stoddard . . . a well-driller . . . one of the last homesteaders in Utah. . . . He was kind enough to take us to Little Valley on the East side of the Lucin Cutoff. . . . He showed us photographs he had taken of "icebergs,"[2] and Kit Carson's cross carved on a rock on Fremont Island. We then decided to leave and go to Rozel Point.

[1] Dialectic of Site and Nonsite

Site	*Nonsite*
1. Open Limits	Closed Limits
2. A Series of Points	An Array of Matter
3. Outer Coordinates	Inner Coordinates
4. Subtraction	Addition
5. Indeterminate Certainty	Determinate Uncertainty
6. Scattered Information	Contained Information
7. Reflection	Mirror
8. Edge	Center
9. Some Place (physical)	No Place (abstract)
10. Many	One

Range of Convergence

The range of convergence between Site and Nonsite consists of a course of hazards, a double path made up of signs, photographs, and maps that belong to both sides of the dialectic at once. Both sides are present and absent at the same time. The land or ground from the Site is placed *in* the art (Nonsite) rather than the art placed *on* the ground. The Nonsite is a container within another container—the room. The plot or yard outside is yet another container. Two-dimensional and three-dimensional things trade places with each other in the range of convergence. Large scale becomes small. Small scale becomes large. A point on a map expands to the size of the land mass. A land mass contracts into a point. Is the Site a reflection of the Nonsite (mirror), or is it the other way around? The rules of this network of signs are discovered as you go along uncertain trails both mental and physical. . . .

[2] "In spite of the concentrated saline quality of the water, ice is often formed on parts of the Lake. Of course, the lake brine does not freeze; it is far too salty for that. What actually happens is that during relatively calm weather, fresh water from the various streams flowing into the lake 'floats' on top of the salt water, the two failing to mix. Near mouths of rivers and creeks this 'floating' condition exists at all times during calm weather. During the winter this fresh water often freezes before it mixes with the brine. Hence, an ice sheet several inches thick has been known to extend from Weber River to Fremont Island, making it possible for coyotes to cross to the island and molest sheep pastured there. At times this ice breaks loose and floats about the lake in the form of 'icebergs'"—David E. Miller, *Great Salt Lake Past and Present*, Pamphlet, Utah History Atlas, Salt Lake City, 1949.

Driving west on Highway 83 . . . we passed through Corinne, then went on to Promontory. Just beyond the Golden Spike Monument, which commemorates the meeting of the rails of the first transcontinental railroad, we went down a dirt road in a wide valley. As we traveled, the valley spread into an uncanny immensity unlike the other landscapes we had seen. The roads on the map became a net of dashes, while in the far distance the Salt Lake existed as an interrupted silver band. Hills took on the appearance of melting solids, and glowed under amber light. We followed roads that glided away into dead ends. Sandy slopes turned into viscous masses of perception. Slowly, we drew near to the lake, which resembled an impassive faint violet sheet held captive in a stoney matrix, upon which the sun poured down its crushing light. An expanse of salt flats bordered the lake, and caught in its sediments were countless bits of wreckage. Old piers were left high and dry. The mere sight of the trapped fragments of junk and waste transported one into a world of modern prehistory. The products of a Devonian industry, the remains of a Silurian technology, all the machines of the Upper Carboniferous Period were lost in those expansive deposits of sand and mud.

Two dilapidated shacks looked over a tired group of oil rigs. A series of seeps of heavy black oil more like asphalt occur just south of Rozel Point. For forty or more years people have tried to get oil out of this natural tar pool. Pumps coated with black stickiness rusted in the corrosive salt air. A hut mounted on pilings could have been the habitation of "the missing link." A great pleasure arose from seeing all those incoherent structures. This site gave evidence of a succession of man-made systems mired in abandoned hopes.

About one mile north of the oil seeps I selected my site. Irregular beds of limestone dip gently eastward, massive deposits of black basalt are broken over the peninsula, giving the region a shattered appearance. It is one of few places on the lake where the water comes right up to the mainland. Under shallow pinkish water is a network of mud cracks supporting the jig-saw puzzle that composes the salt flats. As I looked at the site, it reverberated out to the horizons only to suggest an immobile cyclone while flickering light made the entire landscape appear to quake. A dormant earthquake spread into the fluttering stillness, into a spinning sensation without movement. This site was a rotary that enclosed itself in an immense roundness. From that gyrating space emerged the possibility of the *Spiral Jetty*. No ideas, no concepts, no systems, no structures, no abstractions could hold themselves together in the actuality of that evidence. My dialectics of site and nonsite whirled into an indeterminate state, where solid and liquid lost themselves in each other. It was as if the mainland oscillated with waves and pulsations, and the lake remained rock still. The shore of the lake became the edge of the sun, a boiling

curve, an explosion rising into a fiery prominence. Matter collapsing into the lake mirrored in the shape of a spiral. No sense wondering about classifications and categories, there were none.

After securing a twenty year lease on the meandering zone,[3] and finding a contractor in Ogden, I began building the jetty in April, 1970. Bob Phillips, the foreman, sent two dump trucks, a tractor, and a large front loader out to the site. The tail of the spiral began as a diagonal line of stakes that extended into the meandering zone. A string was then extended from a central stake in order to get the coils of the spiral. From the end of the diagonal to the center of the spiral, three curves coiled to the left. Basalt and earth was scooped up from the beach at the beginning of the jetty by the front loader, then deposited in the trucks, whereupon the trucks backed up to the outline of stakes and dumped the material. On the edge of the water, at the beginning of the tail, the wheels of the trucks sank into a quagmire of sticky gumbo mud. A whole afternoon was spent filling in this spot. Once the trucks passed that problem, there was always the chance that the salt crust resting on the mud flats would break through. The *Spiral Jetty* was staked out in such a way as to avoid the soft muds that broke up through the salt crust, nevertheless there were some mud fissures that could not be avoided. One could only hope that tension would hold the entire jetty together, and it did. A cameraman was sent by the Ace Gallery in Los Angeles to film the process.

The scale of the *Spiral Jetty* tends to fluctuate depending on where the viewer happens to be. Size determines an object, but scale determines art. A crack in the wall if viewed in terms of scale, not size, could be called the Grand Canyon. A room could be made to take on the immensity of the solar system. Scale depends on one's capacity to be conscious of the actualities of perception. When one refuses to release scale from size, one is left with an object or language that *appears* to be certain. For me scale operates by uncertainty. To be in the scale of the *Spiral Jetty* is to be out of it. On eye level, the tail leads one into an undifferentiated state of matter. One's downward gaze pitches from side to side, picking out random depositions of salt crystals on the inner and outer edges, while the entire mass echoes the irregular horizons. And each cubic salt crystal echoes the *Spiral Jetty* in terms of the crystal's molecular lattice. Growth in a crystal advances around a dislocation point, in the manner of a screw. The

[3] *Township 8 North of Range 7 West of the Salt Lake Base and Meridian:* Unsurveyed land on the bed of the Great Salt Lake, if surveyed, would be described as follows:

Beginning at a point South 3000 feet and west 800 feet from the Northeast Corner of Section 8, Township 8 North, Range 7 West; thence South 45° West 651 feet; thence North 60° West 651 feet; thence North 45° East 651 feet; thence Southeasterly along the meander line 675 feet to the point of beginning.

Containing 10,000 acres, more or less (*Special Use Lease Agreement No. 222;* witness: Mr. Mark Crystal).

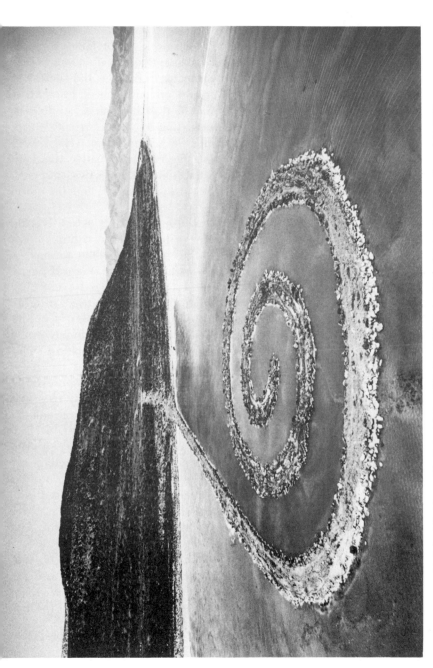

44. Robert Smithson, *The Spiral Jetty*, 1970. Great Salt Lake, Utah. (*Photo: Gian Franco Gorgoni, courtesy John Weber Gallery, New York*)

Spiral Jetty could be considered one layer within the spiraling crystal lattice, magnified trillions of times.

This description echoes and reflects Brancusi's sketch of James Joyce as a "spiral ear" because it suggests both a visual and an aural scale, in other words it indicates a sense of scale that resonates in the eye and the ear at the same time. Here is a reinforcement and prolongation of spirals that reverberates up and down space and time. So it is that one ceases to consider art in terms of an "object." The fluctuating resonances reject "objective criticism," because that would stifle the generative power of both visual and auditory scale. Not to say that one resorts to "subjective concepts," but rather that one apprehends what is around one's eyes and ears, no matter how unstable or fugitive. One seizes the spiral, and the spiral becomes a seizure.

After a point, measurable steps ("Scale skal n. It. or L; It. *Scala*; L *scala* usually *scalae* pl., l. a. originally a ladder; a flight of stairs; hence, b. a means of ascent"[4]) descend from logic to the "surd state." The rationality of a grid on a map sinks into what it is supposed to define. Logical purity suddenly finds itself in a bog, and welcomes the unexpected event. The "curved" reality of sense perception operates in and out of the "straight" abstractions of the mind. The flowing mass of rock and earth of the *Spiral Jetty* could be trapped by a grid of segments, but the segments would exist only in the mind or on paper. Of course, it is also possible to translate the mental spiral into a three-dimensional succession of measured lengths that would involve areas, volumes, masses, moments, pressures, forces, stresses, and strains; but in the *Spiral Jetty* the surd takes over and leads one into a world that cannot be expressed by number or rationality. Ambiguities are admitted rather than rejected, contradictions are increased rather than decreased—the *alogos* undermines the *logos*. Purity is put in jeopardy. I took my chances on a perilous path, along which my steps zigzagged, resembling a spiral lightning bolt. "We have found a strange footprint on the shores of the unknown. We have devised profound theories, one after another, to account for its origin. At last, we have succeeded in constructing the creature that made the footprint. And lo! it is our own."[5] For my film (a film is a spiral made up of frames) I would have myself filmed from a helicopter (from the Greek *helix, helikos* meaning spiral) directly overhead in order to get the scale in terms of erratic steps.

Chemically speaking, our blood is analogous in composition to the pri-

[4] *Webster's New World Dictionary of the American Language* (College edition), New York: World Publishing Co., 1959.

[5] A. S. Eddington, quoted on p. 232 in Tobias Dantzig's *Number, the Language of Science*, New York: Doubleday Anchor Books, 1954.

mordial seas. Following the spiral steps we return to our origins, back to
some pulpy protoplasm, a floating eye adrift in an antediluvian ocean. On
the slopes of Rozel Point I closed my eyes, and the sun burned crimson
through the lids. I opened them and the Great Salt Lake was bleeding
scarlet streaks. My sight was saturated by the color of red algae circulat-
ing in the heart of the lake, pumping into ruby currents, no they were
veins and arteries sucking up the obscure sediments. My eyes became
combustion chambers churning orbs of blood blazing by the light of the
sun. All was enveloped in a flaming chromosphere; I thought of Jackson
Pollock's *Eyes in the Heat* (1946; Peggy Guggenheim Collection). Swirl-
ing within the incandescence of solar energy were sprays of blood. My
movie would end in sunstroke. Perception was heaving, the stomach turn-
ing, I was on a geologic fault that groaned within me. Between heat light-
ning and heat exhaustion the spiral curled into vaporization. I had the red
heaves, while the sun vomited its corpuscular radiations. Rays of glare hit
my eyes with the frequency of a Geiger counter. Surely, the storm clouds
massing would turn into a rain of blood. Once, when I was flying over the
lake, its surface seemed to hold all the properties of an unbroken field of
raw meat with gristle (foam); no doubt it was due to some freak wind
action. Eyesight is often slaughtered by the other senses, and when that
happens it becomes necessary to seek out dispassionate abstractions. The
dizzying spiral yearns for the assurance of geometry. One wants to retreat
into the cool rooms of reason. But no, there was Van Gogh with his easel
on some sun-baked lagoon painting ferns of the Carboniferous Period.
Then the mirage faded into the burning atmosphere. . . .

The helicopter maneuvered the sun's reflection through the *Spiral Jetty*
until it reached the center. The water functioned as a vast thermal mirror.
From that position the flaming reflection suggested the ion source of a
cyclotron that extended into a spiral of collapsed matter. All sense of ener-
gy acceleration expired into a rippling stillness of reflected heat. A with-
ering light swallowed the rocky particles of the spiral, as the helicopter
gained altitude. All existence seemed tentative and stagnant. The sound of
the helicopter motor became a primal groan echoing into tenuous aerial
views. Was I but a shadow in a plastic bubble hovering in a place outside
mind and body? *Et in Utah ego.* I was slipping out of myself again,
dissolving into a unicellular beginning, trying to locate the nucleus at the
end of the spiral. All that blood stirring makes one aware of protoplasmic
solutions, the essential matter between the formed and the unformed,
masses of cells consisting largely of water, proteins, lipoids, carbohydrates,
and inorganic salts. Each drop that splashed onto the *Spiral Jetty* coagu-
lated into a crystal. Undulating waters spread millions upon millions of
crystals over the basalt.

The preceding paragraphs refer to a "scale of centers" that could be disentangled as follows:

> (a) ion source in cyclotron
> (b) a nucleus
> (c) dislocation point
> (d) a wooden stake in the mud
> (e) axis of helicopter propeller
> (f) James Joyce's ear channel
> (g) the Sun
> (h) a hole in the film reel.

Spinning off of this uncertain scale of centers would be an equally uncertain "scale of edges":

> (a) particles
> (b) protoplasmic solutions
> (c) dizziness
> (d) ripples
> (e) flashes of light
> (f) sections
> (g) foot steps
> (h) pink water.

The equation of my language remains unstable, a shifting set of coordinates, an arrangement of variables spilling into surds. My equation is as clear as mud—a muddy spiral.

Back in New York, the urban desert, I contacted Bob Fiore and Barbara Jarvis and asked them to help me put my movie together. The movie began as a set of disconnections, a bramble of stabilized fragments taken from things obscure and fluid, ingredients trapped in a succession of frames, a stream of viscosities both still and moving. And the movie editor bending over such a chaos of "takes" resembles a paleontologist sorting out glimpses of a world not yet together, a land that has yet to come to completion, a span of time unfinished, a spaceless limbo on some spiral reels. Film strips hung from the cutter's rack, bits and pieces of Utah, outtakes overexposed and underexposed, masses of impenetrable material. The sun, the spiral, the salt buried in lengths of footage. Everything about movies and moviemaking is archaic and crude. One is transported by this Archeozoic medium into the earliest known geological eras. The movieola becomes a "time machine" that transforms trucks into dinosaurs. Fiore pulled lengths of film out of the movieola with the grace of a Neanderthal pulling intestines from a slaughtered mammoth. Outside his 13th Street loft window one expected to see Pleistocene faunas, glacial uplifts, living fossils, and other prehistoric wonders. Like two cavemen we plotted how

to get to the *Spiral Jetty* from New York City. A geopolitics of primordial return ensued. How to get across the geography of Gondwanaland, the Austral Sea, and Atlantis became a problem. Consciousness of the distant past absorbed the time that went into the making of the movie. I needed a map that would show the prehistoric world as coextensive with the world I existed in.

I found an oval map of such a double world. The continents of the Jurassic Period merged with continents of today. A microlense fitted to the end of a camera mounted on a heavy tripod would trace the course of "absent images" in the blank spaces of the map. The camera panned from right to left. One is liable to see things in maps that are not there. One must be careful of the hypothetical monsters that lurk between the map's latitudes; they are designated on the map as black circles (marine reptiles) and squares (land reptiles). In the pan shot one doesn't see the flesh-eaters walking through what today is called Indo-China. There is no indication of Pterodactyls flying over Bombay. And where are the corals and sponges covering southern Germany? In the emptiness one sees no Stegosaurus. In the middle of the pan we see Europe completely under water, but not a trace of the Brontosaurus. What line or color hides the Globigerina Ooze? I don't know. As the pan ends near Utah, on the edge of Atlantis, a cut takes place, and we find ourselves looking at a rectangular grid known as Location NK 12–7 on the border of a map drawn up [by] the U.S. Geological Survey showing the northern part of the Great Salt Lake without any reference to the Jurassic Period.

... the earth's history seems at times like a story recorded in a book each page of which is torn into small pieces. Many of the pages and some of the pieces of each page are missing. ... [6]

I wanted Nancy to shoot "the earth's history" in one minute for the third section of the movie. I wanted to treat the above quote as a "fact." We drove out to the Great Notch Quarry in New Jersey, where I found a quarry facing about 20 feet high. I climbed to the top and threw handfuls of ripped-up pages from books and magazines over the edge, while Nancy filmed it. Some ripped pages from an Old Atlas blew across a dried out, cracked mud puddle. ...

The movie recapitulates the scale of the *Spiral Jetty*. Disparate elements assume a coherence. Unlikely places and things were stuck between sections of film that show a stretch of dirt road rushing to and from the actual site in Utah. A road that goes forward and backward between things and places that are elsewhere. You might even say that the road is

[6] Thomas H. Clark & Colin W. Stern, *Geological Evolution of North America*, New York: Ronald Press, n.d., p. 5.

nowhere in particular. The disjunction operating between reality and film drives one into a sense of cosmic rupture. Nevertheless, all the improbabilities would accommodate themselves to my cinematic universe. Adrift amid scraps of film, one is unable to infuse into them any meaning, they seem worn-out, ossified views, degraded and pointless, yet they are powerful enough to hurl one into a lucid vertigo. The road takes one from a telescopic shot of the Sun to a Quarry in Great Notch, New Jersey, to a map showing the "deformed shorelines of ancient Lake Bonneville," to *The Lost World,* and to the Hall of Late Dinosaurs in [the] American Museum of Natural History.

The hall was filmed through a red filter. The camera focuses on an Ornithominus altus embedded in plaster behind a glass case. A pan across the room picked up a crimson chiaroscuro tone. There are times when the great outdoors shrinks phenomenologically to the scale of a prison, and times when the indoors expands to the scale of the universe. So it is with the sequence from the Hall of Late Dinosaurs. An interior immensity spreads throughout the hall, transforming the lightbulbs into dying suns. The red filter dissolves the floor, ceiling and walls into halations of infinite redness. Boundless desolation emerged from the cinematic emulsions, red clouds, burned from the intangible light beyond the windows, visibility deepened into ruby dispersions. The bones, the glass cases, the armatures brought forth a blood-drenched atmosphere. Blindly the camera stalked through the sullen light. Glassy reflections flashed into dissolutions like powdered blood. Under a burning window the skull of a Tyrannosaurus was mounted in a glass case with a mirror under the skull. In this limitless scale one's mind imagines things that are not there. The blood-soaked dropping of a sick Duck-billed Dinosaur, for instance. Rotting monster flesh covered with millions of red spiders. Delusion follows delusion. The ghostly cameraman slides over the glassed-in compounds. These fragments of a timeless geology laugh without mirth at the time-filled hopes of ecology. From the soundtrack the echoing metronome vanishes into the wilderness of bones and glass. Tracking around a glass containing a "dinosaur mummy," the words of *The Unnamable* are heard. The camera shifts to a specimen squeezed flat by the weight of sediments, then the film cuts to the road in Utah.

MICHAEL HEIZER (1944-) / DENNIS OPPENHEIM (1938-) / ROBERT SMITHSON (1938-1973)

Excerpted from "Discussions with [Michael] Heizer, [Dennis] Oppenheim, [Robert] Smithson," *Avalanche*, (Fall 1970). The discussions were held in December 1968 and January 1969.

Dennis, how did you first come to use earth as sculptural material?

D.O.: Well, it didn't occur to me at first that this was what I was doing. Then gradually I found myself trying to get below ground level.

Why?

D.O.: Because I wasn't very excited about objects which protrude from the ground. I felt this implied an embellishment of external space. To me a piece of sculpture inside a room is a disruption of interior space. It's a protrusion, an unnecessary addition to what could be a sufficient space in itself. My transition to earth materials took place in Oakland a few summers ago, when I cut a wedge from the side of a mountain. I was more concerned with the negative process of excavating that shape from the mountainside than with making an earth work as such. It was just a coincidence that I did this with earth.

You didn't think of this as an earth work?

D.O.: No, not then. But at that point I began to think very seriously about place, the physical terrain. And this led me to question the confines of the gallery space. . . .

A good deal of my preliminary thinking is done by viewing topographical maps and aerial maps and then collecting various data on weather information. Then I carry this with me to the terrestrial studio. For instance, my frozen lake project in Maine involves plotting an enlarged version of the International Date Line onto a frozen lake and truncating an island in the middle. I call this island a time-pocket because I'm stopping the IDL there. So this is an application of a theoretical framework to a physical situation—I'm actually cutting this strip out with chain saws. Some interesting things happen during this process: you tend to get grandiose ideas when you look at large areas on maps, then you find they're difficult to reach so you develop a strenuous relationship with the land. If I were asked by a gallery to show my Maine piece, obviously I wouldn't be able to. So I would make a model of it.

What about a photograph?

D.O.: O.K., or a photograph. I'm not really that attuned to photos to the extent to which Mike is. I don't really show photos as such. At the moment I'm quite lackadaisical about the presentation of my work; it's almost like a scientific convention. Now Bob's doing something very different. His non-site is an intrinsic part of his activity on the site, whereas my model is just an abstract of what happens outside and I just can't get that excited about it. Could you say something, Bob, about the way in which you choose your sites?

R.S.: . . . I started taking trips to specific sites in 1965: certain sites would appeal to me more—sites that had been in some way disrupted or pulverized. I was really looking for a denaturalization rather than built up scenic beauty. And when you take a trip you need a lot of precise data, so often I would use quadrangle maps; the mapping followed the traveling. The first non-site that I did was at the Pine Barrens in southern New Jersey. . . . There was a hexagon airfield there which lent itself very well to the application of certain crystalline structures which had preoccupied me in my earlier work. A crystal can be mapped out, and in fact I think it was crystallography which led me to map-making. . . . I decided to use the Pine Barrens site as a piece of paper and draw a crystalline structure over the landmass rather than on a 20 × 30 sheet of paper. In this way I was applying my conceptual thinking directly to the disruption of the site over an area of several miles. So you might say my non-site was a three-dimensional map of the site. . . .

Why do you still find it necessary to exhibit in a gallery?

R.S.: I like the artificial limits that the gallery presents. . . . I think art is concerned with limits and I'm interested in making art. I don't think you're freer artistically in the desert than you are inside a room.

Do you agree with that, Mike?

M.H.: I think you have just as many limitations, if not more, in a fresh air situation.

But I don't see how you can equate the four walls of a gallery, say, with the Nevada mudflats. Aren't there more spatial restrictions in a gallery?

M.H.: I don't particularly want to pursue the analogy between the gallery and the mudflats. I think the only important limitations on art are the ones imposed or accepted by the artist himself.

Then why do you choose to work outdoors?

M.H.: I work outside because it's the only place where I can displace mass. I like the scale—that's certainly one difference between working in a gal-

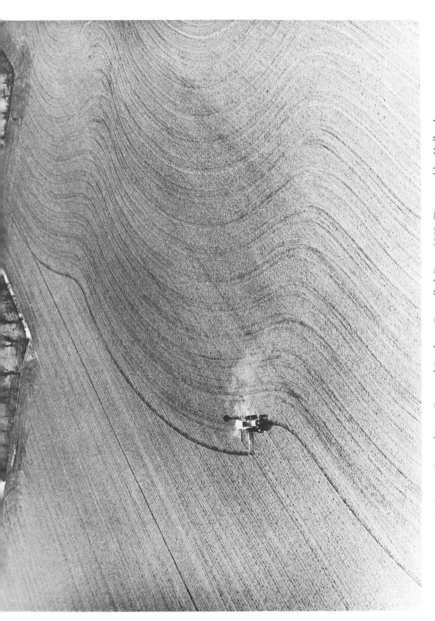

45. Dennis Oppenheim, *Directed Seeding, Cancelled Crop*, 1969. Finsterwolde, Holland. (*Photo: Courtesy Sonnabend Gallery, New York*)

lery and working outdoors. I'm not trying to compete in size with any natural phenomena, because it's technically impossible. . . .

Dennis, recently you have been doing really large-scale outdoor pieces. What propels you to work outdoors rather than in an already structured situation?

D.O.: I'm following a fairly free path at present so I'm not exclusively outdoors in that sense. In fact I'm tending to refer back to the gallery.

Why do you find that necessary?

D.O.: It's a kind of nostalgia, I think. It seems to me that a lot of problems are concerned mainly with presentation. For some people the gallery issue is very important now but I think that in time it will mellow. . . .

Bob, how would you describe the relation between the gallery exhibit and nature?

R.S.: I think we all see the landscape as coextensive with the gallery. I don't think we're dealing with matter in terms of a back to nature movement. For me the world is a museum. . . .

Mike, what are you trying to achieve by working in nature?

M.H.: Well, the reason I go there is because it satisfies my feeling for space. I like that space. That's why I choose to do my art there.

Has your knowledge of archaeological excavations had any bearing on your work?

M.H.: It might have affected my imagination because I've spent some time recording technical excavations. My work is closely tied up with my own experiences; for instance, my personal associations with dirt are very real. I really like to lie in the dirt. I don't feel close to it in the farmer's sense. . . . And I've transcended the mechanical, which was difficult. It wasn't a legitimate art transition but it was psychologically important because the work I'm doing now with earth satisfies some very basic desires.

So you're really happy doing it.

M.H.: Right. I'm not a purist in any sense and if I'm at all interested in Bob's or Dennis's work, it's because I sense in it the same kind of divergence from a single ideal as in my own. . . .

Why do you bother with non-site at all? . . . Why don't you just designate a site?

R.S.: Because I like the ponderousness of the material. I like the idea of shipping back the rocks across the country. It gives me more of a weighty

46. Michael Heizer, *Double Negative*, 1969–70. Rhyolite and sandstone, 240,000 tons displaced, 1500 × 50 × 30 ft. Virgin River Mesa, Nev. Collection Virginia Dwan. *(Photo: Courtesy Xavier Fourcade Gallery, New York)*

sensation. If I just thought about it and held it in my mind it would be a manifestation of idealistic reduction and I'm not really interested in that. . . .

What . . . about the relationship between your work and photographs of it?

R.S.: Photographs steal away the spirit of the work. . . .

What are your primary concerns, Mike, in carrying out one of your *Depressions*?

M.H.: I'm mainly concerned with physical properties, with density, volume, mass and space. For instance, I find an 18-foot-square granite boulder. That's mass. It's already a piece of sculpture. But as an artist it's not enough for me to say that, so I mess with it. . . . If you're a naturalist you'd say I defiled it, otherwise you'd say I responded in my own manner. And that was by putting some space under the boulder. My work is in opposition to the kind of sculpture which involves rigidly forming, welding, sealing, perfecting the surface of a piece of material. . . . Everything is beautiful, but not everything is art.

What makes it art?

M.H. I guess when you insist on it long enough, when you can convince someone else that it is. I think that the look of art is broadening. . . .

ROBERT MORRIS (1931-)

This concise essay, whose title was not the author's choosing, is a first declaration of process art, principally in its differences from minimal or object art, which Morris also characterizes here with the simplicity and clarity of his own minimal sculpture. For a more complex philosophic and thorough study of the new tendencies, see his "Notes on Sculpture, Part 4, Beyond Objects," *Artforum* (April 1969). An exhibition organized by Robert Morris at Castelli's warehouse in December 1968 marked the firm arrival of process art in distinct opposition to minimalism, the then dominant sculptural mode. Among the *Nine at Leo Castelli,* Morris included Richard Serra, Eva Hesse, Alan Saret, Bruce Nauman, all of whom had made sculptures of spineless material, acquiescent to gravity (rubber, string, cloth, wire, etc.). Oldenburg had made soft, sewn works of burlap and canvas at the beginning of the sixties, followed by his numerous vinyl pieces—telephones, bath tubs, and so on; his sculpture by sewing was as consequential an innovation

as sculpture by carpentry and by welding had been earlier in the century. Morris's show also included some works in solid materials—wood, metal, glass, and so on. However, unlike the static, unitary minimal objects executed in precisely planned forms, these pieces were randomly placed conglomerates of varied materials, shapes, and sizes or, as in the case of Serra's thrown lead piece, the form of the work was the direct result of the process of its making (throwing, cutting, hanging, etc.). Tightly contained, geometric, preordained forms were replaced by open, shifting, organically varied hangings, spreads, and sprawls. A few months later, the Whitney Museum presented a large overview of process art in its *Anti-Illusion: Procedures/Materials* show, organized by Marcia Tucker and James Monte.

Robert Morris, "Anti Form," *Artforum* (April 1968)

In recent object-type art the invention of new forms is not an issue. A morphology of geometric, predominantly rectangular forms has been accepted as a given premise. The engagement of the work becomes focused on the particularization of these general forms by means of varying scale, material, proportion, placement. Because of the flexibility as well as the passive, unemphasized nature of object-type shape it is a useful means. The use of the rectangular has a long history. The right angle has been in use since the first post and lintel constructions. Its efficiency is unparalleled in building with rigid materials, stretching a piece of canvas, etc. This generalized usefulness has moved the rectangle through architecture, painting, sculpture, objects. But only in the case of object-type art have the forms of the cubic and the rectangular been brought so far forward into the final definition of the work. That is, it stands as a self-sufficient whole shape rather than as a relational element. To achieve a cubic or rectangular form is to build in the simplest, most reasonable way, but it is also to build well.

This imperative for the well-built thing solved certain problems. It got rid of asymmetrical placing and composition, for one thing. The solution also threw out all non-rigid materials. This is not the whole story of so-called Minimal or Object art. Obviously it does not account for the use of purely decorative schemes of repetitive and progressive ordering of multiple unit work. But the broad rationality of such schemes is related to the reasonableness of the well-built. What remains problematic about these schemes is the fact that any order for multiple units is an imposed one which has no inherent relation to the physicality of the existing units. Permuted, progressive, symmetrical organizations have a dualistic character in relation to the matter they distribute. This is not to imply that these simple orderings do not work. They simply separate, more or less, from

what is physical by making relationships themselves another order of facts. The relationships such schemes establish are not critical from point to point as in European art. The duality is established by the fact that an order, any order, is operating beyond the physical things. Probably no art can completely resolve this. Some art, such as Pollock's, comes close.

The process of "making itself" has hardly been examined. It has only received attention in terms of some kind of mythical, romanticized polarity: the so-called action of the Abstract Expressionists and the so-called conceptualizations of the Minimalists. This does not locate any differences between the two types of work. The actual work particularizes general assumptions about forms in both cases. There are some exceptions. Both ways of working continue the European tradition of aestheticizing general forms that has gone on for half a century. European art since Cubism has been a history of permuting relationships around the general premise that relationships should remain critical. American art has developed by uncovering successive alternative premises for making itself.

Of the Abstract Expressionists only Pollock was able to recover process and hold on to it as part of the end form of the work. Pollock's recovery of process involved a profound rethinking of the role of both material and tools in making. The stick which drips paint is a tool which acknowledges the nature of the fluidity of paint. Like any other tool it is still one that controls and transforms matter. But unlike the brush it is in far greater sympathy with matter because it acknowledges the inherent tendencies and properties of that matter. In some ways Louis was even closer to matter in his use of the container itself to pour the fluid.

To think that painting has some inherent optical nature is ridiculous. It is equally silly to define its "thingness" as acts of logic that acknowledge the edges of the support. The optical and the physical are both there. Both Pollock and Louis were aware of both. Both used directly the physical, fluid properties of paint. Their "optical" forms resulted from dealing with the properties of fluidity and the conditions of a more or less absorptive ground. The forms and the order of their work were not *a priori* to the means.

The visibility of process in art occurred with the saving of sketches and unfinished work in the High Renaissance. In the nineteenth century both Rodin and Rosso left traces of touch in finished work. Like the Abstract Expressionists after them, they registered the plasticity of material in autobiographical terms. It remained for Pollock and Louis to go beyond the personalism of the hand to the more direct revelation of matter itself. How Pollock broke the domination of Cubist form is tied to his investigation of means: tools, methods of making, nature of material. Form is not perpetuated by means but by preservation of separable idealized ends. This is an anti-entropic and conservative enterprise. It accounts for Greek

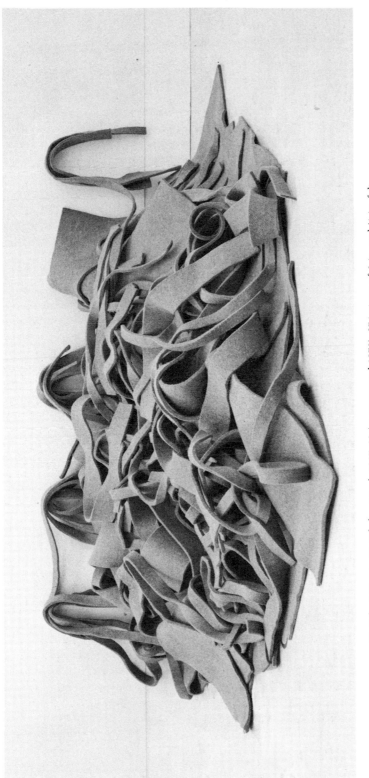

47. Robert Morris, *Untitled*, original, 1967–68 (reconstructed 1970). 254 pieces of 1 in. and ½ in. felt. National Gallery of Canada, Ottawa.

architecture changing from wood to marble and looking the same, or for the look of Cubist bronzes with their fragmented, faceted planes. The perpetuation of form is functioning idealism.

In object-type art process is not visible. Materials often are. When they are, their reasonableness is usually apparent. Rigid industrial materials go together at right angles with great ease. But it is the *a priori* valuation of the well-built that dictates the materials. The well-built form of objects preceded any consideration of means. Materials themselves have been limited to those which efficiently make the general object form.

Recently, materials other than rigid industrial ones have begun to show up. Oldenburg was one of the first to use such materials. A direct investigation of the properties of these materials is in progress. This involves a reconsideration of the use of tools in relation to material. In some cases these investigations move from the making of things to the making of material itself. Sometimes a direct manipulation of a given material without the use of any tool is made. In these cases considerations of gravity become as important as those of space. The focus on matter and gravity as means results in forms which were not projected in advance. Considerations of ordering are necessarily casual and imprecise and unemphasized. Random piling, loose stacking, hanging, give passing form to the material. Chance is accepted and indeterminacy is implied since replacing will result in another configuration. Disengagement with preconceived enduring forms and orders for things is a positive assertion. It is part of the work's refusal to continue aestheticizing form by dealing with it as a prescribed end.

EVA HESSE (1936-1970)

Eva Hesse's brief, tragic life and her continued productivity during her heroic battle against cancer were so touching that criticism tended to deal more with her biography than with her work until Lucy Lippard adjusted the balance in her *Eva Hesse*, New York, 1976.

In a single decade, with less than half of it devoted to three-dimensional work, Hesse created some of the masterpieces of contemporary American sculpture. Her attitude toward process art differed from that of Richard Serra, for example, who deliberately displayed process, sometimes allowing it to become the very subject of the work. Hesse, on the other hand, chafed at the classification, declaring: "Everything is process . . . I never thought of it for any other reason than the process was necessary to get where I was going to." For her it was not a pro-

gram; it was only a means to an expressive end. Nevertheless, it cannot be denied that the process of hanging, falling, drooping, for example, is a prime determinant of her pathetic "absurdity," just as Serra's sawing of huge redwood logs, allowing them to lie as they fell from the cutting, is largely responsible for the nearly brutal aggressiveness of the sculpture.

★ ★ ★

Excerpted from Cindy Nemser's 1970 interview with Eva Hesse in Nemser, *Art Talk: Conversations with Twelve Women Artists,* New York, 1975. Some of this material first appeared in *Artforum* (May 1970) and *Feminist Art Journal* (Winter 1973)

c.n.: Since you didn't feel any strong influence at Yale, were there people in New York who influenced you when you came back and started working on your own?

e.h.: I think at the time I met the man I married, I shouldn't say I went backwards, but I did, because he was a more mature and developed artist. He would push me in his direction and I would be unconsciously somewhat influenced by him. Yet when I met him I had already had a drawing show which was much more me. I had a drawing show in 1961 at the John Heller Gallery which became the Amel Gallery. It was called *Three Young Americans.* The drawings then were incredibly related to what I'm doing now. Then I went back one summer again to an Abstract Expressionist kind of tone—that was really an outside influence. I think that struggle between student and finding one's self is, even at the beginning level of maturity, something that cannot be avoided. I don't know anyone who has avoided it. And my struggle was very difficult and very frustrating. . . . But I worked. . . .

c.n.: When did you start working in soft materials?

e.h.: I started working in sculpture when my husband and I lived for a year and a half under an unusual kind of "Renaissance patronage" in Europe. A German industrialist invited us to live with him and I had a great deal of difficulty with painting but never with drawings. The drawings were never very simplistic. They ranged from linear to complicated washes and collages. The translation or transference to a large scale and in painting was always *tedious.* It was not natural and I thought to translate it in some other way. So I started working in relief and with line—using the cords and ropes that are now so commonly used. I literally translated the line. I would vary the cord lengths and widths and I would start with three-dimensional boards and I would build them out with paper-mâché or kinds of soft materials. I varied the materials a lot but the structure

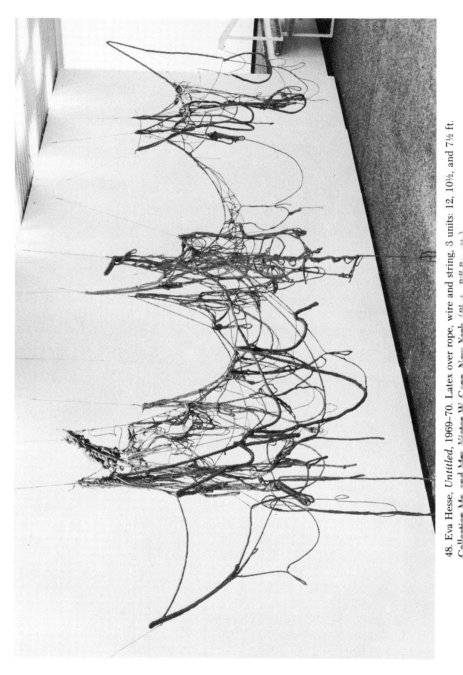

48. Eva Hesse, *Untitled*, 1969–70. Latex over rope, wire and string, 3 units: 12, 10½, and 7½ ft.
Collection Mr. and Mrs. Victor W. Ganz, New York. (Photo Bill Bauca.)

would always be built up with cords. I kept the scale, in Europe, fairly small, and when I came back to America I varied the materials further and I didn't keep to rectangles. Even in Europe I did some that were not rectangles, and then they grew and grew. They came from the floor, the ceiling, the walls. Then it just became whatever it became.

c.n.: How do the soft materials relate to the subject or content of your work? . . .

e.h.: It's not a simple question for me. First when I work it's only the abstract qualities that I'm really working with, which is to say the material, the form it's going to take, the size, the scale, the positioning or where it comes from in my room—if it hangs from the ceiling or lies on the floor. However, I don't value the totality of the image on these abstract or aesthetic points. For me it's a total image that has to do with me and life. . . . And there I'm very complex. I'm not a simple person and the complexity—if I can name what it consists of (and it's probably increased now because I've been so sick this year)—is the total absurdity of life. I guess that's where I relate, if I do, to certain artists who I feel very close to, and not so much through having studied their writings or works, but because, for me, there's this total *absurdity* in their work.

c.n.: Which artists are they?

e.h.: Duchamp, Yvonne Rainer, Ionesco, Carl André.

c.n.: Let's talk about some of your early sculptures

e.h.: There was a piece I did for that show in the Graham Gallery, *Abstract Inflationism, Stuffed Expressionism*, in 1965 or 1966. It was called *Hang-up*—a dumb name. I did the piece when I came back from Europe and I wasn't totally aware of how "hang-up" was being used here. It's unfortunate, but I can't change it. I think it was about the fifth piece I did and I think the most important statement I made. It's close to what I feel I achieve now in my best pieces. It was the first time where my idea of absurdity or extreme feeling came through. It's huge—6 feet by 7 feet. It is a frame, ostensibly, and it sits on the wall and it's a simple structure which if I were to make again I'd construct differently. This is really an idea piece. It is almost primitive in its construction, very naive. It's a very thin, strong metal, easily bent and rebent. The frame is all tied like a hospital bandage as if someone had broken an arm, an absolutely rigid cord around the entire thing. That dates back to those drawings I told you about. I would never repeat that piece of construction but there's a nice quality about it. It has a kind of depth I don't always achieve—a depth and soul and absurdity and life and meaning or feeling or intellect that I want to get. . . . It is also so extreme and that is why I like it and don't like

it. It is so absurd. This little piece of steel comes out of this structure and it comes out a lot. It's about 10 or 11 feet out and it is ridiculous. It's the most ridiculous structure I have ever made and that is why it is really good. It is coming out of something and yet nothing, and it is holding. It is framing nothing. And the whole frame is gradated—oh more absurdity—very, very finely. It really was an effort. And it's painted with liquitex. It is very surreal, very strange. It is weird. It is like those things I did in Europe that come out of nothing in a very surreal and yet very formal way and have really nothing to do with anybody. . . .

C.N.: How about motifs? I notice that you use the circle quite frequently. What does it mean to you?

E.H.: I think the circle is very abstract. I could make up stories of what the circle means to men, but I don't know if it is that conscious. I think it was a form, a vehicle. I don't think I had a sexual, anthropomorphic, or geometric meaning. It wasn't a breast and it wasn't a circle representing life and eternity. . . . I remember always working with contradictions and contradictory forms which is my idea also in life. The whole absurdity of life, everything for me has always been opposite. Nothing has ever been in the middle. When I gave you my autobiography, my life never had anything normal or in the center. It was always extremes. And I think, I know that, in forms that I use in my work that contradiction is certainly there. When I was younger or a less mature artist, I was always aware that I could combine order and chaos, string and mass, huge and small. I would try to find the most absurd opposites or extreme opposites and I was always aware of their contradiction formally. It was always more interesting than making something right size, right proportion. . . .

C.N.: Repetition is very prevalent in your work. Why do you repeat a form over and over?

E.H.: Because it exaggerates. If something is meaningful, maybe it's more meaningful said ten times. It's not just an aesthetic choice. If something is absurd, it's much more greatly exaggerated, absurd, if it's repeated. . . .

C.N.: When I looked at *Ishtar,* the piece that had the half-cups with the cords going through it, it seemed to me that it had sexual connotations and there was a joining of the two sexes. And it's the same in a work like *Repetition 19* where you have container-like forms that are tall and could also be tower-like or phallic.

E.H.: You mean they're both male and female symbols?

C.N.: Because they're containers and they're also cylindrical forms.

E.H.: And the next version gets taller—greater erections. No! I don't see

that at all. I'm not conscious of that at all or not even unconscious. I'm aware they can be thought of as that even in the process of making them, but I am not making that. . . .

c.n.: How about the relation of light and color in your work?

e.h.: I think they are less important. Color is whatever comes out of the material and keeps it what it is. The light—I'm not too concerned with it, because if you use reinforced fiberglass clear and thin the light is there by its nature and the light does beautiful things to it. It is there as part of its anatomy. I an not interested in dramatics and so I de-emphasize the beauty of the fiberglass or the light and just make it natural. I don't highlight it with extra light. It's a by-product, built in there. Maybe dark does beautiful things to it. . . .

c.n.: Here's this piece I like so much from the Whitney's *Anti Illusion, Procedures, Materials* exhibition. What's it called?

e.h.: *Expanded Expansion.* It has also been called *Untitled* because I hadn't really completed it when I went to the hospital. They didn't know it had a title. I never call things *Untitled* since things need to be titled as identification. I *do* title them and I give it a lot of thought most of the time because things being called *Untitled* is a sign of uninterest and I am interested. I try to title them so that it has meaning for me in terms of what I think of the piece and yet it's just like a word. I use a dictionary and a thesaurus. I usually use a word that sounds right too but that doesn't have a specific meaning in terms of content. It's straight but not another word for it. . . .

c.n.: You were insisting your pieces aren't environmental before, yet this piece is so large-scale.

e.h.: Its scale would make it environmental but that is not enough to make something environmental. Then it is leaning against the wall and it looks like a curtain. Those things make it superficially environmental. . . .

c.n.: But you are concerned with the idea of lasting?

e.h.: Well, I am confused about that as I am about life. I have a two-fold problem. I'm not working now, but I know I'm going to get to the problem once I start working with fiberglass because from what I understand it's toxic and I've been too sick to really take a chance. . . . And then the rubber only lasts a short while. I am not sure where I stand on that. At this point I feel a little guilty when people want to buy it. I think they know but I want to write them a letter and say it's not going to last. . . . Part of me feels that it's superfluous and if I need to use rubber that is more important. Life doesn't last; art doesn't last. It doesn't matter. . . .

C.N.: Does your work concern itself with the process, in the sense of Richard Serra's saying he is concerned with pushing or pulling or lifting, etc.?

E.H.: Well, process—that is the mold I felt I was going to be *put* in. I don't really understand it. Everything is process and the making of my work is very interesting but I never thought of it as "now I am rolling, now I am scraping, now I am putting on the rubber." I never thought of it for any other reason than the process was necessary to get to where I was going to get to. I do have certain feelings now to keep things as they are. I have very strong feelings about being honest, also heightened since I have been so ill. And in the process, I'd like to be—it sounds corny—true to whatever I use and use it in the least pretentious and most direct way. Yet you could say that it's not always true, for instance I rubberized cheesecloth. . . .

C.N.: Then it's not the old truth-to-materials doctrine.

E.H.: Yes. It partially is because rubber needs more strength than rubber alone for permanency. And if you like to keep it very thin and airy you have to figure that out. There is a very, very fine plastic glued to a very cheap plastic to get some of those very, very close lines, because cheap plastic is so thin and it clings together well, so when the rubber dries you have all this clinging, linear kind of thing. And I make things too. If the material is liquid, I just don't leave it or pour it. I can control it but I don't really want to change it. I don't want to add color or make it thicker or thinner. There isn't a rule. I don't want to keep any rules. I want to change the rules. In that sense processing the materials becomes important because I do so little with them. I do so little else with the form which I guess is the absurdity. I keep it very, very simple, so then it's like a hanging material. . . .

C.N.: I think you said it was the first time you did a sketch for a sculpture [*Contingent*].

E.H.: I did a whole group at one time—in one or two weeks. I did ten sketches and I think I worked them all out or they are being worked out—every one of them.

C.N.: That was unusual for you because previously the drawings were separate.

E.H.: Yes. I always did drawings but they were separate from the sculpture or the paintings. I don't mean in a different style but they weren't connected as an object, a transference. They were related because they were mine but they weren't related in one completing the other. And these weren't either. They were just sketches. It is also not wanting to have such a definite plan. It is a sketch—just a quickie to develop it in the

process rather than working out a whole small model and following it. That doesn't interest me. I am not even interested in casting. The materials I use are really casting materials. I don't want to use them as casting materials. I want to use them directly, eliminating making molds but making them directly at the moment out of some material. In that sense I'm interested in process.

c.n.: . . . Sonnier used material so that layering was almost a form of painting—one color on top of the other.

e.h.: That is my drawings. My last series of drawings . . . were painted. They were inks, layer over layer, very, very fine washes on paper. They're absolutely paintings. Even those very careful ink drawings were layer over layer. These were very careful too, but they are looser. Those five circle drawings were washes, one over the other.

c.n.: And that extends to the three-dimensional work too?

e.h.: Fiberglass and rubber are layers. Fiberglass less, but it builds up and if I need any thickness it is one fine layer over the other. And rubber is certainly that way. The rubber that I've been using you can't pour on very thick.

c.n.: So your work has more relation to painting than to sculpture which one thinks of as carved-out or molded.

e.h.: But I never did any traditional sculpture. . . . I don't know if I am completely out of the tradition. I know art history and I know what I believe in. I know where I come from and who I am related to or the work that I have looked at and that I am really personally moved by and feel close to or am connected or attached to. But I feel so strongly that the only art is the art of the artist personally and found out as much as possible for himself and by himself. So I am aware of connectiveness—it is impossible to be isolated completely—but my interest is in solely finding my own way. I don't mind being miles from everybody else. I am not, now, possibly. Critics, art historians, museums and galleries do like to make a movement for their own aims and for art history and to make people understand, but I wonder about that. In that way I have been connected to other people but I don't mind staying alone. I think it is important. The best artists are those who *have* stood alone and who *can* be separated from whatever movements have been made about them. When a movement goes, there are always two or three artists. That is all there is. . . .

c.n.: Then your art is more like painting?

e.h.: I don't even know that. Where does drawing end and painting begin? I

don't know if my own drawings aren't really paintings except smaller and on paper. The drawings could be called painting legitimately and a lot of my sculpture could be called painting. That piece *Contingent* I did at Finch College could be called a painting or a sculpture. It is really hung painting in another material than painting. And a lot of my work could be called nothing or an object or any new word you want to call it. . . .

C.N.: Whose work did you really like?

E.H.: . . . I loved most de Kooning and Gorky but I *know* that was for me personally. You know, for what I could take from them. I know the importance of Pollock and Kline and *now*, if you ask me *now*, I would probably say Pollock before anyone. But I didn't in growing up.

C.N.: What about Minimal art?

E.H.: Well, I feel very close to one Minimal artist who's really more of a romantic, and would probably not want to be called a Minimal artist and that is Carl André. I like some of the others very much too but let's say I feel emotionally very connected to his work. It does something to my insides. . . .

C.N.: Are there other artists you admire?

E.H.: Oldenburg is an artist, if I have to pick a few artists, that I really believe in. I don't think I was ever stuck on Oldenburg's use of materials. I don't think I have ever done that with anybody's work and I hope I never do. I can't stand that. But I absolutely do like Oldenburg very, very much. I respect his writings, his person, his energy, his art, his humor, the whole thing. He is one of the few people who work in realism that I really like—to me he is totally abstract—and the same with Andy Warhol. He is high up on my favorite list. He is the most artist that you could be. His art and his statement and his person are so equivalent. He and his work are the same. It is what I want to be, the most Eva can be as an artist and as a person.

CHRISTO (1935-)

For twenty years Christo has been wrapping things—a girl, a museum, a rocky coast in Australia—and he is currently trying, as he has been doing on and off for several years, to make all the legal and political arrangements needed to wrap the Reichstag. His two most vast and dramatic projects thus far realized were the brilliant orange nylon *Valley Curtain*, weighing 8,000 pounds, which spanned 1,200 feet be-

tween heights at Rifle, Colorado, and the 24½-mile-long *Running Fence* of white nylon, 18 feet high, in Marin and Sonoma counties, California. Such projects take years of preparation and directly involve hundreds of people: lawyers, politicians, government agents, blue-collar workers, farmers and other landowners, even pastors in their pulpits. All of these diversified people participate in the art work: they actually become a part of its process. The art work, the *Running Fence*, is its entire history, not just that beautiful white form that snaked across country and into the Pacific for two weeks in September 1976. The film of *Running Fence* dramatically documents the almost insurmountable difficulties which Christo and his wife, Jeanne-Claude, manage to overcome; and the spectacularly beautiful *Valley Curtain* film stands with Smithson's *Spiral Jetty* in the vanguard of films on art.

★ ★ ★

Excerpted from "Dialogue," an unpublished interview conducted by Ching-Yu Chang with Cesar Pelli and Christo, 1979

CHRISTO: I am a bit afraid of any kind of generalities. I like to use words, but only with very precise meanings. Really, I can only talk about my own ideas, my own works. One of the most important things I feel in my work is the "going through." Physically, you like to see what is underneath or on the other side. Mentally you would also like to see what is underneath. Sometimes you can discover that you recognize the object that is inside. . . .

If you take all of my packages, they are all bundles. It makes a new form, a very abstract one. Perhaps you recognize some elements in it, some bottles for example. You like to see what is behind the package, as well as appreciating the new form that has been created, the new visual value. This disturbance is important.

But perhaps all of this is secondary; the most important thing is the passage from one form to another. Also the continuation, that the first form peeks through from behind. No, the thing that is behind is not so important either, only that motion, that passage is important.

When I was doing the *Valley Curtain*, for example, everybody knew that this was a huge curtain crossing a valley. Now, everybody knew what it is that is behind the valley. It was not some secret, because there is a road that you can pass along underneath. When you go to the other side you cannot see the other part of the valley, but then when you come past, you can see down. Now what was important here really and basically was the passing through. The motion. . . .

You know, the world of ideas is a very gratuitous one. It is a lazy world. You can propose many things, not only in art but also in politics and exploration. But when you go to do it, you have to go to a fantastic

amount of energy to really obtain the impact. If you know it is only an idea . . . well I am very cautious of propositions. When I try to do some project I never do a proposition of the idea if there is no chance of it being realized.

It always looks to other people like it is impossible, but I never propose what cannot be done. Like wrapping the Kremlin or something. I know very well that that cannot be done. Our work is almost on the edge of the impossible, but that is the exciting part. The road is very narrow. . . .

It is all very risky, and many of the projects never come true. And when that happens I always blame myself first. Not enough of this or that. But this is what is so good about our projects, we keep learning more and more at every step. We learn more and more that every step is equally important in the final object or the final physical enjoyment. And if we minimize something like seeing a senator, or doing this or doing that at the right time, then we find the project deteriorating, and not going the way we thought. I think that this always depends on us. What important things should we be active on?

CHANG: Yes, that is exactly the point. Every step is important, and that has to be understood when you are designing. The process is so very important . . . many times it is more important than when you finish.

CHRISTO: It is not really that it is *more* important, only that it is one reality and ought to be acknowledged. I don't think it is really one more or less than the other. Everything is done towards that final object; towards the realization of that physical form. You cannot have a process if you do not have a physical goal, or some ending.

Imagine that I will never build the *Running Fence*, and that I was only interested in having this booklet here and having something to discuss with the politicians. Well, then I would never be taken seriously. I would never even have this booklet here, because they would never believe me. If for one second any of the secretaries of any of the congressmen ever doubted that I would really do this thing, the *Running Fence*, then obviously it could never happen. But it was that they were very sure that I was stubborn and dead serious and that I actually would do this *Running Fence*—then they tried to stop me or they tried to give me permission.

And it was very interesting, because it provoked judgments on their parts. They may have refused to make artistic judgments, but still because they were responsible as public servants, they were forced to make judgments anyway. This was one of the really great parts of the project. Their interpretations have enriched the work, since they do not come from a normal way of viewing or thinking about art, like in a museum or something.

When we did the *Wrapped Walk Ways* project in Kansas City, I was

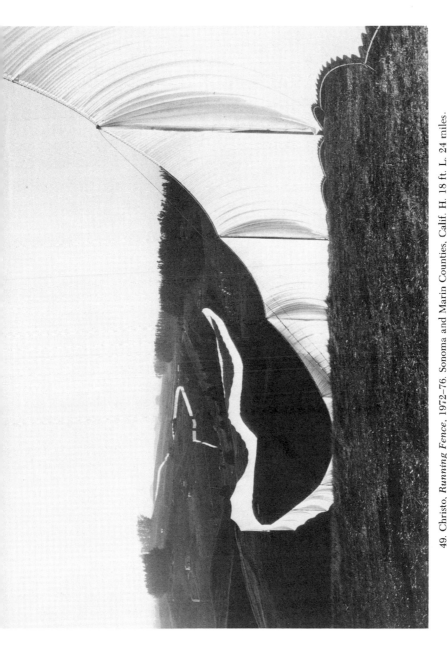

49. Christo, *Running Fence*, 1972–76. Sonoma and Marin Counties, Calif. H. 18 ft. L. 24 miles. (*Photo: Jeanne-Claude, courtesy of Christo*)

aware that this really was a pedestrian project. I liked that part very much. It was one of my most pedestrian projects in a very literal sense, because basically you walk on it, and you can see it from far away, and you can touch it. There were about twenty blind people who went there and they took their shoes off and they walked on it. I never realized before that blind people could see my projects, but they walked for three miles full of all kinds of sensitivity. Not only blind people were there, there were all kinds of people.

I was very fascinated to see how the people walked on the different surfaces. But the climate and the weather and the rain, these things were unpredictable, and greatly influenced the existence of the *Walk Ways.* . . .

CHANG: That is what we were talking about in the car, about the Japanese garden. You never say that it is finished when your part in the design and construction of the garden is finished. . . . Sometimes, a tree placed in a certain position by the designer may not be able to grow in that place and it will die. . . . So only after five years of nature taking her role in the creation, can the thing be called finished. I think that this is a very similar notion. . . .

CHRISTO: That is at the very crux of the young generation. It is a very romantic, nineteenth-century attitude. Many younger artists are increasingly attracted to turning back to these old conceptions. It is reassuring. The world is too complex. . . .

I am fascinated by the complexity of the world, and I don't care if I have to spend two or three days talking with politicians. These people who have nothing to do with art have their own way of thinking, and I find it very resourceful.

Every project is for us a learning process that is more valuable than the images. . . .

I like both the process and the progress. I like to be involved with very big problems. This becomes the source of the good in my projects, because there is no routine, there is no way of predicting. . . .

Other people, they think that the wrapping of the Reichstag is like anything else, but it is not. Because you are aware, you know what the meaning of this is. It is not the same as *Running Fence* or the *Valley Curtain.*

They always say: "Oh, the next project will be very easy for you now, because you are more well known!" But it has nothing to do with being known, because each time there are many diverse problems.

10

Site and Architectural Sculpture

CLAES OLDENBURG (1929-)

In site sculpture, strictly speaking, the place or site determines the form of the work just as system and process do in those two modes. In a more general sense, the term can be applied to sculpture that is formed with regard to a specific place, being modified by it, while underlining and adding to its particular character. In this respect, Oldenburg's colossal monument proposals of 1965 heralded the movement that surfaced in the early seventies. Of these proposals, Oldenburg explains: "The object is chosen because in some way it fits the shape, the conditions and the associations of the site." The extraordinarily inventive Oldenburg also anticipated another type of sculpture, which became popular in the late seventies, architectural sculpture. In the sixties he designed buildings in the shape of their names (a M-U-S-E-U-M, P-O-L-I-C-E station, etc.) and throughout his work he has made precise, architectural renderings of his sculptural projects.

★　★　▲

Excerpted from Claes Oldenburg, "The Poetry of Scale," Interview with Paul Carroll taped in 1968 for *Proposals for Monuments and Buildings 1965-69*, Chicago, 1969. Copyright Claes Oldenburg

OLDENBURG: Monuments became a significant subject for me in the spring of 1965. After a year of travel in Europe and in the U.S., away from New York, I set up in a new studio on East 14th Street. The new studio was huge—a block long—and that scale, combined with my recollections of traveling, had given me an inclination to landscape representation. I couldn't adjust this to what I'd been doing before until I hit on the idea of placing my favorite objects in a landscape—a combination of still-life and landscape scales. By rendering atmosphere and the use of perspective, I made the objects seem "colossal." Some of the first monuments were the *Proposed Colossal Monument for Lower East Side, N.Y.C.—Ironing Board*, 1965, and the *Proposed Colossal Monument for the Intersection of Canal Street and Broadway, New York: block of concrete, inscribed with the names of war heroes*, 1965. The last-named metamorphosed from a pat of butter placed in the slits of a baked potato on the table where we ate. A lot of the monuments were food: pizza, a banana, a Good Humor bar, a baked potato, a frankfurter with tomato and toothpick.

201

Then there were several versions of the *Proposed Colossal Monument for Central Park North, N.Y.C.—Teddy Bear*, 1965, sitting in the north end of Central Park or thrown there so that it rests on its side. . . .

The project began as a play with scale, and that's what it seems to be about—the poetry of scale.

The *Late Submission to the Chicago Tribune Architectural Competition of 1922: Clothespin*, 1967, to replace the Chicago Tribune Tower, is an example. When I flew to Chicago in October 1967, I took along an old-fashioned wooden clothespin because I liked its shape; I also had a postcard of the Empire State Building. I made a sketch, superimposing a clothespin on the postcard; then I stuck the clothespin in a wad of gum I was chewing, and placed it on the little table in front of my seat; and as our plane came over Chicago, I noticed that the buildings down there looked the same size as the clothespin. I made quick sketches. One showed the clothespin building; another, a Great Lakes ore boat in a vertical position, a third, smoke rising from the West Side. All three became proposals for Chicago buildings and monuments.

CARROLL: Did you do any work on the [proposals] between 1958 and 1965?

OLDENBURG: I made some proposals in text form—for example, the *Monument to Immigration*, proposed in 1961. . . .

. . . There'd been talk about a competition for a monument to Ellis Island—the architect Philip Johnson eventually made a proposal for such a monument—and I thought I'd propose a "natural" monument in the sense it would create itself. The monument would begin as a reef placed in the bay; a ship would sail in, hit the reef, and sink; soon another would do the same; and after awhile, there'd be this big pile of wrecked, rusting ships which, as it grew, would be visible from quite a distance. The monument was inspired by a collection of World War II Liberty Ships you can see tied up on a spot up the Hudson. They're known as the "moth ball" fleet because the ships are covered by plastic cocoons. The fleet's very impressive, especially when snow covers the ships; and, in fact, the State of New York officially acknowledged that the Liberty Fleet was a monument by placing a sign and an overlook at the site. *Monument to Immigration* was my first obstacle monument. Later, I did more—such as the *War Memorial* and the mini-monument, *Small Monument for a London Street—Fallen Hat (for Adlai Stevenson)*, 1967.

CARROL: Were there other influences on the project?

OLDENBURG: There were some photos and drawings I saw in the early 1960s when I was working in the library of the Cooper Union Museum. One group of photos showed the Statue of Liberty when it first came

over. Parts of the statue's body were shown lying around Madison Square: the face here, a big foot there, the hand with the torch here. I also saw some photos of those buildings in vogue around 1900 which were made to look like animals. One of these still stood in 1958, south of Atlantic City. It is the shape of an elephant, with windows, painted green and facing out to sea. Also, I came across drawings by the eighteenth-century French architects Boullée, Ledoux and Lequeu. A few years ago, I realized that Lequeu's building shaped like a cow was probably the model for the *Teddy Bear*. Both are structures staring at you with fixed and glassy eyes.

CARROLL: Why did you call your proposals "monuments"?

OLDENBURG: It was a familiar word to signify something very large. Later when I looked up the definition, I realized that "monument" meant a memorial of some kind. At the beginning, I didn't think of it that way.

CARROLL: How do you decide on the location where the monument will stand—for example, why a giant frankfurter on Ellis Island or an ironing board on the Lower East Side?

OLDENBURG: The object is chosen because in some way it fits the shape, the conditions and the associations of the site. The giant frankfurter has a shape like the ships that pass it, going up and down the Hudson. The ironing board over the Lower East Side echoes the shape of Manhattan island and also "shields" the vanishing ghetto, commemorating the million miles of devoted ironing. In the case of the *Teddy Bear*, an object with eyes was important. Looking up the park from the south, one casts the eyes a long distance in an area surprisingly empty in the midst of city congestion. The Bear's eyes are like a mirror of the huge, free glance, returning it like a tennis ball. . . .

CARROLL: After you'd finished the first group of New York monuments in 1965, did you think about creating monuments for other cities as well?

OLDENBURG: . . . Not until I began traveling again. New York was my favorite "room," my main plaything. I made toys for it, my city of cities. Then in 1966 I went to Sweden, Norway and London. In Stockholm I got a lively response to my proposals, which were presented in the papers. Swedes believe in technology. They seemed to think my monuments could actually be built someday. I presented six proposals in photo-enlargements on a billboard rented for me by the Moderna Museet in the center of town. . . .

. . . To make monuments in a new city is to use that city as a studio.

CARROLL: Would you describe in more detail how you get to know a city in which you plan to draw proposals for monuments or buildings?

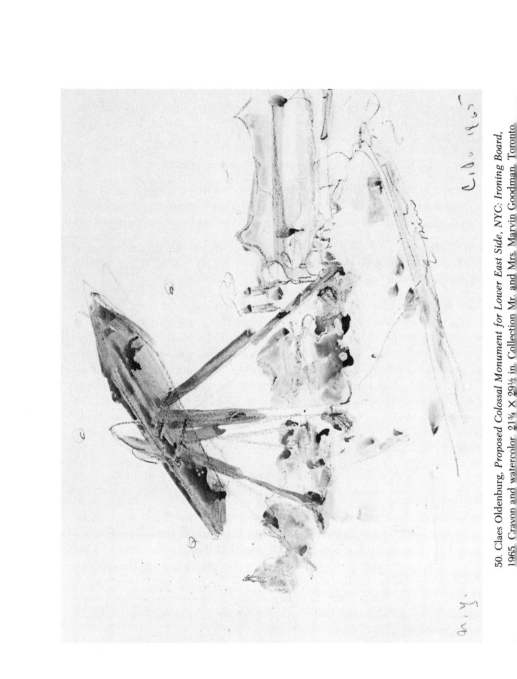

50. Claes Oldenburg, *Proposed Colossal Monument for Lower East Side, NYC: Ironing Board,* 1965. Crayon and watercolor, 21¾ × 29½ in. Collection Mr. and Mrs. Marvin Goodman, Toronto.

OLDENBURG: During the first two or three weeks in a new city, I try to visit as many places as possible, and be taken around by people who live there and know the city. I listen to what they say about it. Also, I try to read every newspaper and magazine on sale. I sketch a lot. And I observe the food.

Food was most influential in Sweden. When a waiter serves you, he first exhibits the plate of food as if it were sculpture or a painting; then he dishes it up and brings it back ready to eat, so you get two pictures of the dish, as if the piece were created and then taken apart and prepared for you to put in your mouth. One monument for Stockholm began with a pyramid of shrimps I'd seen in one of the restaurants. . . .

I use my body to feel and come to know a city. In London I constantly felt cold in my knees—they always ached. It was aggravated by having to squat in those small English cars. 1966 was also the time of knee exhibitionism because of the mini-skirt, especially when "framed" by boots. . . .

So knees were on my mind; and since knees are doubles, I found myself collecting examples of doubles: salt and pepper shakers, double egg cups, and so on. I frequently seize on a formal idea—in this case doubles—and pursue it obsessively, collecting example after example.

I found doubles on the Thames, too. English tug boats have funnels which don't fit under bridges. Therefore, the funnels have hinges in order to fold in two when the boat sails under a bridge: so you see two funnels. . . .

CARROLL: There seems to be a relationship between a water monument like the *Proposed Colossal Monument for Thames River—Thames Ball*, 1966, which rises and winks with the tide, and a mouth monument like the *Giant Lipstick to Replace the Eros Fountain, Piccadilly Circus*, 1966, intended to replace the Fountain of Eros in Piccadilly Circus, in that you indicate the lipstick rises out of and then sinks back into the tube.

OLDENBURG: Yes, the going in and coming out of the tide was always on my mind as I walked the streets of London. My monuments within the city are keyed to this movement, bringing the movement into the city—like breathing on a large scale. When the Thames flows out, the lipstick goes back inside the tube; when the river rises again, so does the lipstick. . . .

CARROLL: Does your interest in architecture mean that the [proposals] might be entering a new phase?

OLDENBURG: . . . At first, the monuments were playful, personal fantasies; then the monuments seemed to become more real and public. I remember Gene Baro asking me in an interview we did in 1966: Did I have any idea of what type of materials would be used if one of the monuments were actually to be built? I hadn't thought too much about it. Earlier that year,

three students of architecture at Cornell made an appraisal of the *War Memorial*. Their estimates shocked me: they figured that it would weigh 5,000,000 lbs., if concrete were used; and that the memorial would sink through the surface the way a pat of butter melts in a baked potato, crushing the subway. Then they drew up plans for rerouting the subways. . . .

I also became aware that practicing architects had taken some interest in the monuments. An invitation came from MIT to talk about projects; I felt honored but rather terrified of being caught out of my element. My monument proposals in relation to tradition began to interest me. . . .

CARROLL: How do you feel about the architectural phase of the [proposals]?

OLDENBURG: . . . I have to decide whether I really want to convert my fantasy to real projects, and on what terms this can be done. One problem is that the shape of my objects makes it harder to build them than if they had abstract forms like cubes or cones. Tony Smith, for example, works in simple geometric forms; the great advantage he's got is that he can enlarge the basically simple form of the cube in much the same way a building's form can be expanded and enlarged. . . .

CARROLL: How does your relationship to the city and your experience of it differ in the [architectural] phase?

OLDENBURG: I go through the same preparations but now I tend to focus on the type of object that seems possible to construct. The *Proposed Colossal Monument for Grant Park, Chicago—Windshield Wiper*, 1967, is a more architectural shape, for example, than the *Teddy Bear*. This is also true of the *Clothespin*. . . .

CARROLL: How would you reply to the question: Is this how Oldenburg sees Modern American life—a world containing only the apotheosis of middle-class icons: vacuum cleaner, toys, baseball bats, hats, windshield wipers on our chariot cars—and so on?

OLDENBURG: A catalogue could be made of all such objects, which would read like a list of the deities or things on which our contemporary mythological thinking has been projected. We do invest religious emotion in our objects. Look at how beautifully objects are depicted in ads in Sunday newspapers. Those wonderful, detailed drawings of ironing boards, for example, showing the inside of the board flipped back to reveal how it's made: it's all very emotional. Objects are body images, after all, created by humans, filled with human emotion, objects of worship.

However, the idea of an object as a magic thing no longer obsesses me as it once did. In the *Clothespin* building, for example, I guess the object was

originally a magic thing to me—like a rabbit's foot or bone or relic—but I became far more interested in the architectural form of the clothespin, which seemed somewhat gothic to me, like the Tribune Tower itself. . . .

CARROLL: Are the monuments you've made for Los Angeles part of your architectural phase?

OLDENBURG: Some of them. I proposed an alternative design for the new Pasadena Art Museum based on an advertisement showing an open package of cigarettes against half of a tobacco tin. It didn't seem far-fetched. In an enlarged version, the package and tin are very building-like and even adapt well to the different functions: a library and restaurant in the extended cigarettes; the exhibits in the package itself; the auditorium in the half tin. From the ground, the structure would appear abstract; it would only look like the original from the air.

The many letter-forms silhouetted against the sky in the Los Angeles basin led to the proposal of colossal block letters scattered across the countryside. These are simple and architectural and, at close hand, also abstract. I further suggested making buildings out of the letters of the word that describes the building's function. A bank, for example, using B-A-N-K in colossal form, or P-O-L-I-C-E for a police headquarters. Arguments about how a building should look would be reduced to arranging these huge letters. Such structures would blend well with those existing in Los Angeles.

RICHARD SERRA (1939-)

While Richard Serra is mentioned above as a process artist par excellence, the following text by him refers to his work in site sculpture, of which *Shift* is a brilliant early example (1970–72). Serra's analysis is a clear exposition of how the work did not just conform to the site but was formed by it, and by the experience of walking through the place.

★ ★ ★

Excerpted from Richard Serra, "Shift," edited by Rosalind Krauss, *Arts magazine* (April 1973)

Surrounded on three sides by trees and swamp, the site is a farming field consisting of two hills separated by a dog-leg valley. In the summer of 1970, Joan and I spent five days walking the place. We discovered that two people walking the distance of the field opposite one another, attempting to keep each other in view despite the curvature of the land, would mutually determine a topological definition of the space. The

boundaries of the work became the maximum distance two people could occupy and still keep each other in view. The horizon of the work was established by the possibilities of maintaining this mutual viewpoint. From the extreme boundaries of the work, a total configuration is always understood. As eye-levels were aligned—across the expanse of the field— elevations were located. The expanse of the valley, unlike the two hills, was flat.

What I wanted was a dialectic between one's perception of the place in totality and one's relation to the field as walked. The result is a way of measuring oneself against the indeterminacy of the land. I'm not interested in looking at sculpture which is solely defined by its internal relationships. . . . In the work there are two sets of stepped walls, with three elements in each set. The walls span two hills which are, at their height, approximately 1500 feet apart. Each element begins flush with the ground and extends for the distance that it takes the land to drop 5 feet. The direction is determined by the most critical slope of the ground. Therefore the length, direction, and shape of each element is determined by the variations in the curvature and profile of the hills. . . .

The intent of this work is an awareness of physicality in time, space and motion. Standing at the top of the eastern hill, one sees the first three elements in a Z-like linear configuration. The curvature of the land is only partially revealed from this point of view, because the configuration compresses the space. Until one walks into the space of the piece, one cannot see over the rise, as the hill descends into its second and third 5-foot drop. This again is because the land's incline is inconsistent in its elevational fall.

The hills were back-hoed; form-boards were sunk into place; steel rebar was set into the footings; and the cement was poured. The exposed 5-foot vertical edge of each wall was angled so that it would align itself in the trajectory of the succeeding wall. This was done for two reasons: (a) to allow the stepping-down of the walls to be continuous as each changed direction in relation to the one before; (b) more importantly, the bevel of the wall's vertical edge returns one's eye to the topology of the land rather than to the planar relationships of the wall itself.

The work establishes a measure: one's relation to it and to the land. One walks down the hill into the piece. As one does, the elements begin to rise in relation to one's descending eye-level. The first descent ends with the top of the wall directly at eye-level: 5 feet. This rising-up of each vertical plane seems to establish the element as a kind of horizon line—articulating one's relation to the breadth of the land. In effect, the line of the top edge of the piece draws a visual cross-section into the elevational slope, while the bottom edge defines the specific curvature of the earth at the point where one stands. The plane itself in no way acts as a barrier to

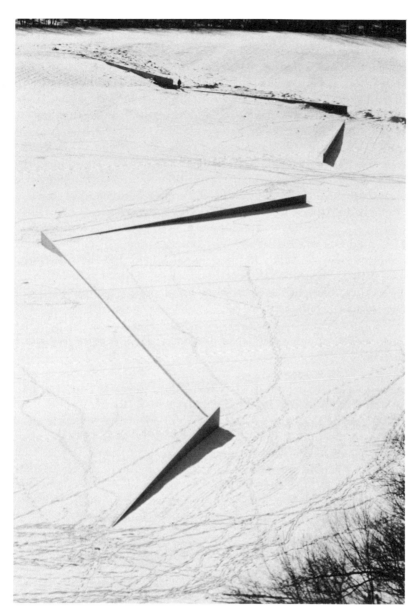

51. Richard Serra, *Shift*, 1970–72. Six cement sections totaling 815 ft. in length, each 5 ft. high × 8 in. thick. King City, Canada. (*Photo: Courtesy John Weber Gallery, New York*)

perception. As one follows the work further into the field, one is forced to shift and turn with the work and look back across the elevational drop. Insofar as the stepped elevations function as horizons cutting into and extending towards the real horizon, they suggest themselves as orthogonals within the terms of a perspective system of measurement. The machinery of renaissance space depends on measurements remaining fixed and immutable. These steps relate to a continually shifting horizon, and as measurements, they are totally transitive: elevating, lowering, extending, foreshortening, contracting, compressing, and turning. The line as a visual element, per step, becomes a transitive verb. . . .

From the top of the hill, looking back across the valley, images and thoughts are remembered which were initiated by the consciousness of having experienced them. This is the difference between abstract thought and thought in experience. The time of this experience is cumulative—slow in its evolution. One experiences a new kind of compression. The land is sensed as a volume rather than as a recessional plane, because from this point of view the valley has become abridged. For the first time, the alignment of the elevational steps is apparent. This alignment contracts the intervals of the space—not as drawing (or linear configuration) but as volume (as space contained).

Robert Morris, "The Present Tense of Space," *Art in America* **(January-February 1978)**

Among the artists whose work Morris illustrates in his article but does not refer to by name in the text are Robert Irwin, George Trakas, Richard Serra, and Alice Aycock. Two other artists who deal particularly with the role of time and its relation to space and the viewer's experience of this relationship (i.e., the "present tense," the "I" factor), the "new relations to nature," and the "subjective aspects of perception" are Mary Miss and Athena Tacha (see the latter's essay below). For a discussion of Morris's own highly diversified art, see an interview with him by E. C. Goossen in *Art in America* (May–June 1970).

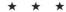

Since the mid-sixties a number of more or less successful options to the independent specific object have proliferated. I want to stitch a thread of connection through some of these and go back to far earlier work with it. . . .
The thread of this historical narrative will pass through certain types of emptiness—focused zones of space whose aspects are qualitatively different from objects. The seventies have produced a lot of work in which space is strongly emphasized in one way or another. . . .
Now images, the past tense of reality, begin to give way to duration, the

present tense of immediate spatial experience. Time is in this newer work in a way it never was in past sculpture. . . .

What I want to bring together for my model of "presentness" is the intimate inseparability of the experience of physical space and that of an ongoing immediate present. Real space is not experienced except in real time. The body is in motion, the eyes make endless movements at varying focal distances, fixing on innumerable static or moving images. Location and point of view are constantly shifting at the apex of time's flow. . . .

But sculpture has for some time been raiding architecture. Some of the contemporary sculptors illustrated here focus on space, both internal and external, as much as on the materials and objects which delimit or articulate these spaces. . . .

The building as closed object which shuts out space was less adhered to in many examples of Middle and Far Eastern building types. This is especially apparent in uncovered or partially open structures—the mosque, Chinese bridge and pavilion work, the Indian step well, etc. Absent here is the totally enclosing environmental container which houses both objects and the human figure. In Central and South America, the Mayan ball courts, temple platforms and various observatory-type constructions have the same openness to the sky. Besides a general openness, sharp transitions between horizontal and vertical planes of floor and wall are often absent. Elevations vary, projections interrupt. One's behavioral response is different, less passive than in the occupation of normal architectural space. The physical acts of seeing and experiencing these eccentric structures are more fully a function of the time, and sometimes effort, needed for moving through them. Knowledge of their spaces is less visual and more temporal-kinesthetic than for buildings which have clear gestalts as exterior and interior shapes. Anything that is known behaviorally rather than imagistically is more time-bound, more a function of duration than what can be grasped as a static whole. Our model of presentness begins to fill out. It has its location in behavior facilitated by certain spaces which bind time more than images.

Having indicated a few historical examples for a model of art which has questioned the narrow option between container or object, and having articulated to some extent an experimental model for presentness as a spatial domain, it is possible to turn to more recent work which has sought options beyond the autonomous, timeless object.

Beginning in the late 1950s, most of the artists associated with "Happenings" also produced various kinds of environmental work. Most of these works, while attempting to avoid the object, collapsed into a kind of architectural decor. Containment replaced things, and a centrifugal focus replaced a centripetal one. But the field force of the space was generally

weak. Beginning in the sixties, quite a bit of work was done which utilized the lateral spread of the floor. The hardware employed was generally small, sometimes fragmented. Elevation, the domain of things, was avoided. The mode was a kind of relief situation moved from wall to floor. A shallow, slightly more than two-dimensional "down" space was developed which gave the viewer a kind of "double entry" by allowing him to occupy two domains simultaneously: that of the work's shallow blanket of space, and those upper regions free of art from which he commands a viewpoint outside the work. The viewer's feet are in the space of the art, but his vision operates according to the perception of objects. Some "scatter" pieces occupied the entire floor, the walls acting as limiting frame.

More recently, certain "miniature" works have maintained the lateral spread of floor space but have altered its character [e.g., Joel Shapiro]. The miniature or model quality of the elements charges the space with an implied vastness compressed below the knees of the viewer. Neither the objects nor the space are their actual size. One becomes a giant in their presence. These shrunken works, while definitely object-predominant, emphasize the space to a greater degree than earlier scatter works as they depict a space which seems larger in real-size, squeezed down around the miniature representations. The whole is removed from our own space and time. It seems that these works owe something to photography, which can fascinate for the same ability to compress vastness into miniature scale. One accepts the photograph (unlike representational painting) as shrunken reality, as a kind of projection of the world. We believe it to have registered the space through which we move. Miniature three-dimensional work effects a similar dislocation—with the difference that we sense our own space around us and simultaneously feel it shrunken by the work in our presence. Space is at once both large and small. But, as with photographs, we are here the detached, voyeuristic tourist to the depicted worlds at our feet.

The recent works which have relevance to the subject proper of this narrative form no cohesive group. Some participate more fully than others in a confrontation with spatial concerns. None are miniatures, some are oversize. They have been located indoors as well as outside. Early examples of work intensely focused on space can be found in the mid-sixties. While this spatial focus is more frequent today, it isn't always clearer than in some of the earlier works, and in many cases, recent work is only a refinement. But within the many examples of work cited here by illustration it is possible to find this spatial focus biased toward one or the other of two generic types of spaces: those articulated within contained structures and those operating in an open "field" type situation. One could almost term these "noun" and "verb" type spaces. On occasion, both types are found in a single work. Works of the former type generally

present a strong outside shape as well as an interior space. In some cases the interiors of large-scale works—whether physically or only visually accessible—are little more than the results of the exterior shell. But it is not the large object which might be hollow that reveals a shift in thinking about sculpture. It is in approaches motivated by the division and shaping of spaces—which may or may not employ enclosing structures—where directions different from and opposed to Minimalism are to be found.

It is worth observing how much and in what way Minimalism is behind all spatially focused work—as well as in what way it now may present a block to its further development. From the very beginning of Minimalism there was an opposition between forms which accentuated surface and inflected details of shape, and work which opted for a stricter generality. It was the latter which opened more easily to the inclusion of space as part of, rather than separate from, the physical units. These forms were more suitable as markers and delimiters. Space was not absorbed by them as it was by the more decorative specificity of objects presenting greater finish and eccentricity of detail. This use of generality of form to include space has been extended in several directions in the seventies. Some emphasized greater rawness of material, more size, weight, fascination with system or construction, and arrived at the somewhat opened-up monument. Other efforts, restraining an emphasis on the phenomenal aspects, moved more directly into a confrontation with space. Some, by presenting articulated interiors, have moved close to an architectural imagery. Other work opens up the extended spatial field by employing distances rather than contained interiors. In most cases the overall unifying gestalt form has usually prevailed. These have been structural options which various works have found rather than programmatically followed.

It is indicative of the power of the wholistic, generalized gestalt form, that it sustained most all of these developments by providing a structural unity first for objects and then for spaces. The nature of gestalt unity, however, is tied to perception which is instantaneous—in the mind if not always in the eye. But this "all at once" information generated by the gestalt is not relevant and is probably antithetical to the behavioral, temporal nature of extended spatial experience.

It should be remembered that work which has a wholistic structure originated inside gallery spaces and was later enlarged and transferred in the mid-sixties to exterior sites. It is wrong to describe gallery and museum spaces as "spatial" in the sense in which I have been using the term. Such rooms are anti-spatial or non-spatial in terms of any kind of behavioral experience, for they are as wholistic and as immediately perceived as the objects they house. These enclosed areas were designed for the frontal confrontation of objects. The confrontation of the independent object doesn't involve space. The relationship of such objects to the room nearly always has had to do with its axial alignment to the confines of the walls.

Thus the wholistic object is a positive form within the negative, but equally wholistic, space of the room. The one echoes the other's form: a tight if somewhat airless solution. Claims for the independent object were actually claims for a hidden relation: that of the object to the three-dimensional rectilinear frame of the room. It might be said that such a space both preceded and generated the so-called independent object. Little wonder that the gestalt object when placed outside seldom works.

In the broadest terms work based on the wholeness of the gestalt is work which still maintains assumptions established by classical Renaissance art: immediacy and comprehensibility from one point of view, rationalistic structure, clear limits, adjusted proportions—in short, all those characteristics which the independent object of the sixties redefined. Despite the variations played on this theme by a lot of seventies work, that which maintains the wholistic maintains the classicism and all that implies. . . . The concerns of the new work in question—the coexistence of the work and viewer's space, the multiple views, the beginnings of an attack on the structure provided by the gestalt, the uses of distances and continuous deep spaces, the explorations of new relations to nature, the importance of time and the assumptions of the subjective aspects of perception—also describe the concerns of the Baroque. It would seem that much of the work most cogent to my discussion, work which pushes hardest against sixties definitions, has to some extent moved into a Baroque sensibility and experience without, for the most part, the accompanying Baroque imagery. . . .

Most, but not all, of the work which is the subject of this narrative is of the construction type, is frequently wholistic and can be represented with traditional plan and elevation images. But the relation of this representational scheme to space is just that—schematic rather than structural, as in the case of objects. The reason for this is that no temporal encoding exists in plans or elevations. One might at some point be developed, since all representations of time must be spatialized to be represented: clocks, calendars, musical scores, etc. But at this point space has no adequate forms of representation or reproduction. . . .

In the space-oriented works under discussion here, the notion of closeness/distance is redefined. They are not experienced except by the viewer locating himself within them. Closeness dissolves into physical entry. Distance, a parameter of space, has an ever-changing function within these works.

Smithson's outside mirror pieces were quite clear early investigations of "verb-type" spaces. They defined a space through which one moved and acknowledged a double, ever-changing space available only to vision. There was an exactness as well as a perversity implied by his photographing and then immediately dismantling these works. Exact because the thrust of the work was to underline the non-rememberable "I" experi-

ence; perverse because the photograph is a denial of this experience. Defined space implies a set of tangible, physical limits and these can be measured and photographed. The distances between these limits can be measured as well. But photography never registers distance in any rational or comprehensible way. Unlike recorded sound or photographed objects, space as yet offers no access to the transformative representations of media.

The question arises as to whether my claims about space are not a stubborn insistence that the subjective side of spatial perception be the only allowable one. As mentioned before, space can be measured and plotted, distances estimated. Stairways, small and large rooms, crowded gardens and open plains, and most every other type of space (except perhaps weightless outer space) has some degree of familiarity and none of the types illustrated here present mysterious experiences. What I have insisted upon is that the work in question directly uses a kind of experience which has in the past not been sustained in consciousness. The work locates itself within an "I" type of perception which is the only direct and immediate access we have to spatial experience. For the sake of comprehension and rationalization, this experience has always been immediately converted into the schemata of memory. The work in question extends presentness as conscious experience. . . .

ATHENA TACHA (1936-)

Especially in her step constructions, begun in 1970, Tacha's work is a synthesis of both site and architectural sculpture. Her lucid essay demonstrates the organic and scientific orientation of her work and the necessity of actual physical kinesthetic experience of it, in real time. One must walk up and down and across Tacha's step sculptures, feeling their rhythms with one's body, to realize their analogy to new concepts of space. Moreover, through the rhythms she establishes, Tacha produces kinesthetic *form*, not just kinesthetic experience.

★ ★ ★

Excerpted from Athena Tacha, "Rhythm as Form," *Landscape Architecture* (May 1978). Copyright Athena Tacha 1977

"All things flow." —HERACLITUS

In ancient India it was believed that each artist, before becoming painter, sculptor, poet or musician, had first to master dance, mother of the arts. Indeed, excepting perhaps architecture, dance is the only art which

combines all the elements that separately constitute the domain of the different visual and auditory arts;[1] the only one which merges space and time as vehicles of formal expression; and also the only art in which the live body is the prime transmitter of form.

In many ways, my sculpture is comparable to dance. Naturally, it exists in real space and relies greatly on visual means (including color). Yet, it can be fully experienced only through body-locomotion, and therefore through the element of time and physical participation of the human body.

Time enters my sculpture at many levels.

One, and perhaps the only way to perceive time is through displacement *in space* of one body in relation to another, i.e., through motion.[2] Repetition of motion can structure time, give it a perceptible "form"—a rhythm. Many regularly repeated movements (e.g., the rotations of the Earth and the Moon) create cyclical rhythms that structure or measure our time. The most familiar biological clock, our body, contains a number of cyclical rhythms (heartbeat, breathing, etc.). Normally, walking is also such a rhythm, a regular beat, due to the fact that we have two legs of similar structure and length, and a steady relationship to the pull of the Earth. However, walking depends on other factors as well . . . above all, it is determined by the ground, whose configuration can alter the walking rhythm in terms of regularity, speed and direction. Walking is one of our prime relationships with the environment: the vital *body-to-ground* relationship.

One cannot modify to any great extent the possibilities and limitations of the act of walking as controlled by our bone and muscular make-up. . . . All these elements that define walking are human constants. There is no getting away from the facts that, generally, people's steps measure between 2 and 3 feet (note the measuring unit), and that a person will take equal steps on flat ground. However, one can manipulate walking by changing the ground's

[1] Architecture depends not only on three- and two-dimensional form, but also on rhythmic effects (fenestration, colonnades, etc.) and on being experienced through body-locomotion. However, function has placed so many demands and constrictions on architecture that it almost stands halfway between science (engineering) and art. Theater, of course, depends partly on space and visual effects, but its literary element (and therefore its time-dependency) is of far greater importance. Only a recent development of the visual arts, "body" or "performance art," can be said, like dance, to use equally as vehicles of expression space, time and the live human body. Nonetheless, body art can be distinguished from dance or theater by its non-reliance on rhythm or language.

[2] Sound, which can also structure time, is in fact displacement of air molecules; and light-signals are release of moving particles. Continuous change, which is another way of experiencing time, can be broken down to multiple motions on a microscopic, atomic or subatomic level. Subjective experiencing of time, on the other hand, is due to chemical changes in the body, which can also be reduced to motion on the cellular and molecular levels.

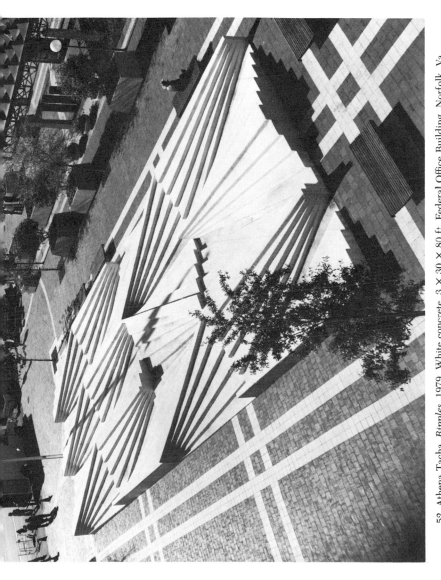

52. Athena Tacha, *Ripples*, 1979. White concrete, 3 × 30 × 80 ft. Federal Office Building, Norfolk, Va. (*Photo: Courtesy Athena Tacha*)

configuration, by controlling the environment's visual stimuli, and by subtly altering the body's relationship to gravity.

These are the means I employ to transform the body-rhythm of walking into a receiver of artistic expression, a sensor of a new kind of form. By disrupting the usual expectations about walking, ascending and descending, I try to re-attune our sensitivity to kinesthetic experiences. By breaking up the ground into steps (the two meanings of the word are no coincidence), and by varying the height, depth, width, inclination, direction and regularity of these steps, I aim to create a rich variety of temporal patterns, a different feeling of space and a new awareness of gravity.

Our vertical position when standing and our horizontal perception of the ground are closely connected to our sense of stability and balance, which has become second nature. This, in addition to practical reasons, accounts for the extraordinary predominance of the rectangle in man-made environments, and for its becoming our instinctive measuring unit of space. Rectangular architecture and urban design have so saturated our vision that we tend to feel disoriented in an environment made of tilting planes or ambiguous curves. If one loses the "measuring rod" of the gravity-defined horizontal and vertical, one tends to mistake approximate horizontals and verticals at right angles to each other for the real thing. The eye, our all-powerful detector of the surrounding world, is able to mislead the key sensor of gravity, the ear's labyrinth. Also, the absence of parallels (which are our usual guide, due to our intuitive grasp of perspective changes) can cause us problems in space interpretation, i.e., in locating objects in depth or estimating distances and sizes.

Naturally, my real aim has been far from physical or psychological manipulation of the spectator. What led me to develop this range of forming devices was the need to express some of my vital interests. The fundamental importance of gravity in the structure of the universe and in the very nature of space and matter; the interchangeability of matter and energy; the equivalence between acceleration and gravitational pull; the interdependence of space and time, and the peculiar characteristics of the latter (e.g., apparent irreversibility); the possible dependence of space on matter (or vice versa), and a certain "materiality" of space which endows it with qualities such as elasticity and malleability—these and other such concepts that modern science has developed are subjects of great excitement to me, which I want to render tangible and communicable to others through the language of form. I am a great believer in the power of form as a probing tool for understanding reality. I am even willing to imagine that matter comes into existence by way of form (or structure).

On a less abstract or intellectual level, I am immensely fascinated by observing in nature some kinds of forms (waves, spirals, spheres) recurring at all levels and scales of reality. . . .

Here is then another aspect of time's importance. . . . I see time as a constant denominator of form. The sphere, a classic symbol of equilibrium, is actually the form of minimum surface for maximum volume, and of minimum energy expenditure—of temporary balance (e.g., a drop of water). Waves are the form of motion in fluids, or rather of interfaces between moving fluids. The spiral is the form of growth and of turbulence (faster motion in fluids). Erosion patterns are created by the passage of liquids over denser matter—again the record of a time process. It should be noted that waves and series of vortices, my most frequent sources of inspiration, are periodic or cyclical phenomena, like walking.

Ultimately, I wish to express in my sculpture the various forms of *fluidity* which appears to be the constant state of matter. The predominant formal idioms of the sixties, Minimalism and Serial-Systemic Art, were clearly incapable of this task. Rectangularity and uniformity are basically static and rarely encountered in nature (e.g., in crystals). I had to develop . . . a new way of composing or structuring form, almost antithetical to existing modes, much closer to music than to the visual arts. I wanted *rhythms* (not shapes), unhomogeneous but self-consistent, interweaving with each other, regular only in their irregularity, growing naturally like ivy in the woods, fluctuating like a swarm of insects. Thus, without realizing it, my sculpture became itself an interface between air and earth, as if the ground were a moving fluid and the sculpture its surface. My visual syntax was born to match the kinesthetic vocabulary which is the sister-carrier of my message (both of them progeny of time). . . .

Another effect of time that fascinates me, much as I rebel against it, is the process of aging—evolution, disintegration, change. I naturally want my sculptures to be permanent, so that they carry their message to more people through their physical presence. But I also want them to last in order to have a chance to age—to be worn out from use, covered partly with weeds or scars, mellowed by time, slowly taken over by nature and blended with it. I think that my forms will be little affected by the ravages of time, since my method of composing is compatible with nature's ways, such as organic growth—though I follow the principles of lower organisms (for instance, plants). A tree can lose a branch without substantial change of its shape (which relies on its character, on the way it grows), whereas a higher animal becomes clearly disfigured by the loss of a limb. So does a Greek temple by losing a column, or a Minimal sculpture by having a corner broken off. Some works of art (the closed-form type) depend on the wholeness of their entity. They spring from our anthropocentric Western culture. A medieval cathedral, on the other hand, or a work of Gaudi, can be deprived of a major part (even a tower) and can receive later additions without suffering too much. My work belongs

to this latter, open-ended sprawling kind of art, in spite of its "classical" serenity.

The structural kinship of my sculpture with "lower" organisms or aspects of "inanimate" nature comes ultimately from my deep-rooted conviction that all matter is alive—a kind of pantheistic attitude. . . . How can we not be in communion with all matter, since we are made up of the same atoms and particles which are constantly pulsating inside every bit of stone or metal? The properties of such materials are manifestations of their inner life. Steel's tensibility makes possible vibrant forms that are inherent in a sheet of metal. Thus, my metal sculpture makes use of yet another aspect of time: latent energy.

In order for time-rhythms to be experienced by body-locomotion, a large enough expanse of space is needed. . . .

I am interested in yet other aspects of scale, such as its effects on perception of form. It is most likely that form exists everywhere, but we cannot always perceive it, because of great differences in scale or a disadvantageous point of view. For instance, we cannot see that our galaxy has a spiral shape, because it is much too large and we are within it. This stupendous difference in scale between nature's various domains is actually one of its most awesome and puzzling mysteries. The human mind cannot conceive the vastness of either intergalactic or infra-atomic space (Pascal's "two infinities"). Even matter may change its behavior and follow different laws in drastically distinct scales. However, form seems to remain constant: a subatomic particle within a magnetic field moves (at nearly the speed of light!) in a spiral similar to many galaxies, or to the whirlpool that the water makes when one flushes the toilet.[3] It is possible that the underlying fabric of space dictates the formal laws of matter at all scales.

Since my work needs to be walked on and lived with in order to become fully communicable, it ideally should be located in public places. Like other artists, I am consciously breaking away from the twentieth-century tradition of having art concentrate on its own ontological questions—a highly specialized direction. I would welcome a link with the general public, a social or urban function for my art—such as its being a square or a park. I would like my art not to be set apart as art, looked at with awe or antagonism, but to exist in the context of daily life. In this way, I would hope that the average person, crossing the work routinely, would absorb unconsciously my message, just as Romans get into their marrow part of the meaning of the Spanish Steps or St. Peter's Square. I

[3] It should be noted that the time scales are also vastly different in the three cases mentioned: a water vortex in our daily reality occurs within a few seconds, galactic events take place in millions or billions of years, while the lives of subatomic particles are measured in billionths and trillionths of seconds.

would hope that through my work, as with Indian dance, people's bodies can eventually capture an echo of the rhythms that permeate the universe as I see it—in constant flow.

ALICE AYCOCK (1946-)

Alice Aycock is another of the seventies sculptors who works within an architectural idiom. Besides those previously mentioned are such artists as Patricia Johanson, who makes sculptures and drawings for buildings in the form of plants and animals, and Siah Armajani, whose sculpture takes the form of bridges, houses, rooms, doors, windows. Furniture does not often bring to mind such adjectives as "serious" and "noble," but they are not inappropriate when applied to Scott Burton's work in that genre. Aycock's work differs from other architectural sculpture in the narrative, theatrical, Surrealist quality that flavors it.

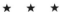

Excerpted from Alice Aycock, "Work 1972-74," in Alan Sondheim, ed., *Individuals: Post-Movement Art in America*, New York, 1977

In general the work included here reflects the notion that an organism both selects and is selected by the environment. The structures, i.e., spaces and materials of construction, act upon the perceiver at the same time as the perceiver acts on or with the structures. The spaces are psychophysical spaces. The works are set up as exploratory situations for the perceiver. They can be known only by moving one's body through them. They involve experiential time and memory. The works are sited in terms of a preexisting landscape feature and are visible from a distance like a Greek temple. They are goal-directed situations, involving what Peckham refers to as "signs of orientative transition." The actual physical structures are impermanent since I do a minimum of maintenance. The work satisfies my need to deal with both ideas and physical things and my megalomaniac and somewhat destructive need to take on more than I can handle. A friend recently pointed out that I seem to relate everything to everything else. While the work is designed in terms of my own body, the contruction tests the limits of my physical strength. I often feel that I am in over my head. The works are a synthesis. They give me pleasure. They turn back on history and back on themselves. Like the example of Christianity outrunning the sign of the cross, the generative ideas/sources outrun the actual structures.

—December 1974

53. Alice Aycock, *Maze*, 1972. Wood, 30 ft. diameter. Gibney Farm, New Kingston, Pa.
(*Photo: Courtesy John Weber Gallery, New York*)

Maze

Executed July 1972 on the Gibney Farm near New Kingston, Pennsylvania. A twelve-sided wooden structure of five concentric dodecagonal rings, approximately 32 feet in diameter and 6 feet high.

The *maze* has the appearance of a hill fortification. I was influenced by the American Indian stockade and the Zulu kraal.

I got the idea while paging through the *World Book* for the definition of *magnetic north*, and accidentally came across a circular plan for an Egyptian labyrinth. The labyrinth was designed as a prison.

The temple dedicated to Asclepius as healer at Epidaurus was composed of a circular stepped platform and twenty-six outer Doric columns axially aligned with fourteen Corinthian columns within the cella wall. An ornamental pavement, concentric rings of black and white tiles, surrounded a center spiral staircase which led down to the center of the labyrinthine substructure. From the center pit one moved through the labyrinth to the "dead end of the outer ring" underneath the temple. The name of the building recorded on an inscription is Thymela or Place of Sacrifice. . . .

Originally, I had hoped to create a moment of absolute panic—when the only thing that mattered was to get out. Externalize the terror I had felt the time we got lost on a jeep trail in the desert in Utah with a '66 Oldsmobile. I egged Mark on because of the landscape, a pink and gray crusty soil streaked with mineral washouts and worn by erosion. And we expected to eventually join up with the main road. The trail wound up and around the hills, switchback fashion, periodically branching off in separate directions. Finally, the road ended at a dry riverbed. . . .

Like the experience of the highway, I thought of the *maze* as a sequence of body/eye movements from position to position. The whole cannot be comprehended at once. It can only be remembered as a sequence. . . .

Because the archaeological sites I have visited are like empty theaters for past events, I try to fabricate dramas for my buildings, to fill them with events that never happened.

11

Performance Art, Film, and Video

By 1970, several artists in both California and the East had taken up performance art—whether as a deliberately chosen alternative to the static object-commodity or as an inevitable outcome of the shifting directions and premises and the expansion of boundaries that had occurred in modern art. In any case, it was not long before museums were hosting performances, as they had eventually presented happenings; and galleries were selling to museums and schools the films and video tapes which artists had made, sometimes as a record of the event, but more often *as* the art work itself. Video is particularly desirable as a medium for performance art because, unlike films, it allows the artist to see and criticize his/her work during the process of making it. Performance and body art evolved not only from happenings (and their ancestors), but also from Abstract Expressionism or Action Painting in respect to the idea of the art work as event and as the result of the artist's whole body action and identification with the work. The physical body and autobiographical subject matter and content that pervaded the arts of the seventies reflected overall cultural concerns familiar to everyone—whether or not they joined a consciousness-raising group, came out of the closet, took up yoga, ate health foods, jogged, or just went swimming.

During the seventies the magazine *Avalanche* was a primary source of statements, interviews, and photographs of work by artists in performance, film, and video. In the later seventies other journals presenting artists' comments and writings came to the fore, among them *Tracks* and *View;* the latter devotes each issue to an interview with one artist.

BRUCE NAUMAN (1941-)

Bruce Nauman makes clear how the artist's awareness of his/her own body is communicated to the spectator in performance or body sculpture. See also a previous Nauman interview with Willoughby Sharp, *Arts magazine* (March 1970), which deals with his earlier installations and sculptures and several of his interior architectural pieces, that is, the corridors, with or without video and sound accompaniment.

★ ★ ★

Excerpted from Willoughby Sharp, "Interview with Bruce Nauman," *Avalanche* (Winter 1971)

w.s.: How did you arrive at the San Jose piece, did it grow out of your *Performance Corridor?*

b.n.: Yes, because the first pieces that were at all like it were just corridors that ended at a wall and then made into a V. Then I put in another V and finally I put in the mirror.

w.s.: Why did you decide to use it that way?

b.n.: The mirror?

w.s.: No, the change in the interior, the second V.

b.n.: When the corridors had to do with sound damping, the wall relied on soundproofing material which altered the sound in the corridor and also caused pressure on your ears, which is what I was really interested in: pressure changes that occurred while you were passing by the material. And then one thing to do was make a V. When you are at the open end of the V there's not too much effect, but as you walk into the V the pressure increases quite a bit, it's very claustrophobic. . . .

Originally a lot of the things that turned into videotapes and films were performances. At the time no one was really interested in presenting them, so I made them into films. No one was interested in that either, so the film is really a record of the performance. After I had made a few films I changed to videotape, just because it was easier for me to get at the time. The camera work became a bit more important, although the camera was stationary in the first ones. . . .

w.s.: Were these the films of bouncing balls?

b.n.: Yeah. The videotapes I did after those films were related, but the camera was often turned on its side or upside down, or a wide angle lens was used for distortion. . . . As I became more aware of what happens in the recording medium I would make little alterations. Then I went back and did the performance . . . at the Whitney during the *Anti-Illusion* show in 1969. I had already made a videotape of it, bouncing in the corner for an hour. . . .

w.s.: The concern for the body seems stronger now than when we did the *Arts magazine* interview.

b.n.: Well, the first time I really talked to anybody about body awareness was in the summer of 1968. Meredith Monk was in San Francisco. She had thought about or seen some of my work and recognized it. An aware-

ness of yourself comes from a certain amount of activity and you can't get it from just thinking about yourself. You do exercises, you have certain kinds of awarenesses that you don't have if you read books. So the films and some of the pieces that I did after that for videotapes were specifically about doing exercises in balance. I thought of them as dance problems without being a dancer, being interested in the kinds of tension that arise when you try to balance and can't. Or do something for a long time and get tired. In one of those first films, the violin film, I played the violin as long as I could. I don't know how to play the violin, so it was hard, playing on all four strings as fast as I could for as long as I could. I had ten minutes of film and ran about seven minutes of it before I got tired and had to stop and rest a little bit and then finish it.

w.s.: But you could have gone on longer than the ten minutes?

b.n.: I would have had to stop and rest more often. My fingers got very tired and I couldn't hold the violin any more.

w.s.: What you are saying in effect is that in 1968 the idea of working with calisthenics and body movements seemed far removed from sculptural concerns. Would you say that those boundaries and the distance between them have dissolved to a certain extent?

b.n.: Yes, it seems to have gotten a lot smaller.

w.s.: What you have done has widened the possibilities for sculpture to the point where you can't isolate video works and say, they aren't sculpture.

b.n.: It is only in the last year that I have been able to bring them together.

w.s.: How do you mean?

b.n.: Well, even last year it seemed pretty clear that some of the things I did were either performance or recorded performance activities, and others were sculptural—and it is only recently that I have been able to make the two cross or meet in some way.

w.s.: In which works have they met?

b.n.: The ones we have been talking about. The first one was really the corridor, the piece with two walls that was originally a prop in my studio for a videotape in which I walked up and down the corridor in a stylized way for an hour. At the Whitney *Anti-Illusion* show I presented the prop as a piece, called *Performance Corridor*. It was 20 inches wide and 20 feet long, so a lot of strange things happened to anybody who walked into it . . . just like walking in a very narrow hallway.

54. Bruce Nauman, *Green Light Corridor*. Wallboard and fluorescent light, variable dimensions. Giuseppe Panza di Biumo, Milan.

w.s.: You had been doing a lot of walking around in the studio. When did you start thinking about using corridors?

B.N.: Well, I don't really remember the choice that led me to . . . I had made a tape of walking, of pacing, and another tape called *Rhythmic Stamping in the Studio* which was basically a sound problem, but video-taped . . . I was just walking around the studio stamping in various rhythms.

w.s.: Did you want the sound to be in sync?

B.N.: The sound was in sync on that one. In the first violin film the sound is out of sync, but you really don't know it until the end of the film. . . .

w.s.: Is the film of the two bouncing balls in the square out of sync? Did you play with the sync on that?

B.N.: No. I started out of sync but there again, it is a wild track, so as the tape stretches and tightens it goes in and out of sync. I more or less want-ed it to be in sync but I just didn't have the equipment and the patience to do it.

w.s.: What did you think of it?

B.N.: It was all right. There's one thing that I can't remember—I think I cut it out of some of the prints and left it in others. At a certain point I had two balls going and I was running around all the time trying to catch them. Sometimes they would hit something on the floor or the ceiling and go off into the corner and hit together. Finally I lost track of them both. I picked up one of the balls and just threw it against the wall. I was really mad.

w.s.: Why?

B.N.: Because I was losing control of the game. I was trying to keep the rhythm going, to have the balls bounce once on the floor and once on the ceiling and then catch them, or twice on the floor and once on the ceiling. There was a rhythm going and when I lost it that ended the film. My idea at the time was that the film should have no beginning or end: one should be able to come in at any time and nothing would change. All the films were supposed to be like that, because they all dealt with ongoing activi-ties. So did almost all of the videotapes, only they were longer, they went on for an hour or so. There is much more a feeling of being able to come in or leave at any time.

w.s.: So you didn't want the film to come to an end.

B.N.: I would prefer that it went on forever.

w.s.: What kind of practice did you have for those films? Did you play the violin to see what sound you were going to get?

B.N.: I probably had the violin around for a month or two before I made the film.

w.s.: Did you get it because you were going to use it, or did it just come into your life?

B.N.: I think I bought it for about fifteen dollars. It just seemed like a thing to have. I play other instruments, but I never played the violin and during the period of time that I had it before the film I started diddling around with it.

w.s.: When did you decide that it might be nice to use it?

B.N.: Well, I started to think about it once I had the violin and I tried one or two things. One thing I was interested in was playing . . . I wanted to set up a problem where it wouldn't matter whether I knew how to play the violin or not. What I did was to play as fast as I could on all four strings with the violin tuned D.E.A.D. I thought it would just be a lot of noise, but it turned out to be musically very interesting. It is a very tense piece. The other idea I had was to play two notes very close together so that you could hear the beats in the harmonics. I did some tapes of that but I never filmed it. Or maybe I did film it while I was walking around the studio playing. The film was called *Walking Around the Studio Playing a Note on the Violin*. The camera was set up near the center of the studio facing one wall, but I walked all around the studio, so often there was no one in the picture, just the studio wall and the sound of the footsteps and the violin. . . .

I guess we talked about this before, about being an amateur and being able to do anything. If you really believe in what you're doing and do it as well as you can, then there will be a certain amount of tension—if you are honestly getting tired, or if you are honestly trying to balance on one foot for a long time, there has to be a certain sympathetic response in someone who is watching you. It is a kind of body response, they feel that foot and that tension. But many things that you could do would be really boring, so it depends a lot on what you choose, how you set up the problem in the first place. Somehow you have to program it to be interesting.

. . . With the films I would work over an idea until there was something that I wanted to do, then I would rent the equipment for a day or two. So I was more likely to have a specific idea of what I wanted to do. With the videotapes I had the equipment in the studio for almost a year; I could make test tapes and look at them, watch myself on the monitor or have

somebody else there to help. Lots of times I would do a whole perform-
ance or tape a whole hour and then change it.

w.s.: Edit?

b.n.: I don't think I would ever edit but I would redo the whole thing if I
didn't like it. Often I would do the same performance but change the
camera placement and so on. . . .

w.s.: Did you consider using a video system in the San Jose piece?

b.n.: Well, in this piece the mirror takes the place of any video element.
In most of the pieces with closed circuit video, the closed circuit functions
as a kind of electronic mirror.
 . . . The mirror allows you to see some place that you didn't think you
could see. In other words you are seeing around the corner. Some of the
video pieces have to do with seeing yourself go around a corner, or seeing
a room that you know you can't get into like one where the television
camera is set on an oscillating mount in a sealed room.

w.s.: That was at the Wilder show, wasn't it?

b.n.: Yes. The camera looks at the whole room; you can see the monitor
picture of it, but you can't go into the room and there is a strange kind of
removal. You are denied access to that room—you can see exactly what is
going on and when you are there but you can never get to that place.

w.s.: People felt they were being deprived of something.

b.n.: It is very strange to explain what that is. It becomes easier to make a
picture of the pieces or to describe what the elements are, but it becomes
much more difficult to explain what happens when you experience them.
. . . It had to do with going up the stairs in the dark, when you think there
is one more step and you take the step, but you are already at the top . . .
or going down the stairs and expecting there to be another step, but you
are already at the bottom. It seems that you always have that jolt and it
really throws you off . . . when these pieces work they do that too. Some-
thing happens that you didn't expect and it happens every time. You
know why, and what's going on but you just keep doing the same thing. It
is very curious.

w.s.: The Wilder piece was quite complicated.

b.n.: It is hard to understand. The easiest part of the piece to get into was
a corridor 34 feet long and 25 inches wide. There was a television camera
at the outside entrance, and the picture was at the other end. . . . When
you walked into the corridor, you had to go in about 10 feet before you
appeared on the television screen that was still 20 feet away from you. I

used a wide angle lens, which disturbed the distance even more. The camera was 10 feet up, so that when you did see yourself on the screen, it was from the back, from above and behind, which was quite different from the way you normally saw yourself or the way you experienced the corridor around yourself. When you realized that you were on the screen, being in the corridor was like stepping off a cliff or down into a hole. It was like the bottom step thing—it was really a very strong experience. You knew what had happened because you could see all of the equipment and what was going on, yet you had the same experience every time you walked in. There was no way to avoid having it.

VITO ACCONCI (1940-)

This entire issue of *Avalanche* is devoted to an analysis by Acconci of his work to 1972. He had been engaged in poetry and other writing from 1964 to 1969, when he turned to performance art. Among numerous other Acconci documents, two should not be missed: "Vito Acconci on Activity and Performance," in "Notebook," *Art and Artists* (May 1971); and Acconci, *Think/Leap/Re-Think/Fall*, in which he presents the history of an installation piece (for Wright State University, Dayton, Ohio, 1976) from its inception throughout the entire process, and his thoughts about it.

★ ★ ★

Excerpted from Liza Béar, Interview with Vito Acconci, *Avalanche* (Fall 1972)

v.a.: I think that when I started doing pieces, the initial attempts were very much oriented towards defining my body in a space, finding a ground for myself, an alternate ground for the page ground I had as a poet. It seemed very logical that this could be me, my person, and work from there. But from 1969, after those body definition photograph pieces, the interest has really been in an interactive element, what I would call throwing my voice, setting up a power field, though not so much that I want to grab and trap someone. In pieces like *Points, Blanks*, I was a sort of margin surrounding the audience. . . . Then there was a shift from me as say, margin, to me as center point, as focal point. This particularly came out in my films—most of which were done in a few months in 1970—*Hand and Mouth, Grass and Mouth*, in almost all of which I am the central figure. But it seems that since then I am in a marginal situation again. In *Seedbed*, I'm under the ground—in *Crossfronts* I'm crisscrossing through people, around people. The way I want the space to

55. Vito Acconci, *Trademarks*, 1970. Activity. "Biting myself: biting as much of my body as I can reach. Applying printers' ink to the bites; stamping bite-prints on various surfaces."
(*Photo: Courtesy Sonnabend Gallery, New York*)

work is not so much viewer on one side, me on another, as kind of mingling that involves me moving around the space, being at different points. In a way, that's also the concern of the early performances—the difference is that in those, my interest was in a very neutralized presence. Anybody could have walked to the gallery, anybody could have stared. But obviously something was missing, hence the track toward me as central figure, almost to enable me to go back to the margin, but now as personalized marginal presence, rather than neutralized marginal presence. . . . And my interest over the past year is not in another person as an outsider observing my behavior, but more sort of seeping into what's inside my behavior, seeping into my experience, and my sort of sinking into his.

L.B.: To say "marginal presence" is slightly misleading, isn't it? It seems inconsistent with wanting to affect the public space, exert some kind of power over it . . .

V.A.: I mean physically marginal—being around a room rather than at a point—not marginal in the sense that my presence can be forgotten about or sloughed off. I would be a part of the walls, part of the floor, but I would be making them come alive in such a way that they would strike, rather than draw back. It's more powerful to exist around four walls or under a floor than in one place. I have more points to act from. . . .

L.B.: Would you say that very often the structure of a piece couldn't be developed without that play on words—in *Seedbed, Broadjump 71,* for example?

V.A.: . . . Well, in *Seedbed,* I knew what I wanted the general structure of the piece to be, I wanted myself as a presence that would exist during the viewer's presence, that would be at more than one point—I wanted myself to be part of the space in which the viewer was. One convenient way to do this was to be under the floor, under the ground, which implied some kind of growth, plants underground, develop something, grow something. And the specific activity became clear in thinking in terms like underground, undercurrent, going from that to seedbed. So though the general structure might have been determined by the situation of a public gallery space, the activity itself was a combination of the space and terms for that situation—the words provided the activity. With all this emphasis toward post-studio, post-gallery art or whatever, it seems incredibly retrograde that what I'm doing really demands a gallery space. It really brings back the gallery rather than goes away from it . . . gallery space is not so much a space with an audience—an audience is bad—as a space with passers-by. What I like about 420 are the stairs from floor to floor; the galleries seem like stations on some transportation system, transient exchange points—that kind of situation seems so much the basis of what I've been doing lately.

. . . This interest in movement. Trace it back to poetry, movement over a page. Trace it back to childhood. We always lived in small apartment space—it could never be considered a place for me to be somewhat self-sufficient in. It was always a place from which I had to go, to which I could return.

L.B.: You're clenching your teeth.

V.A.: Maybe the words'll get out through them anyway. . . . When I think of my relationship with my father, I think in terms of walks. Anytime I talked with him we were always walking—walks in the Botanical Gardens in the Bronx. On Sunday mornings my mother would stay home cooking and we would walk. I remember a nursery rhyme he used to tell me. It was about a man with a rubber leg, and it went something like this— "Crossing the river, the man did drown, but his leg kept jumping on." I'm *sure* that was an incredible influence on everything I've ever thought about since. That idea I always talk about, of power field, reverberations . . . the guy is dead, drowned, but that leg keeps going, it just keeps *moving*, it doesn't *stop*. That's like the urge behind *Seedbed*, behind so many of those pieces, the urge to have something continue. . . .

I've always been incredibly interested in drift, though probably my keynote is drive . . . I was thinking particularly of a movie called *Hatari*, which is about a trek in Africa, with John Wayne. . . . The drift element in Hawks's *Hatari* is something I have never quite gotten to, though I think it's been my attempt in the past few months—even in *Seedbed*, though there is a drive, the attempt is to do something all day, and to drift from point to point. . . .

. . . A piece like the Documenta performance—all the things I've been saying lately about acting as the space, becoming part of the space, adhering to the terms of the walls—why, because this would make me drift around the room, from corner to corner.

L.B.: You want to slow down your drive into something more fluid.

V.A.: Yes, because the drive is too much involved with points, and I want that surrounding more than I want the point. . . . It could be a drift with a drive at the back of its mind.

CHRIS BURDEN (1946-)

It is often frightening and always startling to watch Chris Burden's performances, in which he subjects his body to violently dangerous situations that, as he remarks, reflect elements he finds in our culture. No

one could fail to respond to his dramatic pieces; often visually as well as emotively compelling, they set up currents like flashes of energy between the artist and his audience, as Burden himself points out.

★ ★ ★

Excerpted from Chris Burden, "Church of Human Energy, An Interview by Willoughby Sharp and Liza Béar," *Avalanche* (Summer–Fall 1973)

w.s.: What do you see as your central concerns?

c.b.: Well, in some of the pieces I'm setting up situations to test my own illusions or fantasies about what happens. *The Locker* piece, for instance . . . I didn't know what it was going to feel like to be in that locker, that's why I did it. I thought it was going to be about isolation; it turned out to be just the opposite. I was seeing people every single minute for thirteen, fourteen hours a day, talking to them all the time. In *Secret Hippie*, I thought I was gonna get hurt when I got that stud hammered in my chest, but it didn't hurt at all, there was absolutely no feeling. In *Shoot* I was supposed to have a grazed wound. We didn't even have any Band-aids— the power of positive thinking. It's not that I consciously decided *not* to think about what might happen . . . I had no plans of going to the hospital; I was going to get drunk or stoned afterwards.

Five Day Locker Piece, *April 26–30, 1971, Irvine, California*
I was locked in locker No. 5 for five consecutive days and did not leave the locker during this time. The locker measurements were 2 feet high, 2 feet wide, 3 feet deep. I stopped eating several days prior to entry, thereby eliminating the problem of solid waste. The locker directly above me contained 5 gallons of bottled water; the locker below me contained an empty 5 gallon bottle.

Shoot, *November 19, 1971, F Space, Santa Ana, California*
At 7:45 pm I was shot in the left arm by a friend. The bullet was from a copper-jacketed 22 long rifle. My friend was standing about 12 feet away.

w.s.: You didn't think it was dangerous?

c.b.: I knew it was dangerous, but I figured it would work out perfectly, the bullet would just nick the side of my arm. It didn't work out that way, but it wasn't a bad wound.

w.s.: So it doesn't matter much to you whether it's a nick or it goes through your arm.

c.b.: No. It's the idea of being shot at to be hit.

w.s.: . . . Why is that interesting?

c.b.: Well, it's something to experience. How can you know what it feels like to be shot if you don't get shot? It seems interesting enough to be worth doing it.

w.s.: Most people don't want to be shot.

c.b.: Yeah, but everybody watches it on TV every day. America is the big shoot-out country. About fifty percent of American folklore is about people getting shot.

w.s.: Do you see a lot of violence in the culture?

c.b.: It's not always out front, but it's there. That's what was so exciting about the sixties, all those big rock festivals and riots in Berkeley. It was horrible but it was interesting. When that was on TV, you watched it.

w.s.: Do you feel that you come out of Southern California?

c.b.: To some degree. I've lived here for six years now. I lived on the East Coast for five years. I don't think of myself as a California artist. But it certainly has influenced me.

w.s.: How has the outdoors, the sun, and the emphasis on one's body affected your work?

c.b.: It's not exactly that, because I don't think of California as being eternally sunny. Look at it now, it's pretty foggy. It's foggy in the winter for months. It's more that there's a different perspective. I used to hate it. In LA the first thing that bugs you is that the horizon is really weird, it's more spaced out, because you're usually looking at it in your car, traveling at sixty, seventy miles an hour . . . I do a lot of thinking when I'm driving on the freeway.
 . . . In some ways there's so much else to do that art is almost not important.

w.s.: But isn't that the same everywhere?

c.b.: It seems that in New York there's more art pressure, so to speak.

w.s.: Why is your work art?

c.b.: What else is it?

w.s.: Theater?

c.b.: No, it's not theater. Theater is more mushy, you know what I mean? . . . It seems that bad art is theater. Getting shot is for real . . . lying in bed for twenty-two days . . . there's no element of pretense or make-believe in

it. If I just stayed there for a few hours or went home every day to a giant dinner it would be theater. Another reason is that the pieces are visual too. . . .

w.s.: What's the significance of the drawing you showed at Newspace, *The Church of Human Energy?*

c.b.: The reason I did that drawing is that it represents things that go on when I do pieces. There's an energy that goes back and forth between me and the audience, like electricity.

c.b.: Everything matters, every single thing. Every detail is important, more so than in regular life. . . .

w.s.: How critical are you of the pieces?

c.b.: I'm always pissed off if I don't get good photos. I'm trying to work that out. It always seems something fucks up; it's just unbelievable. So I think, Why didn't I make a movie of that? What the hell was I thinking about? Or why didn't I have somebody there taking pictures? If I'd had more time at Oberlin, I might have done the piece there a little different-ly. But it all works out to the good. I wanted to do it a lot higher, and if I'd had two or three days, I would have probably gotten a bigger ladder and hung myself higher up, but then I would have gotten crunched. . . . It's hard to say. Some of the fire pieces, like *Icarus*, have been really tricky. The matches were supposed to be thrown simultaneously . . . I real-ized I should have practiced with Roger and Charles.

Icarus, *April 13, 1973, 823 Oceanfront Walk, Venice, California*
At 6:00 pm three invited spectators came to my studio. The room is 15 by 25 [feet] and well lit by natural light. Wearing no clothes, I entered the space from a small room at back. Two assistants lifted one end of a 6-foot sheet of plate glass onto each of my shoulders. The sheets sloped on to the floor at right angles from my body. The assistants poured gasoline down the sheets of glass. Stepping back they threw matches and ignited the gasoline. After a few seconds, I jumped up sending the glass crashing to the floor.

w.s.: But it would be artificial to rehearse, wouldn't it?
c.b.: Well, I did practice with them ten minutes beforehand. But I real-ized that I'd have to do it not once or twice but a lot of times, so that they wouldn't be freaked out by the gasoline. And they were freaking out. . . . But if I had, it wouldn't really have happened . . . they would just have gone through the motions, it would have been more choreographed. . . . But you're right, I can only experience being dropped on the floor once; I

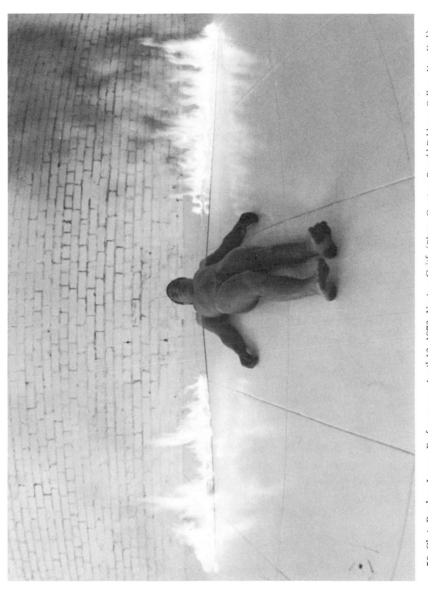

56. Chris Burden, *Icarus*, Performance, April 13, 1973, Venice, Calif. *(Photo: Courtesy Ronald Feldman Gallery, New York)*

can only experience getting the gasoline lit close to me once, because if I do it again I'll know what to expect. The unknown's gone. I mean, there's no point in ever getting shot again.

LAURIE ANDERSON (1947-)

Laurie Anderson's performances—especially those early ones combining her violin, singing, electronics, and film images—are among the most poetic and touching in the contemporary field. Her remarks below are particularly illuminating with regard to the spatial, sculptural character of her performances. Since most artists working in performance, film, and video (i.e., visual artists) consider themselves as sculptors, it is particularly valuable to have one of them analyze what constitutes "sculpture" in that kind of work. Anderson was among the first to "cross over" between visual art and music, a common practice among the currently popular New Wave and Punk groups.

"Laurie Anderson," Interview by Robin White, *View* (January 1980)

L.A.: . . . One of the most interesting things I did last year was a seminar in the Midwest with Benedictine nuns. . . . They had gotten my name from a national list of artists. . . . It said something about "artist who deals with spiritual issues of our times." . . . I think I'd written it myself. And since they could only have women at the convent, I was a natural choice. I was amazed—this is the biggest Benedictine convent in the world, 3,000 nuns. Benedictines are scholars but they also want to balance it with physical activity. They're very strong. They work in the garden and have pigs and cattle and then they work in the library . . . and pray. On the way into the convent we passed an enormous graveyard of nuns; it was a very moving experience to me because all of the stones, all of the crosses—little crosses, were marked with the same four or five names, you know—Theresa, Maria Theresa, Maria, Theresa Theresa—Everything was given up . . . the way they lived. I wasn't really sure for the first day or so what I should do—

R.W.: What could be more foreign to the contemporary art world or avant-garde art, if you want to call it that, than a Benedictine convent?

L.A.: I think it's very close to the art world in a lot of ways. The nuns are isolated, but these are people who think and feel and have a relationship to—to a kind of ideal, a spiritual or intellectual ideal.

. . . I thought about it a lot last spring when I was trying to write something about the difference between theater and performance—

I was thinking of it in a couple of ways: one is that in theater there is, first of all, character and then motivation, and finally situation. For instance, if you want to have earthquakes in your play, you might have a character who's really interested in earthquakes, a geologist. Or you might tell the story of something that happened during an earthquake that the characters remember and they bring it up in the play.

R.W.: There has to be a logical sequence.

L.A.: Yes. There has to be motivation for the character to say or do something. In a performance, though, you don't have to have character. If you want to talk about earthquakes all you have to do is say "earthquakes," and whatever follows from that. . . .

. . . This [*Americans on the Move*] is the first part of a four-part series about American culture. This first part is transportation, the second part is money, the third is kind of the psycho-social situation and the fourth is, ah, love. All of the pieces, in some way or another, in the first part relate to transportation; they have a diagrammatic connection to each other. . . .

I've tried to reserve the options to pull things out as I see how it feels— Rather than finish the whole thing and call it the final form. I like doing things in different situations because each time you have a completely different physical set-up. You can learn a lot. . . .

Originally my idea was not to be this person on a stage, mostly because that idea reminded me a lot of theater. I wanted the work to be about space, in a certain way, so I used architectural images that wouldn't jar with the space so much—

R.W.: Like that piece at the Whitney in 1976 where you sang and talked in front of a film of the window in your loft, with the curtains blowing— things like that?

L.A.: Yes. So the performing space would be a logical extension of the room itself, without being reminiscent of some other situation. It was another way to hide, to be in the dark, to not be there, to be a bulge in the film surface. And then I thought—since I have spent a lot of time working as a sculptor, ideas about space were real important to me and . . . I wanted to emphasize physical presence in a real room. . . .

In my first performances you felt that spatial situation, your own presence in the room the whole time. I began, at that point, sending standing waves through the audience. Just really emphasizing the room tone—

R.W.: Sending standing waves? When was this? What are standing waves?

L.A.: It was in the mid-seventies. The standing waves were just barely

audible; they produced a physical sensation. You became aware, because of these waves, of your placement in the room. It's like being blind, in a sense, because you feel the space behind you; it's a way to prevent falling into an illusion, into film space. I really wanted to, umm . . .

R.W.: Locate people in reality?

L.A.: Yes, exactly. I began to understand that my idea of space in terms of performances was really almost as if people were there for scale you know? I mean I set it up so that they would feel their physical presence. That's very sculptural, spatial, etc. But it's not about energy. . . .

I think I really wanted to ignore the fact that there were people there because I . . . was nervous. I thought I'd be a librarian, you know. It's what I always wanted to be—or a scholar, someone who's near books.

R.W.: Retiring?

L.A.: Yes, and near ideas. I got into the work I do through a series of things that I thought seemed logical and then when I found that I was— there were people, that's when I turned out the lights and wanted to be a voice in the dark.

. . . The power the audience has—I've been noticing in the last few years that I respond to that really directly. Now I really like to watch people.

. . . Artists are supposed to be innovators and yet we have our own little system set up which is very closed and which doesn't really infiltrate the culture.

. . . One nice thing about the work that I do is that I get to go around the different parts of the country. I also take a lot of trips even without doing work. Just going some place with no money and no plans.

Not taking a tape recorder or cameras—

. . . Really the chance to be not myself, you know, to be an observer and not to have to act in a particular way.

. . . These are the times that I really learn the most.

. . . But it's more especially when I play the violin, because the violin is, for me, another voice. The violin is in my vocal range pretty much, and I feel that in the duets I do talking and playing become really the same thing. And of course the way the whole instrument works is just so beautiful. I like to combine electronics with the violin; it's like combining the twentieth and nineteenth century. Electronics is so fast and the violin is a hand instrument.

R.W.: The combination of nineteenth and twentieth century is like incorporating history into the present.

L.A.: Incorporating, and *updating* history. For me, the action of the bow

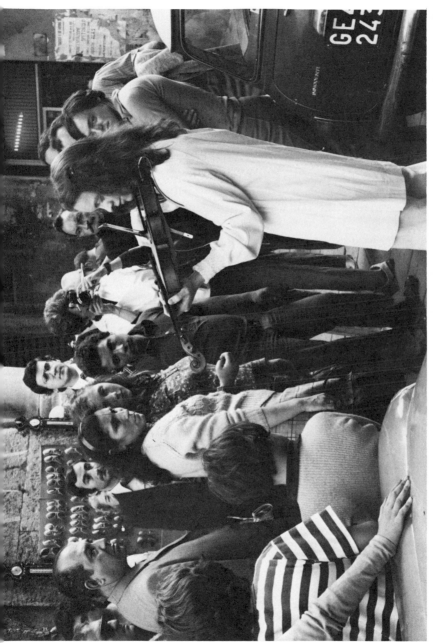

57. Laurie Anderson, *Duets on Ice*, 1974 Performance, Genoa. (Photo: Courtesy Holly Solomon Gallery, New York)

seems like an endless source of images, or ways to be. A lot of the pieces that I've made come out of this action.

R.W.: The action of the bow across the strings?

L.A.: A lot of the stories I use are about this kind of balance of glide activity. One of the first ones I did was *Unfinished Sentences,* which has a very linear design. There was a sentence, a bow length sentence, and then the bow just goes you know, this way, like that—

R.W.: A bow length sentence, in other words, a sentence you would speak while you were moving the bow over strings: Or was it one of the tape bows?

L.A.: It was strictly acoustic—using a bow with tape is another variation on that. Actually, the thing about using tools is that you need constant access to them. It seems strange that so many art students, for instance, work with video tape although they have limited access to the equipment. It's like a painter who thinks about a work for months and then, one day, goes out to rent a brush—paints the painting in twenty-four hours and returns the brush—clean—the next day.

R.W.: No chance to really work with the material.

L.A.: As for me, I like to work with whatever equipment I have, you know, and not plan things for equipment that I don't have—because it teaches things, the material does, in doing it; it teaches me things.

R.W.: That sounds like John Cage. . . . I'm wondering if Cage had been a specific influence on you?

L.A.: I'm sure of it. Also, through other people who are influenced by him. . . . And thinking about the artists who influenced me, one of them was Vito Acconci. . . .

It's so easy sometimes to forget that you are part of a whole thought structure that is going on, and you participate in that, without—

. . . You think you're alone and thought this up yourself, you know, and you're not; you're a part of this intricate web of twentieth-century thought. That, to me, is incredibly lovely because I—it's just less lonely.

12

Decorative, Narrative, and Popular Image Painting and Installations

Decorative or pattern painting has as ancient and respected a history as realism. Its recent adoption by numerous painters springs from multiple sources, including feminist art concerns and the 1970s sympathy for, and sometimes emulation of, a more natural, tribal mode of living. In "primitive" societies the decorating of utilitarian objects flourished; however, to American Indians, for example, each decorative motif had a meaning, a purpose beyond that of simply appealing to the eye. To the extent that a contemporary pattern painting lacks meaning or purpose beyond embellishment, to some critics it lacks conviction or authenticity. Another objection springs, ironically, from the very fact that much contemporary decorative painting does have a useful function outside of its own existence. Since so much of modern art had been based on the premise that art is supremely useless, the idea that painting might be used to decorate a room, or worse, a utilitarian object, was anathema to the practitioners and critic-priests of high art. But such a premise does not die easily—or rather, at all—and its continuance creates a vital tension in the contemporary work.

Anticipating the recent decorative current were Peter Young's cabalistic image paintings, and his stick and thong pictures deriving from his sojourn with the Bourca tribe in Costa Rica; Alan Shields's stitched and painted cloth strip hangings and floor pieces; and Ree Morton's decorated environmental constructions—all of which alluded to and were touched by the magic of tribal, non-Western art. However, the sacred overtones of Ree Morton's work elevated it above a "merely decorative" or utilitarian status, and Alan Shields's tent was not meant for camping; but Peter Young's bead necklaces were meant to be worn as well as contemplated. The women's movement added impetus to the decorative tendency throughout the seventies. Miriam Schapiro makes clear how her work grew out of her participation in the *Womanhouse* exhibition, from her own and her mother's domestic life, and from costumes, quilts, and other "women's work."

In her totally decorated rooms, Cynthia Carlson combines Abstract Expressionist painterly marks and gestures, the repeated unit of serial art, and the flatness of modernist painting; and she engages these multiple factors in a dialogue with architectural motifs taken from the

245

particular building that houses her installation. Making a completely contemporary painting of a historic pattern motif is as ironically different from, though mindful of, traditional decorative painting as Manet's *Déjeuner sur l'herbe* was from the detail of a Marcantonio Raimondi engraving after a lost Raphael painting.

I tend now to think that a critical distinction between contemporary and earlier decorative art is the kind of questioning of itself that persists in the new work and adds bite to the dialogue between "high" art and "low" decoration. Peter Young's beads allude to process art and to Matisse's "cutting" of color as much as to Indian necklaces. Miriam Schapiro's 52-foot-long *Anatomy of a Kimono* has as much, if not more, to do with Matisse, Delaunay, and grand-scale color field painting as with a Japanese garment. Robert Kushner's costumes and paintings, exaggeratedly gorgeous and gaudy, or in his words, "awful" and "so sweet that you can't stand it," function, ironically, as Lichtenstein's at one time did, at the very edge of "bad taste"—both embracing and commenting upon it. Kushner is aware of the tension generated by his paradoxically joining the most safely traditional pattern-making with a brassy avant-garde will to shock by doing something because "you're not supposed to."

By the end of the seventies a good many artists were saying "Why not?" to the decorative impulse. After all, even Duchamp had decorated his bathroom.

MIRIAM SCHAPIRO (1923-)

Excerpted from Miriam Schapiro, "Notes from a Conversation on Art, Feminism, and Work," in Sara Ruddick and Pamela Daniels, eds., *Working It Out*, New York, 1977

When the dollhouse was finished [1973, for *Womanhouse*], I realized that it was a pivotal expression in my life. I returned to my studio, and the work just poured out of me.

The new work was different from anything I had done before. I worked on canvas, using fabric. I wanted to explore and express a part of my life which I had always dismissed—my homemaking, my nesting. I wanted to validate the traditional activities of women, to connect myself to the unknown women artists who made quilts, who had done the invisible "women's work" of civilization. I wanted to acknowledge them, to honor them. The collagists who came before me were men, who lived in cities, and often roamed the streets at night scavenging, collecting material, their junk, from urban spaces. My world, my mother's and grandmoth-

er's world, was a different one. The fabrics I used would be beautiful if sewed into clothes or draped against windows, made into pillows, or slipped over chairs. My "junk," my fabrics, allude to a particular universe, which I wish to make real, to represent.

Excerpted from Miriam Schapiro, "How did I happen to make the painting *Anatomy of a Kimono*?", Statement prepared for the exhibition of the painting at Reed College, Portland, Oregon, 1978. Copyright Miriam Schapiro 1978. Reprinted in Thalia Gouma-Peterson, *Miriam Schapiro: A Retrospective 1953–1980*, Art Museum, College of Wooster, Ohio, 1980

I received a book from Sherry Brody (1976), a woman who had been my assistant at Cal Arts when I lived in California, and the book was on Japanese kimonos.[1] I usually talk about the things that interest me for years preceding working on them and she remembered that I had been talking about fabric, kimonos, and Japan, and sent the book.

Immediately I . . . selected one kimono in particular for inspiration. It reminded me of a Cubist reference, in the way that vertical stripes were subdivided into curious patches that resembled the geometric divisions, in Cubist painting, that passed for perception when the divisions were really part of the "Cubist system." When I was in college and first learned about Cubism, I thought that each "patch" was an isolated phenomenon referring back to a splintered vision of the original perception. I didn't know that a system had been devised which was easily reproducible as in Juan Gris's work.

Then in the same book on kimonos I found the separate image of the obi and finally the separate image of the "kick." I used both of them as inspiration.

Andre Emmerich called me three months before the show was to open (September 1976). I went to the gallery and stayed there a while remembering my last show there and how unhappy I was in the space with all the 60-by-50-inch paintings looking like postage stamps in the huge gallery.

So I took the measurements of the space and went home and did a lot of thinking. I realized that if I utilized the largest part of the gallery for one work, it would be a very direct way of "saying something." I asked myself what did I want to say and then I asked who I wanted to say it to.

I wanted to say that I was back from California, that I had taken up residence again in New York City, my home, and that I could paint.

. . . As always since my conversion to Feminism in 1970, I wanted to speak directly to women. I chose the kimono as a ceremonial robe for the

[1] Seiroki Noma, *Japanese Costume and Textile Art*, New York & Tokyo: Weatherhill, Heibonsha, 1974.

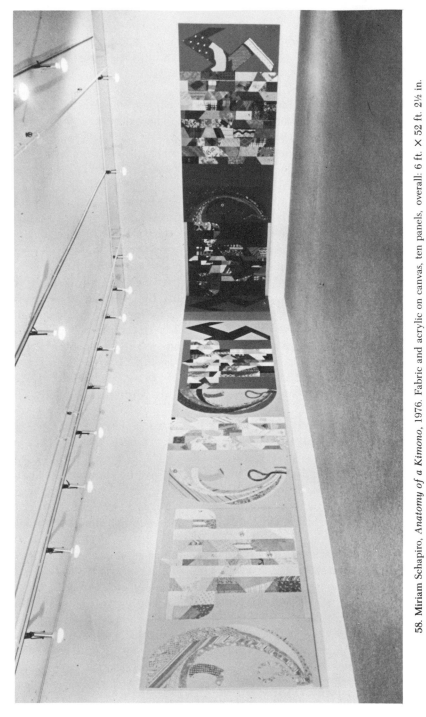

58. Miriam Schapiro, *Anatomy of a Kimono*, 1976. Fabric and acrylic on canvas, ten panels, overall: 6 ft. × 52 ft. 2½ in. Collection Bruno Bischofberger, Zurich.

new woman. I wanted her to be dressed with the power of her own office, her inner strength. I wanted the robes to be rich, dignified; it meant that I imagined I would use a lot of gold and silver. I wanted the robes to be clear but also I wanted them to be a surrogate for me—for others. Later I remembered that men also wore kimonos and so the piece eventually had an androgynous quality. Nice. . . .

I had already painted the grey section of *The Anatomy of a Kimono*. I decided to expand the painting, going both ways. I had a slide of the painting . . . and I went downstairs to Jaime Canvas (my art supply store) and had the color slide Xeroxed on the color slide machine. Then I reversed the slide (remember it had the basic three elements in it—the kimono, the kick and the obi form). Then I Xeroxed it many more times and reversed it and Xeroxed it many more times and with all the Xeroxes, I went upstairs to my studio, to play.

There I conceived the form of a symphony and began to paint the Xeroxes to conform to my ideas of moving the color (as music) through the form to create a color/time sequence.

I called the stretcher maker (Jack Tomlin) and read him my calculations as to the kind of stretchers I wanted. I decided on nine panels besides the original one. Each panel was to carry one of the color messages and each group of four would constitute a section of the whole. The first section was to be pale, the second was the original neutral painting, the third was to be dark and sonorous, and finally the red crescendo—finale, bango.

Finally a bit of discussion on the form factors in the painting aside from the kimono itself. Why the kick and the obi?

. . . I needed two alternative forms to flank the kimono. One had to be geometric and one must be curvilinear. I looked through the kimono book until I found what I wanted. I recreated the "kick" to be an audacious form and I ended the painting with the kick so that the painting would walk or strut its way into the eighties.

The "anatomy" section—that section that exists without the contour of the kimono around it—is the explosion of the fabrics themselves and their demand to be seen in another context so that their reality as old bits of lace or as contemporary Indian cottons or as embroidered tea towels or as Japanese contemporary rayon fabric will be evident.

CYNTHIA CARLSON (1942-)

Excerpted from Cynthia Carlson, Statement prepared for her exhibition *Homage to the Academy Building* at the Morris Gallery, Pennsylvania Academy of Fine Arts, Philadelphia, 1979

This exhibition has its sources in architecture and decoration, with specific references to "wallpaper." It is an homage to the Academy building itself, which represents what Paul Goldberger ("Ten Buildings with a Style of Their Own," *Portfolio Magazine* [June–July 1979]) calls "much of what modern architecture rebelled against: rich ornament, complex details, picturesque massing, and a reliance on history.". . .

Things come to have their meaning for us because of context. Normally decoration depends for its effect on whatever spare attention we can find for it. It is peripheral to our "more important" visual goals. I would change the context of decoration by altering the circumstances of traditional placement (location) and means, to bring it to the center of interest.

I am using architectural detail, and decoration itself, as the subject. The details of our surroundings *are* our surroundings. The "wallpaper" metaphor brings with it its own instant history, as well as its whole inherited past history. . . .

In this exhibition, I am pointedly calling attention to the place of exhibition, to the Academy itself. The art must never overpower the architecture.

ROBERT KUSHNER (1949-)

Excerpted from "Robert Kushner," Interview by Robin White, *View* (February–March 1980)

R.W.: How did you start to make decorative painting? . . .

R.K.: Basically it was a response to everything else I was looking at. I found myself looking at a lot of things, particularly Oriental rugs.

R.W.: Let me be more specific; you went to art school, right? In California, at U.C. San Diego. When you were there, did you make paintings, did you make sculptures?

R.K.: Oh, I see. The first work I did was making sculpture. I was making clouds out of polyurethane, and then covering them with fur and feathers and things like that—sort of strange.

. . . A lot of them hung from strings in the room. Also I would occasionally hang fabric. I had a piece that was chiffon˙ scarves with faces of angels painted on them with glitter . . . everything was suspended; I wanted to see things in the middle of a room. I wanted them to be able to make their own space. And then I went to New York for a visit and started finding all this stuff on the street, like leather jackets.

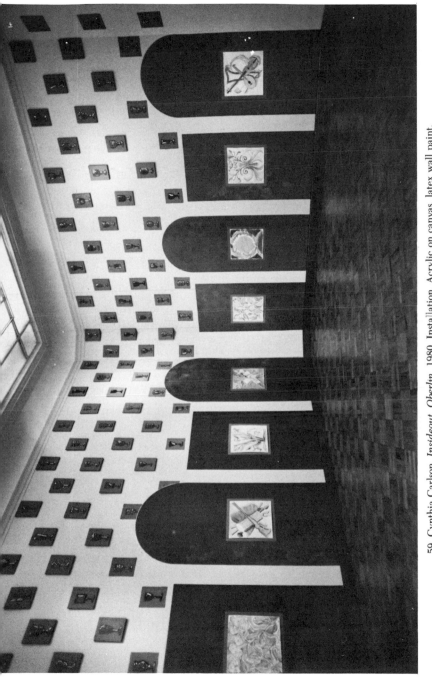

59. Cynthia Carlson, *Insideout, Oberlin*, 1980. Installation. Acrylic on canvas, latex wall paint, watercolor on paper, acrylic and charcoal on masonite, fired and spray-painted ceramics. Overall: 17 ft. 6 in. × 24 ft. × 32 ft. (*Photo: Cynthia Carlson*)

. . . I started taking apart one of these leather jackets and I realized when it was half apart that it could become sculptural—as a costume hanging on the body. And that realization put me in touch with a whole chain of work I did over about six months—just taking existing garments and changing them a lot. These costumes led me into performance and all kinds of different directions. . . . At first I was adamant that the costumes could only be shown when they were worn on bodies. When they weren't on bodies they didn't exist as art. . . .

R.W.: Were you making costumes for anything, like for a theater company?

R.K.: No, I was making the costumes as sculpture and I was making the grids on leather as paintings. Occasionally I made a performance to show, you know, the costumes I had been making. . . .

R.W.: In looking through the catalogues from patterning and decoration shows, I've noticed that motifs or patterns that might be simply small, decorative elements, are often done by artists in a large scale. The scale seems to take the form out of the realm of the simple little decoration. I mean, often when you think of a decoration, you think of something small, so by virtue of its large scale it transcends the notion—

R.K.: I think it is the temperament of our times. I take exception to what you've said because I don't think there is any reason to transcend pure decoration. I mean, pure decorations are the highest goals, I think, of mankind—but we can talk about that later.

The thing is that decoration can be small scale, like this cloth on the table here. That is a very good piece of small-scale decoration. I think the fact that several artists now are working on a large scale, myself included, is a temperamental issue, you know?

R.W.: It's also in keeping with the scale of painting and sculpture in the sixties and seventies—

R.K.: Big paintings are an accepted mode. But also there's the desire to encompass the viewer, which, of course, other painters have done with non-decorative intentions. And then there are a lot of people who want to define a particular space, to have their work relate to a particular space, which I think is an extremely decorative intention, whenever that happens. . . .

The traditional, as I would contrast it to the avant garde, is behind the theme of decoration, because most decorative forms are traditional, let's say conservative. There is an interest in analyzing, repeating, what happened before and changing it a little bit, rather than accepting the mod-

ern notion of examining what went before and rejecting it in favor of doing something brand new. A conservative approach makes a lot of sense to me right now; I think the avant garde is totally burned out. . . .

Here we are in 1980 with people struggling to maintain the idea of the avant garde but with nowhere else to go. It just seems much more comfortable to say: well, I don't care. I can view what I'm doing as a continuation and a slight update of a vast conservative tradition. It's been overlooked just because it is conservative.

R.W.: It's ironic that out of a very conservative tradition comes what seems to be a heresy against modern art.

R.K.: If you look at it in the context of that tradition, it's not heretical.

R.W.: But your work is shown in the context of contemporary art.

R.K.: Sure, sure, it makes a big difference.

R.W.: . . . There was no really dramatic change from making costumes to making paintings?

R.K.: They were going on simultaneously. Then there was a dramatic change. In 1974, I took a trip to Iran.

R.W.: With Amy Goldin, right?

R.K.: Yes. We looked at lots of stuff and I realized something looking at these monuments. See, up until this time there was also a perverse interest, for me, in decoration—I was making decoration because you weren't supposed to.

It *was* avant garde, it was like what can I do that is unacceptable—what can I do that is not art? And these drawings served that. Then, on this trip, seeing these incredible works of genius, really master works, which exist in almost any city, I really became aware of how intelligent and uplifting decoration can be. And that's why I said I disagree with you about the need to transcend decoration.

. . . The garments interested me a lot, especially the veil that the women wear. As soon as I got home, one of the first things I did was to try to cut one out just to see what it would feel like—and when I did, I realized very quickly that there was this big, sort of flattened half circle shape that I could paint on.

From there on I really took off and I painted lots and lots of these shapes. It really solved the problem that no one ever saw my work when it wasn't being worn—these could be worn in performance—here was this live sculpture—and then they could be hung flat on the wall.

As paintings. That was very, very exciting to me. And working that

60. Robert Kushner, *Biarritz* from *The Persian Line, Part 1*, 1975. Acrylic on synthetic and cotton lace and fringe, 74 × 85 in. Courtesy Holly Solomon Gallery, New York and Galerie Bischofberger, Zurich.

way lots of things started to happen. . . . I had had a tremendous amount of trouble putting color into the little patterns that I was working on—

. . . I felt I was a good colorist in the costumes and a terrible colorist as a painter. But somehow the color just started to happen. . . .

R.W.: I think in a way you are trying to make the point that what was once considered decoration is also art.

R.K.: But I am not interested in trying to separate art, even modern art, from life. Art is one thing people do, and within the whole arena of things that people do, the thing that I am interested in separating out is decoration.

R.W.: I would think that as a proponent of decorative art you would really want to try to include it, rather than try to—

R.K.: Some people do. It's just interesting to me to try to pinpoint what it is that makes things decorative . . . I just think a lot of people have been making decoration for a long time without knowing it. So that's why it's useful to think about defining decoration. I just can't help but think that if a lot of artists knew that they were making decoration and felt comfortable with that, they'd be making better paintings. . . .

R.W.: Can you give me an example of someone who has made decoration without knowing it? Or acknowledging it?

R.K.: Well, one of the examples that I used in the discussion after my talk on Ponape was Morris Louis. He was obviously concerned with the formal properties of his paintings, yet I think that if you look at them formally from today's viewpoint, they seem horribly silly. But if you just flip the coin and look at them as really wonderfully fresh works of decoration, they suddenly become much more interesting.

R.W.: Could you name a painter of about the same generation who isn't a decorator?

R.K.: I have to think a while because so much recent art is decorative.

R.W.: Well, what about Ellsworth Kelly?

R.K.: Often decorative. I think those rainbow stripes are wonderful decoration. But Kelly has done a lot of things that are non-decorative. . . .

R.W.: What about Sol LeWitt?

R.K.: Almost always decorative.

R.W.: You know, when I was at home, reading my notes from Ponape and thinking about your work, I looked at a print by LeWitt that I have on

my wall. . . . And it fit all your qualifications for the decorative: it's flat—no deep space; it has a pattern, it expands out beyond its borders; it has no subject matter, at least not readily apparent subject matter.

R.K.: LeWitt is a terrific decorator; he's very good at it.

R.W.: . . . The things that you make aren't so easy to accept. . . . When we were looking at the big etchings that you've made, I was struck by the very complex, explosive relationships of color you've used. The color etching is really hovering on the edge—

R.K.: Yes, I have a particular penchant for things that are awful, that just make it by the skin of their teeth. Which is why I draw the way I draw, too—because I really like that feeling of it looking almost like I had no idea what I was doing. But if you look a little more closely. . . .
 . . . I think there's a real risk of being ingratiating, you know? I do want to put some responsibility on the viewer, to look through and see what's going on, rather than that the work just be totally sweet.

R.W.: O.K., so, you're not interested in making pure decoration. There's a certain amount of risk involved in accepting your work?

R.K.: I feel I have done things that are true—are pure decoration. But I seem to be, at this point, interested in things that are, you know, muddling the issue a little bit. . . .
 You have to realize that decoration can be dislikeable.

R.W.: So that its likeability does not necessarily define something as decorative.

R.K.: No. You're not making decoration because you think it will be pleasing to a larger number of people, otherwise you'd be a commecial designer.
 I don't think that's the issue, whether or not something's acceptable. My work is a reflection of the way I think, you know? And I think in terms of opposites, of things looking one way, being something else. . . .
 So, I like the fact that there's this junky fabric, but it really looks beautiful. And that gives me a lot of excitement—to take something that would have been overlooked and make it an object of scrutiny. . . .

R.W.: It's interesting that each of the decorative painters comes out of a different art background—

R.K.: Most of the practitioners of this school are considerably older than I am, though really, once you hit thirty, it doesn't matter.

R.W.: . . . Why do you think artists are interested in decoration, now?

R.K.: Well, I think a lot of it is a response to a limitation, you know?

Because it really was true, for a while, that you had to work in a certain way if you wanted to show your work.

And I think . . . I have the temperament for very dense, very bright, very gaudy things, potentially in bad taste.

R.W.: . . . Are you still interested in doing performance?

R.K.: Yes. I still perform—I don't do it as often as I used to. But I do about one piece a year. . . .

The last one I did before this was a series of eight duet strip teases. . . . They covered a big range. Some of them were funny, and some of them I wanted to be very beautiful. I wanted to have the performer totally transcend your expectations about strip tease.

R.W.: How?

R.K.: Just be, you know, lovely. There's one with lots of pieces of silk, which are wrapped around us and then taken off, one by one. As we take them off, we do different things—like walking so they go up in the air in different ways. It's surprising—you become focused on the manipulation of the cloth, instead of the body.

R.W.: And the new piece?

R.K.: This new piece has a lot of allegorical material, it is a realization of the myth of Narcissus and Echo.

It's a solo—I'm both Narcissus and Echo.

It has a lot to do with mood; I wanted to have various moods. Also, presenting fables is a way to examine some of our cultural myths that we know are a little sentimental, but we still hold onto.

R.W.: Yes. There must be parallels with decorative painting there—

R.K.: I don't think so. I really think at this point those two aspects of my work are kind of separate. There's a lot of content in the performances. The one thing I feel that I do in performance is address meaning and message much more clearly than I can in the paintings. . . . I get really impatient with a lot of paintings that have all these profound thoughts hitting you, you know, the same way every time. At least in performance, you sort of raise the issue and then it disappears, and if it stays in people's minds, that's very nice. It doesn't hit them over the head with it every time they turn around and look at the painting.

R.W.: . . . The thing that's most striking about them [your paintings] is not their grace or their beauty but their edge, their bite and their humor— and that's not at all part of decoration.

R.K.: It could be. I think what you're saying is partly true, but, again,

decoration doesn't have to be soothing, and pretty—it can be aggressive. . . .

But I do feel like most of the things we associate with decoration are very sweet and pretty. In that case I like those things to get so sweet that you can't stand it.

NEIL JENNEY (1945-)

Contemporary image painting, which grew in popularity in the late seventies and dominated the *Aperto 80* exhibition at the 1980 Venice Biennale, is most often referred to as "new image" painting—a far from satisfactory designation. How long, let alone when, can something be really "new"? Janet Kardon's suggested "vernacular image" is better, conveying, as it does, the source in common, popular imagery; but it is rather too upper class-sounding to be quite appropriate. Nor am I satisfied with "naive" image, even given the "naive" in quotation marks. The "naive" or "dumb" term suggests the deliberately unsophisticated, untutored-looking subject-situation and/or pictorial style characterizing much of this work—another manifestation of the ironical attitude at play in "high" art's engagement with "low" sources. Neil Jenney's heavily brushed, simple theme paintings of the late sixties are either early examples or immediate antecedents of the work in question, which Marcia Tucker called "bad painting." Philip Guston's hooded, big-footed, thickly contoured figures occupy a somewhat similar position in the history of the movement, as do the paintings of the Hairy Who group in Chicago (Jim Nutt, etc.) and the California Funk artists, including de Forrest, Wiley, and so on.

★ ★ ★

Excerpted from statement by Neil Jenney in Richard Marshall, *New Image Painting*, Whitney Museum of American Art, New York, 1978

When I first devised this group of paintings in 1968, I was considering the direction that our culture was inevitably moving toward. I could see that realism was going to return, and that the parameters of realism had not been defined. When you do realism you have to decide what degree of realism you are going to attempt and I decided that I did not want to be concerned about the technical factors; I wanted to develop a style that was unconcerned with position, lines, and color. I was more concerned with approaching the viewer with relationships—for instance, a crying girl and a broken vase, birds and jets, or trees and lumber. I'm not interested in a narrative; I'm interested in showing objects existing with and

61. Neil Jenney, *Cat and Dog*, 1970. Acrylic on canvas, 58 × 117 in. (including frame). Private collection, New York.

relating to other objects because I think that is what realism deals with—objects relating to other objects. I am interested in using imagery that is universal and transcultural—and an imagery that is profound. I wanted the objects to be stated emphatically with no psychological implications.

. . . I wanted to isolate objects and place them on a unified background. . . . There is actually no distinction between abstraction and realism. All realism must resolve abstract complications because you are involved with space and balance and harmony. Realism is a higher art form because it is more precise—it not only solves all abstract concerns, but it involves precise philosophical interpretation.

I am not trying to duplicate something that I see in nature because you must always compromise—it is always going to be paint, you cannot out paint the paint. I was not trying to disguise the fact that these are paintings. I was not trying to mimic photographs. I never wanted to avoid the realization that I was using paint; in fact, I wanted to emphasize it.

Realism is illusionism and all illusionistic painting requires frames. At first, I did not realize the crucial factor that frames can play in the illusion. The frame is the foreground and it simply enhances the illusion—it makes the illusion more functional. I designed and built the frames to suit the paintings—I realized that the frames would enhance the illusion and be a perfect place to put the title.

NICHOLAS AFRICANO (1948-)

The situations in which Nicholas Africano's stiff little humans are engaged gain poignancy through their small size, frequently in the center of a large empty space, and always down stage. His work emphasizes another source of recent image painting—the narrative mode that evolved from conceptual art in the work of such artists as Eleanor Antin, Peter Hutchison, Dottie Attie.

★ ★ ★

Statement by Nicholas Africano in Richard Marshall, *New Image Painting,* Whitney Museum of American Art, New York, 1978

I had been a writer of short, non-discursive prose. I was trying to make a direct and immediate image and began to substitute small drawings for words within the writing. Eventually the emphasis fell on the visual imagery, for it seemed more effective and was more fulfilling to me.

However, my attitude about making work remained intact. It is important for me to work from the specific to the general, to focus on a highly

62. Nicholas Africano, *Lighting Her Cigarette*, 1978. Acrylic on wax on canvas, 60 × 84 in. Private collection, New York. (*Photo: Courtesy Holly Solomon Gallery, New York*)

specific moment of an experience—and allow that to become more generalized through another person's response.

I want my paintings to be about something, as opposed to being about nothing or being about themselves. Their reference is human experience, so they are figurative and narrative. I don't assume a rhetorical posture as a painter and I don't want my work to reiterate rhetorical assumptions—I want something to mean something, in a cogent and revealing way, because I want to be purposeful, even useful. So I regard subject matter as my primary concern as an artist.

In order to present figurative imagery and the content it involves most blatantly, I minimize the physical issues and painterly considerations in the work. I make my decisions about its presence and appearance with the singular purpose of burdening the work with clear intent.

JONATHAN BOROFSKY (1942-)

The images in Jonathan Borofsky's installations have the intensity of remembered dreams or nightmares. Freed creatures of the air, the figures in his wall paintings and cut-outs leap across corners, jump out of the wall, and plunge from the ceiling, totally denying the architecture of the room as they obliterate its corners and disregard its scale. It is indeed Borofsky's dreams, as much if not more than graffiti and street litter, that are the inspiration and subject of his art.

★ ★ ★

Jonathan Borofsky, excerpt from a letter to Ellen Johnson, August 28, 1980

The images I create refer to my personal, spiritual, and psychological self. They come from two sources: an inner world of dreams and other subconscious "scribbles," such as doodles done while on the telephone, and an outer world of newspaper photographs and intense visual moments remembered. All of these images are recorded on various small scraps of paper and later some are enlarged onto walls by projection, or made into three-dimensional objects.

To balance this attraction to the mystical-spiritual and often emotional visual imagery of my personal unconscious, I have been writing numbers in a linear, rational manner since 1968. I began this conceptual exercise by writing the number 1, and I'm now on the number 2,686,886. These written numbers have been crowded onto approximately 14,000 sheets of paper which are stacked vertically as one continuously growing unit. Whenever I record an image or a dream, I affix a number to it—the

63. Jonathan Borofsky, Installation, December 1–27, 1980, Hayden Gallery, Massachusetts Institute of Technology, Cambridge. (*Photo: Courtesy Paula Cooper Gallery, New York*)

number I have reached at that particular moment in my counting.

Most of my work is an attempt to reconcile opposite tendencies—to wed the Western rational mind with that of the Eastern mystic.

JUDY PFAFF (1946-)

Without Judy Pfaff's statement, one would not readily identify the inspiration of several of her recent installations. However, their brilliantly colored, extravagantly varied materials, shapes, and spaces in constant motion—swaying, darting, hovering—do evoke the aurally silent, visually noisy, time-suspended world without gravity under the surface of the sea. My first art-historical reaction to *Deep Water* was to recall Jim Rosenquist's 1964 Green Gallery exhibition of dazzling Dayglo paintings, with multiple layers and appendages, and sculptures of colored wood, neon, and barbed wire, and to imagine it all stirred up by a giant eggbeater. Although each Judy Pfaff installation gives form and energy to the entire space of the room where it appears, her work, like that of several other contemporaries, does indeed have much in common with Pop Art, once so shocking and now so classic. However, Pfaff totally energizes the spaces she forms with her installations.

Finally, if it needs saying, none of this art is wild and unstructured, nor is it "just" decoration or naive imagery. It has meaning beyond source and subject, and is as committed as any other contemporary mode which, in the beginning, seemed to come as close to the edge of the cliff as it could without falling off.

Judy Pfaff, statement in Miranda McClintic, *Directions 1981,* Hirshhorn Museum and Sculpture Garden, Washington, D.C., 1981

Formula Atlantic is the third sculpture I have made that has its genesis in the same experience. Swimming in the Caribbean off the coast of Mexico in Quintana Roo, I discovered a world undersea that corresponded to a new direction I had been struggling towards in my work. *Quintana Roo,* at the Contemporary Arts Center in Cincinnati, was made directly after that experience. The confinements of planar space and gravity gave way in this work to a new fluidity of form and sense of weightlessness. *Quintana Roo* was about the surface, that interface where one world slipped suddenly into another.

Deep Water, the second sculpture, at Holly Solomon Gallery, went further. In the ocean the deeper you go, the less light there is, and the strang-

64. Judy Pfaff, *Kabuki (Formula Atlantic)*, detail, February 12-May 3, 1981. Installation, *Directions 1981*, Hirshhorn Museum and Sculpture Garden, Washington, D.C.

er the life forms become. The formal vocabulary for this work became more abstract and visually more dense. There were less fixed reference points. *Deep Water* was about a deeper engagement and a greater risk.

It is hard to predict what *Formula Atlantic* will be. I am pursuing a deeper and a denser space, an intensified feeling of vertigo, and something of the terror of that sensation of placelessness. *Formula Atlantic* should be about maximum speed. I want to exhaust the possibilities and push the parameters of dislocation and immersion as far as I can. My threshold increases with each piece. I want there to be a kind of synchro-mesh between my thinking and the making of the work, to free the gesture with the thought.

I feel strongly about this new work. The forms are generative and necessary for me to test my limits personally and artistically.

ILLUSTRATIONS

INDEX